GARÇON STYLE

Published by
Laurence King Publishing Ltd
361–363 City Road
London EC1V 1LR
United Kingdom

T +44 (0)20 7841 6900
enquiries@laurenceking.com
www.laurenceking.com

A catalogue record for this book is
available from the British Library

ISBN: 978-1-78627-496-0

Design: Nicolas Franck Pauly

Printed in China

Laurence King Publishing is committed
to ethical and sustainable production.
We are proud participants in The Book
Chain Project®: bookchainproject.com

GARÇON STYLE

NEW YORK LONDON MILANO PARIS

Jonathan Daniel Pryce

Laurence King Publishing

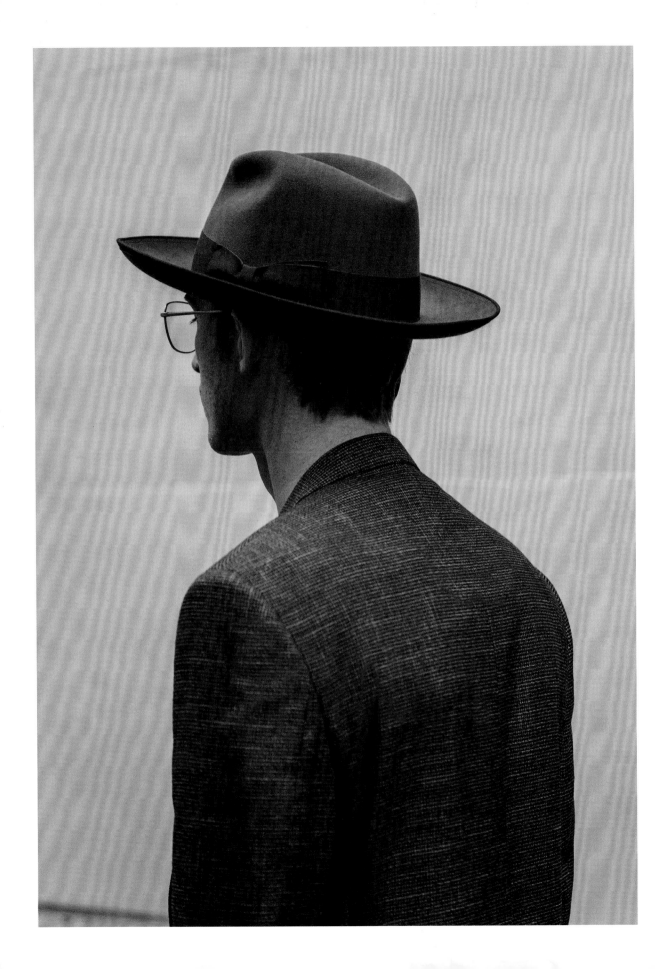

Table of Contents

Photography has always been a part of my life. My dad was an amateur photographer who developed his own photographs in a darkroom in our attic. My first camera was a Kodak Retinette. Back then, you had to look through a viewfinder and locate the image. I would save up money to buy a 36-exposure roll of film, shoot it and hope to get something good. I never knew what the result was until I got it back from the developer. It taught me how to look and see. Today, there are many who look but don't actually see.

I am inspired by shape, shadow and texture. When taking a walk, my focus is less on the clothes that people wear and more on the bigger picture. On the street, I see shapes and angles, size and dimension, rough and smooth. When I first saw Jonathan's photography, what really interested me was his lateral thinking. The world is there to be photographed if you want it, it's just about having the eye to spot it. Jonathan captures the context of a location, from architectural details to the vastness of the sky. A stone staircase becomes something curious. Texture against texture, pattern against pattern.

I've been designing clothes for what feels like a very long time. I opened my first shop in 1970, when there wasn't much men's fashion around. Men were quite nervous about wearing fashionable clothes. Luckily, things have changed. At Paul Smith we have always focused on designing something 'classic with a twist'. There's always some kind of surprise. I'm not one for making radical or revolutionary design changes. It's only *slightly bigger – slightly smaller – slightly longer – slightly shorter*.

‘I like that Jonathan finds characters within each city, the men who put their own unique stamp on a look.’

That's the challenge. It nudges forward, season on season, and men personalize with subtlety. I enjoy the challenge of the 'nudge'. I like that Jonathan finds characters within each city, the men who put their own unique stamp on a look. His focus isn't on the perfect way of dressing or obvious trends and statements, it's about personality.

I still get excited when I spot someone on the street wearing one of my designs – it gives me goose bumps. I love it most when people are able to make it their own, adding their own twist. One of the most exciting things is when we have a sale on and I see a student from Central Saint Martins coming in to get a deal. An art student from somewhere like Japan can come

in and buy one item to pair with their dad's old kimono and the styling becomes genius. For me, the most interesting part of street style is documenting the way someone chooses to wear an item, rather than the design of the garments themselves.

You can be very flippant about photography today: an eight-year-old could take a good photograph, but developing a good eye takes practice and skill. When I first discovered Jonathan's photographs, I was reminded of the curiosity of Saul Leiter – his use of colour and angle shows me that Jonathan has an eye that enjoys surprises, just like my own!

My entire career is based on instinct. The photographer Elliot Erwitt once visited me and we looked through his contact sheets. I asked him why he chose a particular frame and he just said, 'Because, it was the *right one*.' He didn't justify it in any other way. Looking through Jonathan's selections for *Garçon Style*, I can see this instinct. So much of photography is to do with the state of mind.

While there's a lot of generally acceptable street style photography around, what I see from Jonathan goes beyond the expected. He gives context; he gives life. A friend of mine is a successful sports writer, and I remember a report he did on the San Siro Stadium in Milan. Six paragraphs in and all he had talked about was the sounds along the walk to the stadium, passing by vintage Fiat 500 automobiles and the smell of fresh coffee – it was an article about a football match, but the details brought the story to life.

It's clear that Jonathan has trained his eye to look and see. He understands the concept of creating drama. He has his own perspective, is skilled at observing light and creates narratives that don't feel staged. Now, he brings us *Garçon Style*, which challenges the reader to look, see and get lost in the cities he's travelled to.

I'm a lateral thinker and can see Jonathan is too. His work is good, it's very good.

Introduction
Jonathan Daniel Pryce

On a study year abroad in New York City, 2007, I took my first street style photograph with a second-hand Pentax 35mm film camera. I developed the film myself in a tiny lab in Jersey City. At the time, style blogs had begun to influence my creative perspective: I loved to pore over portraits taken in cities I'd never visited and study the unusual faces that inhabit them. This new digital counter-culture, and the freedom that came with it, prompted me to find my own voice.

Inspired by the book *On The Street* by Amy Arbus, I walked through the East Village alone and imagined how people would react to a complete stranger stopping them for a photo. It turned out they were surprisingly eager to have their photograph taken. Soon, I was given my first DSLR camera, which I took out onto the streets of New York and then back to Britain.

These photographs became my first blog project, *Les Garçons de Glasgow*, where I posted a mixture of street style and nightclub photography from my hometown of Glasgow. I wanted to present my city in a positive light, in contrast to its sometimes sketchy reputation. *Les Garçons de Glasgow* became my workshop and, for several years, was the arena where I could hone my technical skill, broaden my view of the world and provide a platform to interact with a global following.

After a first experiment with street style at New York Fashion Week, I made a serious attempt at the London shows the following year. I took my camera to Somerset House, the then-hub of London Fashion Week, and continued my search for interesting characters, just as I had been doing in Glasgow.

I love the immediacy and urgency of the street. Far more than just a concrete slab with pedestrians, it's a theatrical space: layers of interaction traverse each other, creating a liminal space. I snap a slice of that. There is no choice but to work swiftly with the light, subject and location to capture what fleetingly appears in front of my lens. The uncertainty is the challenge but bears the best fruit.

Over the years, my primary focus has naturally gravitated to the menswear seasons. I have something to contribute to this industry and innately understand menswear. I know the confidence a pair of leather-soled brogues can bring; I can comprehend the attitude that only comes with a vintage leather motorcycle jacket. I understand men, their moods, tastes and priorities – all elements I feature in my work.

> **'I understand men, their moods, tastes and priorities – all elements I feature in my work.'**

Trends in menswear also move at a slower pace and are influenced by wider cultural shifts, like those in music and film. I relish this connection. The goal, as Tennessee Williams suggested, is not to create an illusion with the appearance of truth, but to give truths the pleasant disguise of illusion.

Over time, I've developed a rapport with men who work in the fashion industry, sharing mutual admiration of style and, often, friendship. I keep a mental list of the best-dressed men who not only photograph exceptionally well, but who also have something interesting to say. I've selected some of our conversations to feature in this book, our discussions proving that these men live their lives with positive intention and a certain mindfulness. Style originates from more than just a good wardrobe.

The street photographs in this book have been selected from seven years of shooting fashion weeks – a distillation of what I've seen and learned and admired. The four fashion capitals – New York, London, Milan and Paris – are all featured here, and the men in the images are editors, stylists and producers. They are the men behind the brands: the buyers and managers, the influencers and fashion fans who make up the industry.

My goal is not to celebrate celebrity, but to document our time. The way we live now.

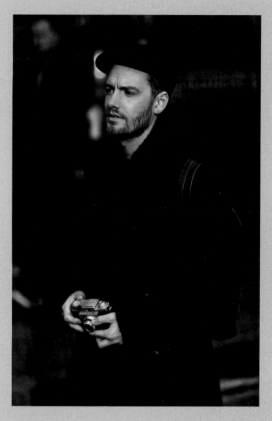

Photograph by Alastair Nicol

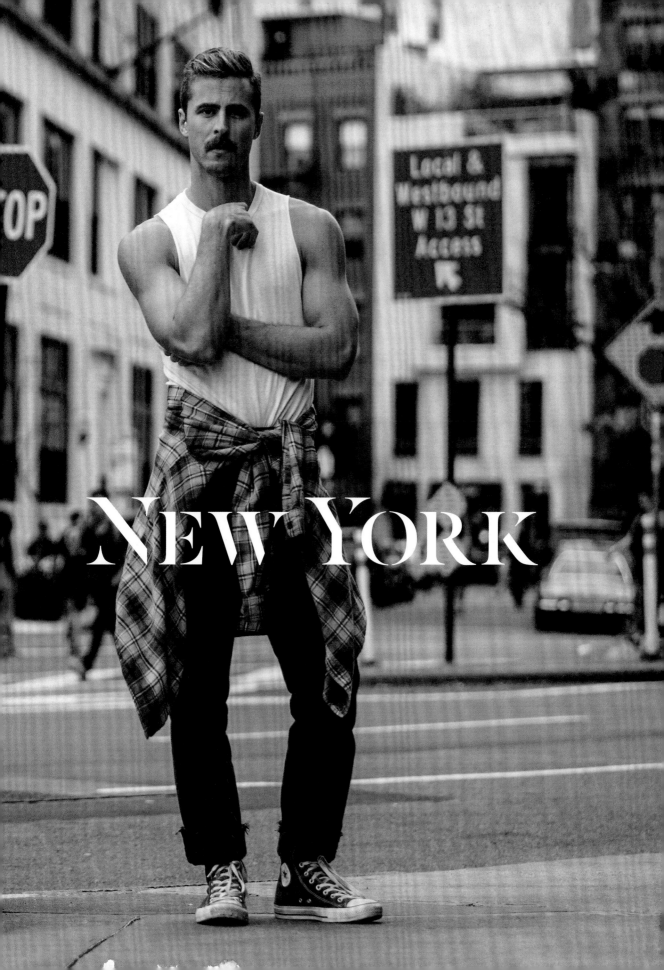

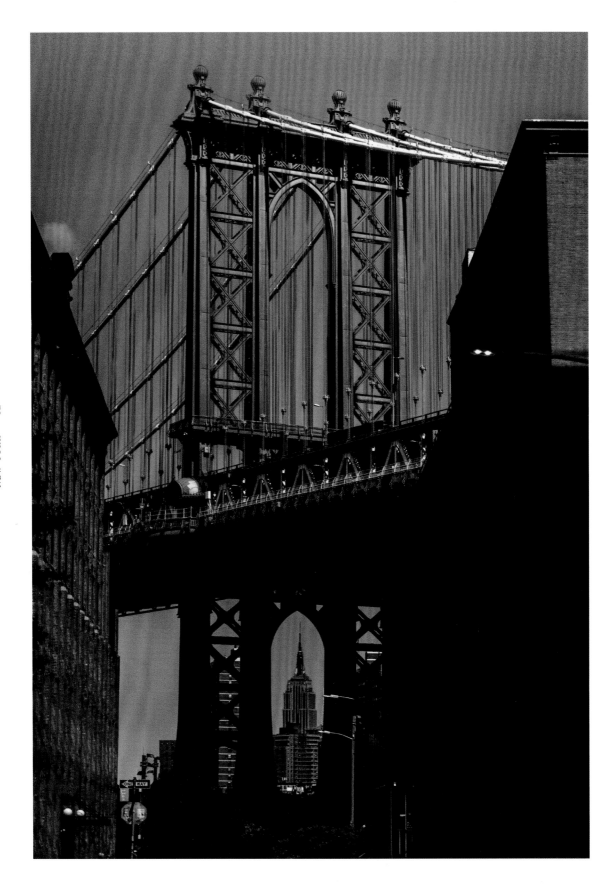

'New York never stops. From Midtown Manhattan to east Brooklyn the energy is always on. As the capital of streetwear, the casual yet sleek fashion aesthetic is at its peak influence. The mix of cultures, openness and youthful attitude make it my home of choice.'

Alex Badia
Style director at *WWD* and
NYC resident for 22 years

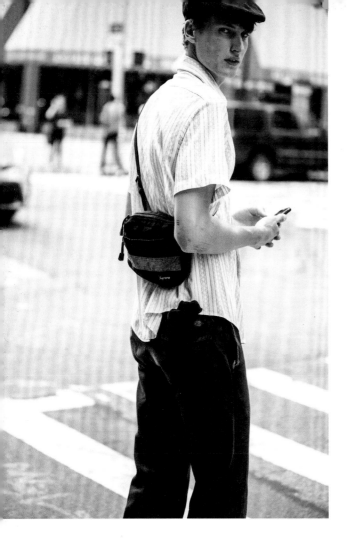

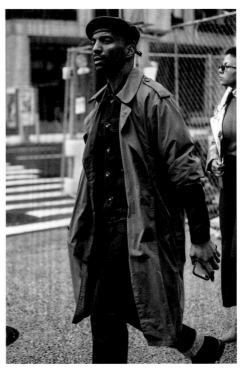

BOTTOM RIGHT - Mr David Comrie picked up this military-issue trench coat at Beacon's Closet. He wears it here over Levi's selvedge denim.

Vandam Street

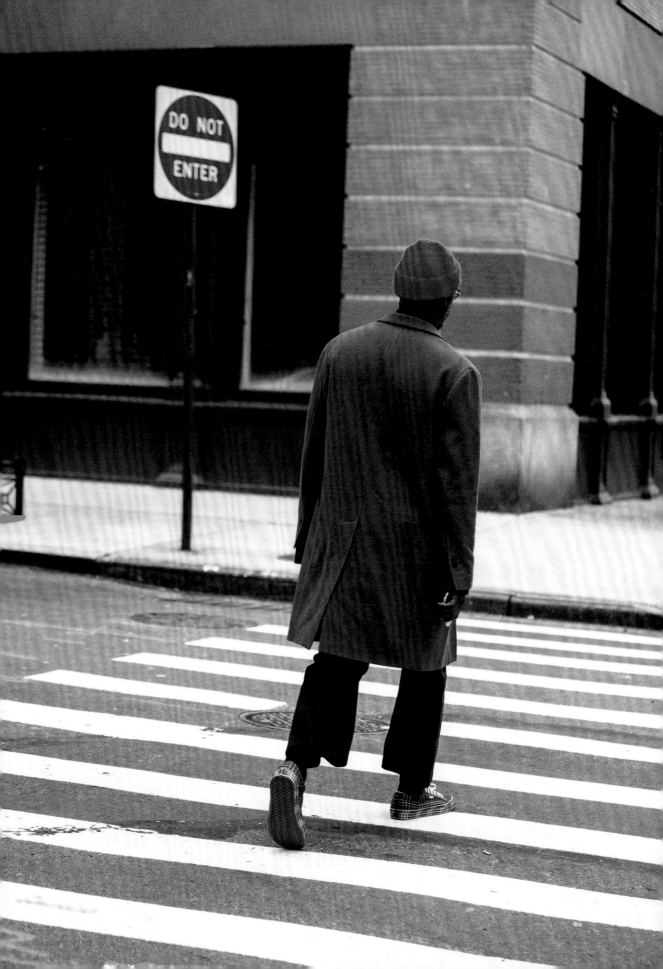

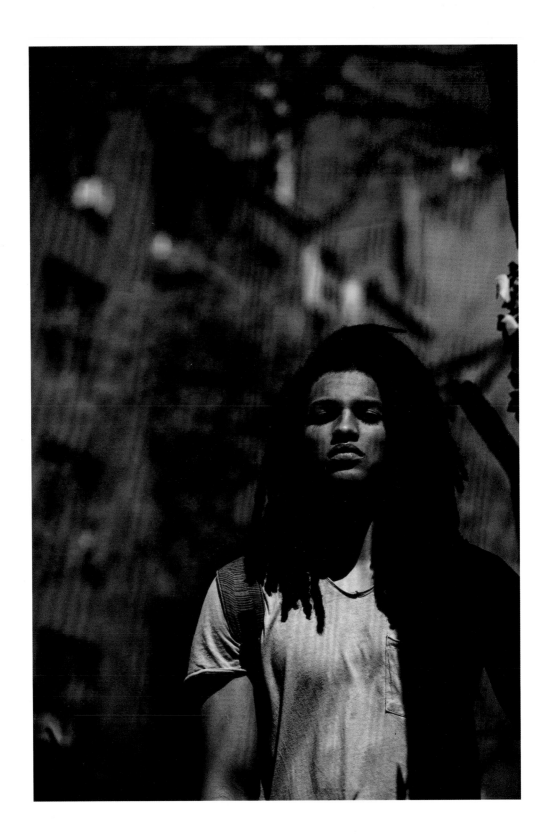

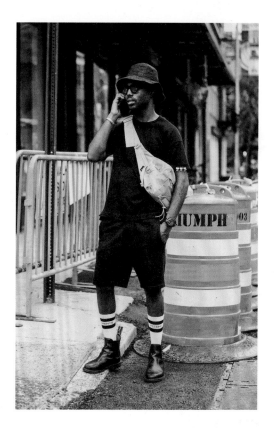

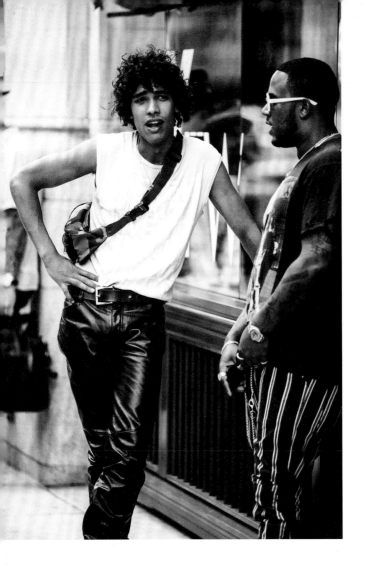

OPPOSITE - Despite the holes in the elbows, this shirt is Mr Alix Legrand's favourite item of clothing because it belonged to his father.

Washington Square Park

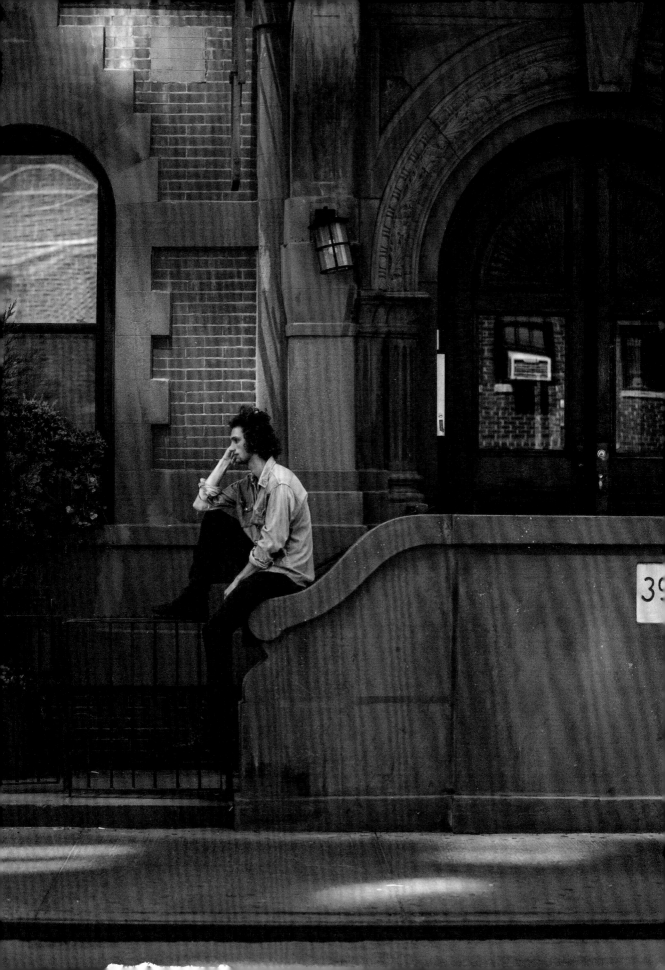

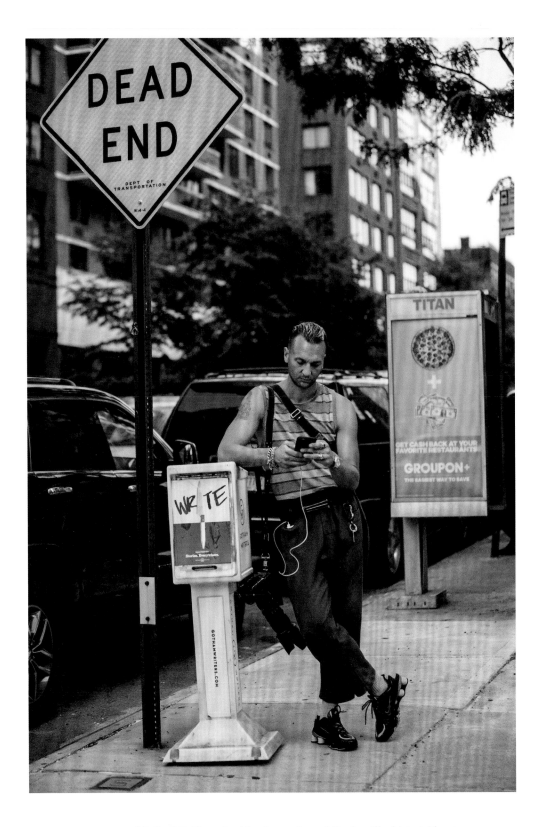

OPPOSITE - Mr Paul Bui bought this vintage Issey Miyake silk shirt at About Glamour in Brooklyn. His trousers are by Charles Jeffrey Loverboy.

Sullivan Street

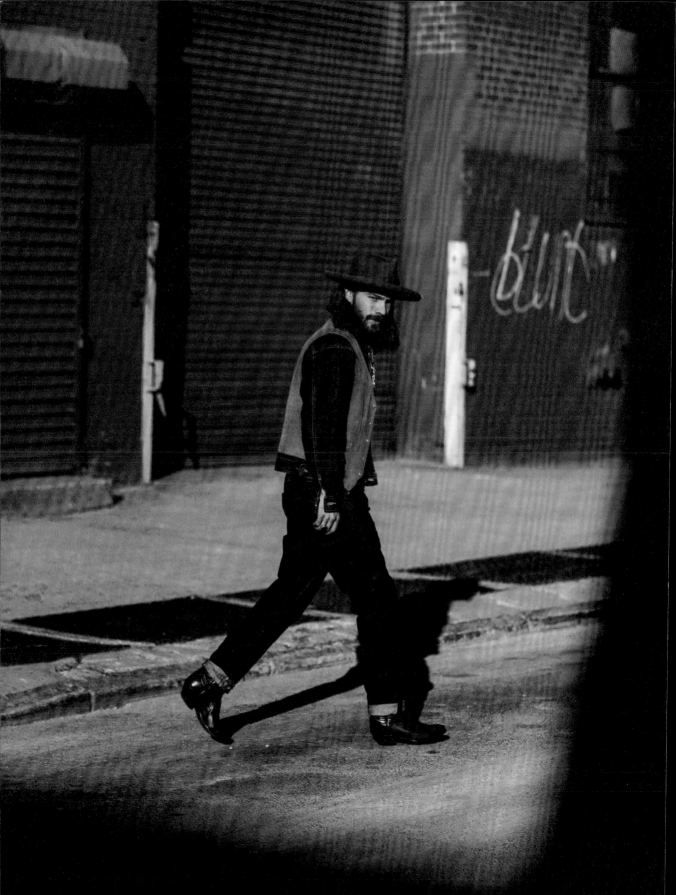

Mr Juan Manuel Salcito

ACTOR & ARTIST

Living in an artist's studio in Brooklyn, Juan surrounds himself with photography and paintings. The work is experimental and varied. There is a large portrait of Tilda Swinton on the wall, her pale skin and red hair contrasting against a royal-blue backdrop. On another side, an abstract oil painting sits on the floor. Juan shares the loft with a group of friends, and when I entered I felt a sense of community. The smell of incense drifted up to the tall ceiling.

I began to look through a rack of clothing at one side of the room and noticed a dark indigo-blue selvedge denim jacket hanging under a grey pinstripe suit. A pair of trousers that had been created from two, cut in half and sewn back together, was folded on a hanger, one leg green camouflage, the other sand coloured. A pair of worn-down brown leather Cuban heel ankle boots was sitting on the floor with a pile of red bandanas, a woman's handbag and white suede desert boots. The broad variety made me question if they all belonged to one person.

It's all mine. I love to be in a constant state of change. I change my hair often. If I shave I look one way, if I grow a beard I look another. My mood dictates what I choose to wear. Generally, I love anything cut from the 1950s. I like to take a modern trend and wear it through a vintage lens. This season I've seen a lot of menswear brands create colourful, bold prints, for example; I translate that into vintage Hawaiian shirts from the 1960s.

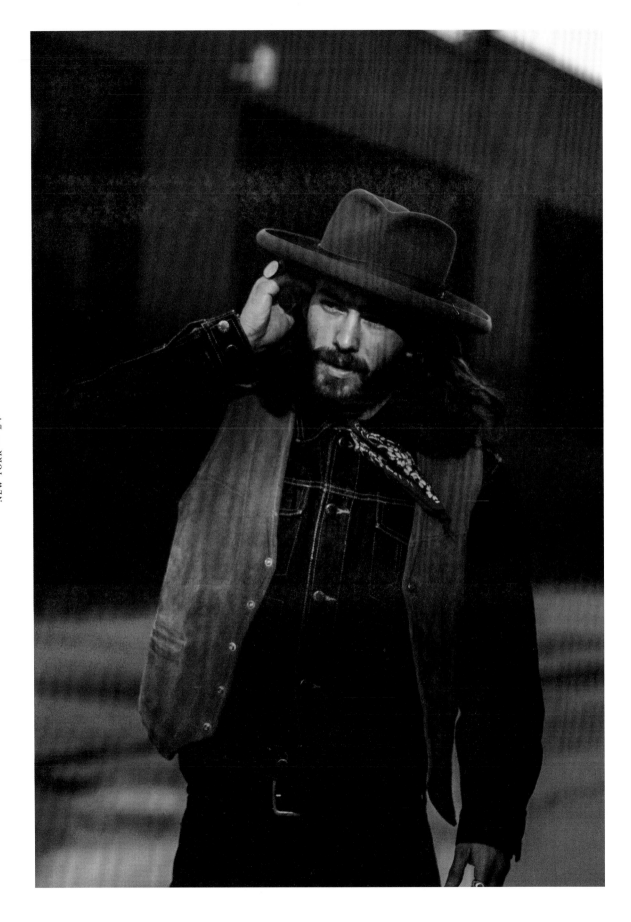

Born in Argentina, Juan moved to northern California at seven years of age, an experience that has clearly influenced his outlook.

Being an immigrant in the United States has been a huge challenge. I'm the first person in my family to attend college. I'm the first person in the family to try and fully engage with American culture without picking it apart. In some ways, I dressed to assimilate when I was younger but now I'm far more confident. Living in Brooklyn also gives me a sense of freedom and autonomy. I came to New York to discover who I was, and every day I take another step to figuring that out.

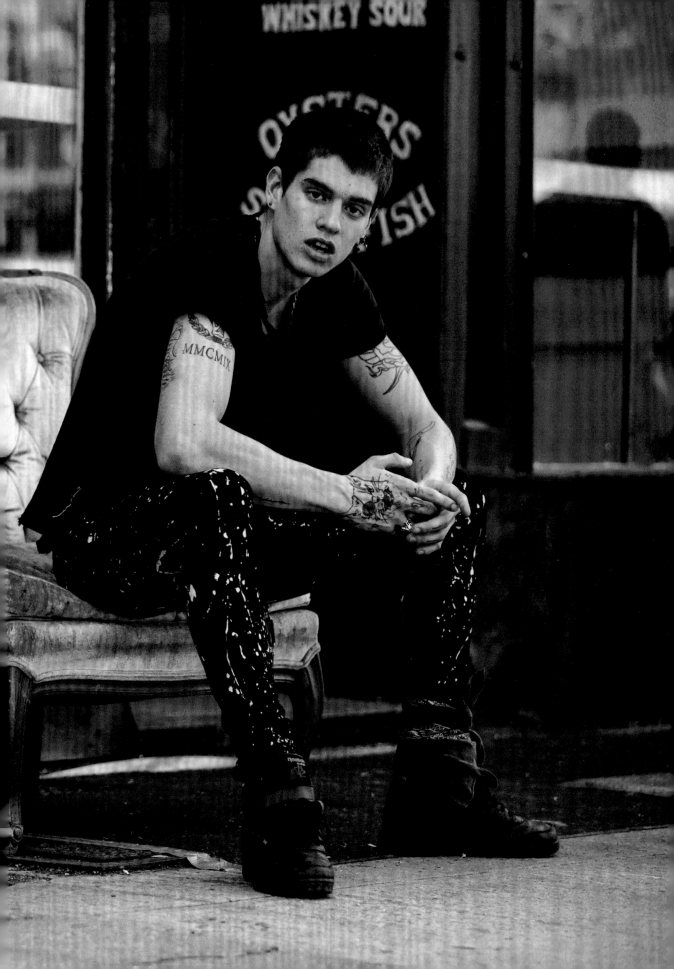

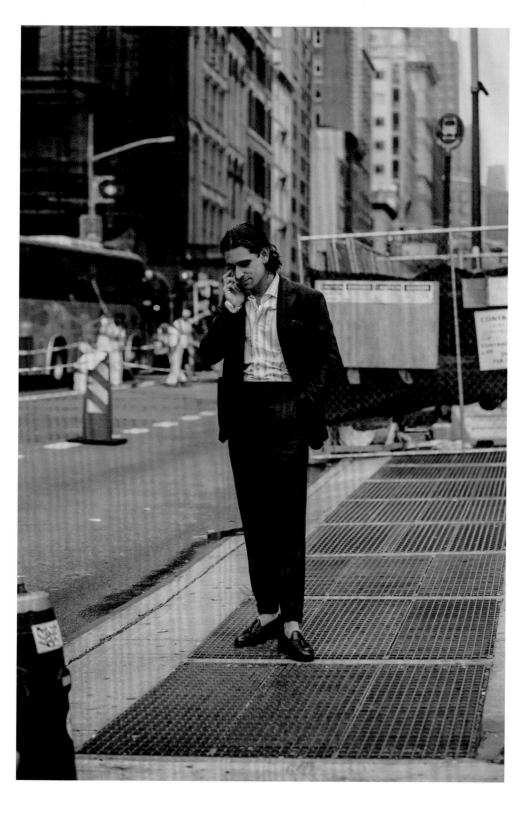

ABOVE - Mr Moses Manley is the co-founder of London-based Lockwood Umbrellas.
He's pictured here in a suit his father bought at Drake's, also in London.

Canal Street

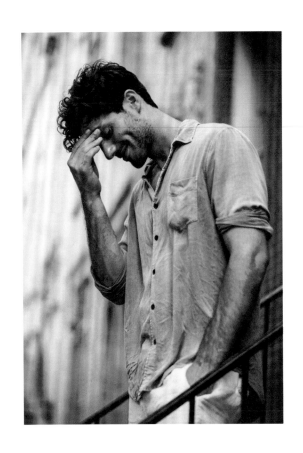
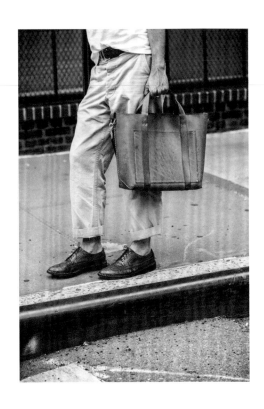

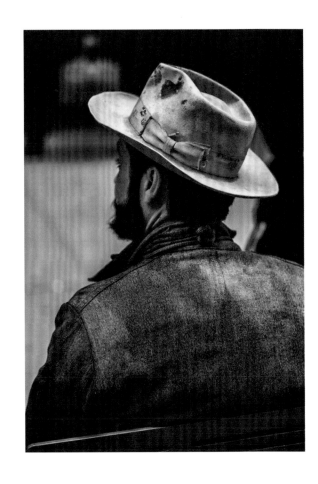

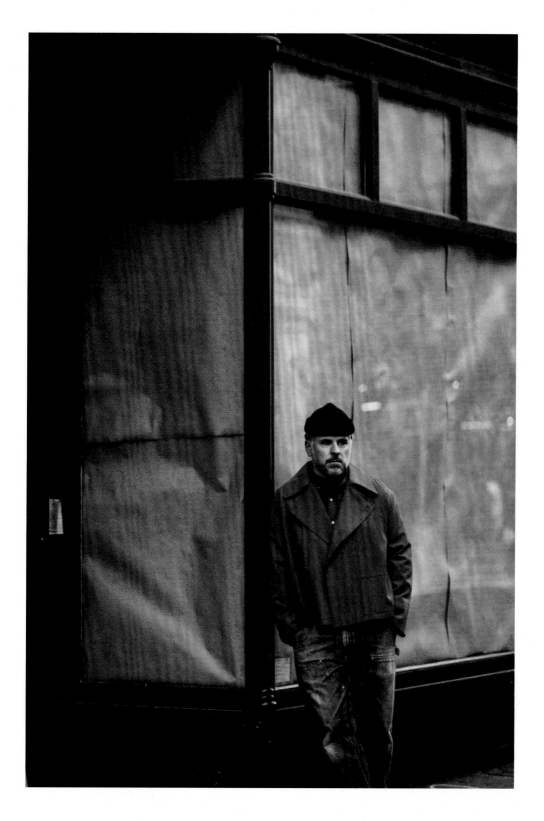

ABOVE - Illustrator Mr Ryan McMenamy wears a jacket by
Lemaire with Carhartt jeans, his favourite to work in.

Spring Street

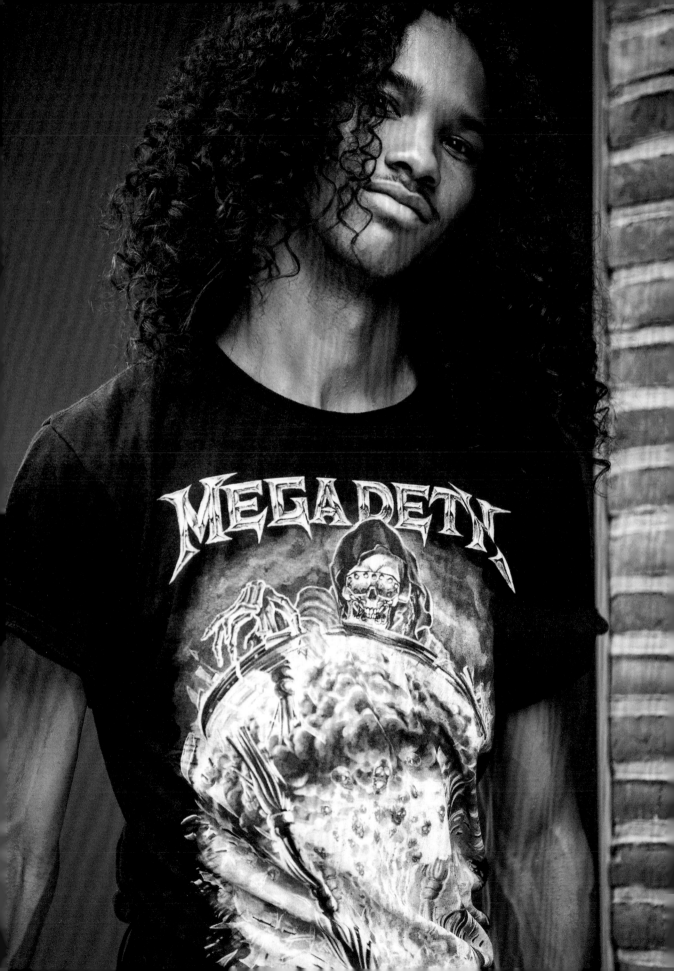

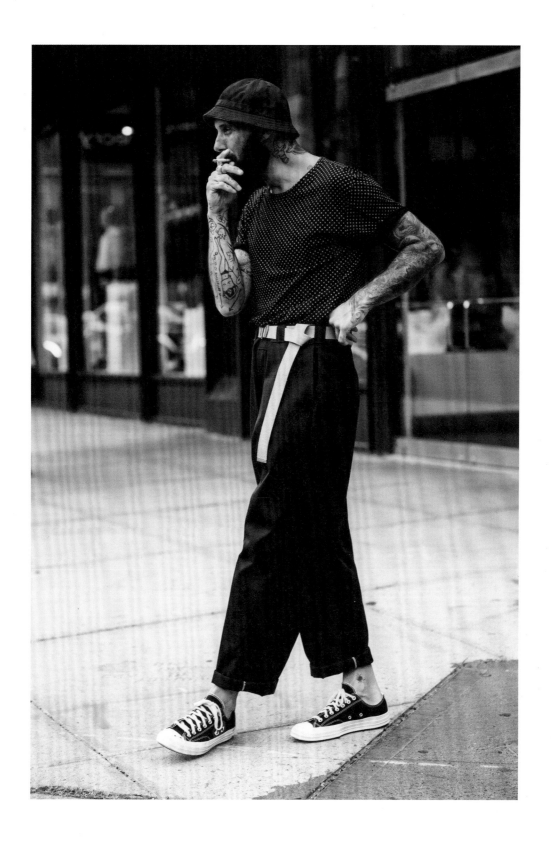

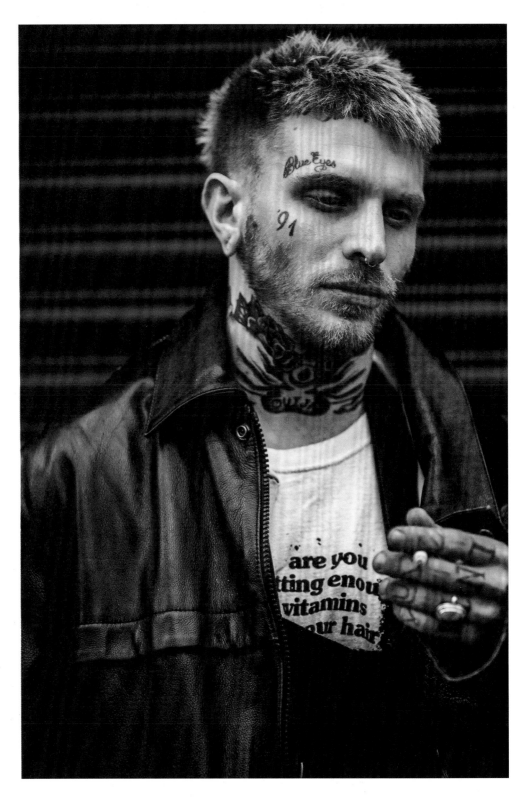

ABOVE - Mr Pat McLaughlin discovered this vintage punk Surfbort T-shirt
in a Brooklyn thrift store. The turquoise ring is one of several he
has collected from various stores along the East Coast.

Greenwich Street

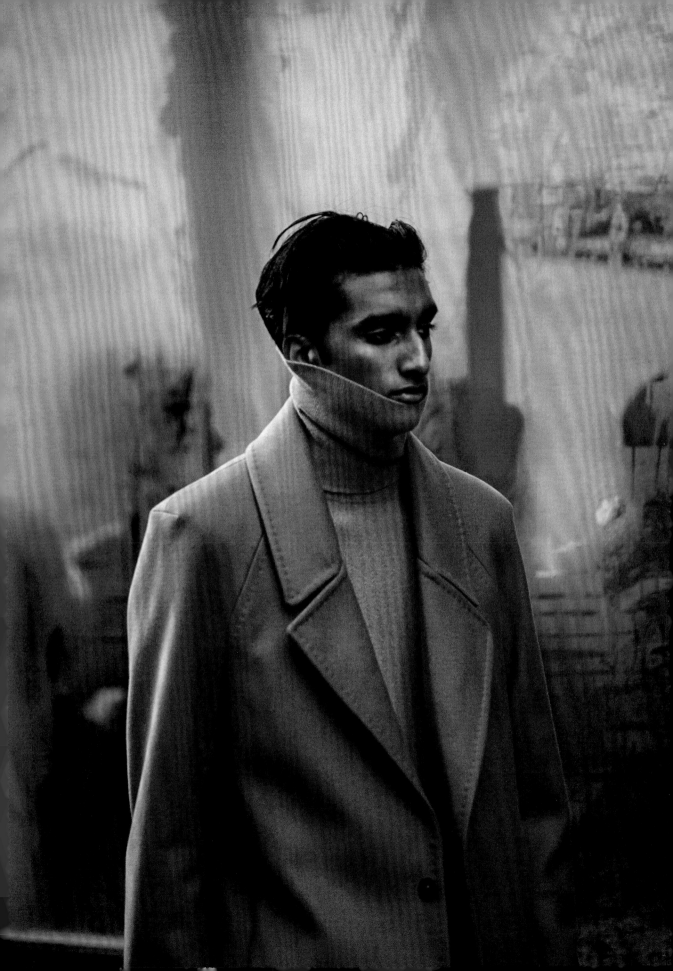

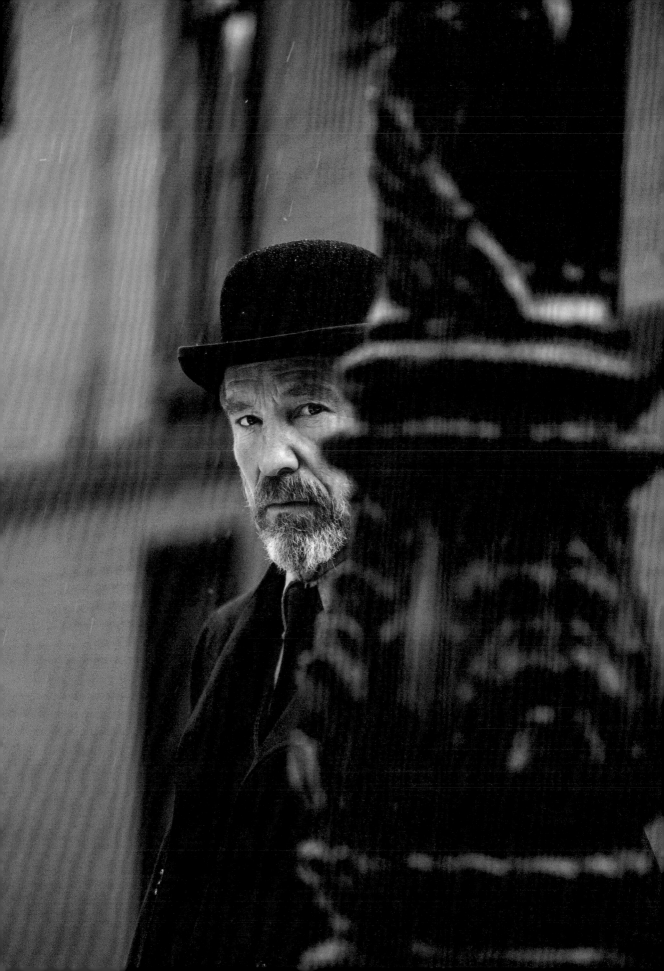

Mr Rainer Andreesen

ARTIST

Rainer Andreesen has the face of an intellectual gentleman. True to form, his talent as a painter is in crafting portraits that show his subject in an introspective and poised study.

I'd seen Rainer many times before I met him: occasionally on the street in New York, sometimes on huge billboards and often on Instagram. Before meeting, I anticipated an intelligent man with strong opinions, warmth and stature. I wasn't wrong. Rainer has a powerful presence that is contrasted with kind blue eyes and a mischievous smile. Walking with him around Greenwich Village, I noticed a reaction from passers-by, admiring his Thom Browne suit and bowler hat. On the street he stands out, even though this has been his home for over 20 years. I asked whether his art informs how he presents himself.

I feel that being an artist influences my style simply by being aware of aesthetics and how they are perceived. Dressing up makes me feel good and gives me a confidence boost. I grew up on a small island off the west coast of Canada, so the environment was very different. I moved to Manhattan as soon as I could. I've been here since 1994.

His top-floor Greenwich Village apartment overlooks the city and on a snowy February morning we looked out over the rooftops and admired the white flakes that had settled. His apartment had recently been redesigned and it perfectly reflects his good taste. The rooms are quiet and clean with an open-plan living space that allows natural light to flood in – the type of grounded space perfectly suited to an artist who is considered and reflective. A selection of his artwork was on display – some portraits of friends, loved ones and family. His subjects are often sophisticated, dressed in fine tailoring, sitting in majestic light.

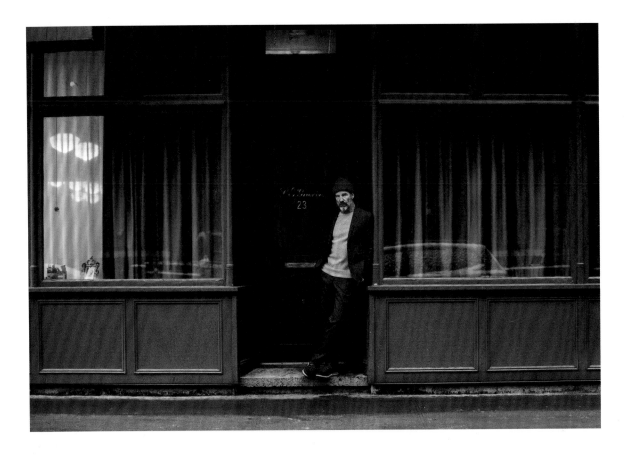

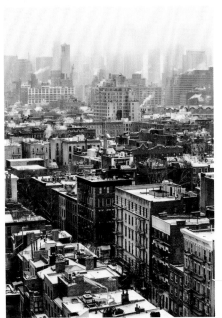

There's an intimacy to his work, a sensitivity, a maturity. I wondered how he developed this style.

I started painting watercolour and drawing at the age of five. My childhood was strange. I felt like an outcast. As I grew older I felt the urge to escape and discover myself. At the time, I remember feeling like I related more to my friends' parents than to my peers. My art teachers were very encouraging and really pushed me forward, introducing me to the old masters. John Singer Sargent is a constant inspiration to me.

Later, we walked together to get a coffee and newspaper, a real New York experience that feels so special in its simplicity. We spoke of how his neighbourhood has changed over the years, and where he goes to find sartorial delights.

I love to observe the city by foot. I walk to Century 21 on a regular basis, down to the World Trade Center. I search for bargains in the ever-changing landscape of brands. On the way back, I usually stop at Thom Browne to look at the beautiful garments. Sometimes I buy, sometimes I take a note of which ones I hope will find their way to the sale rack.

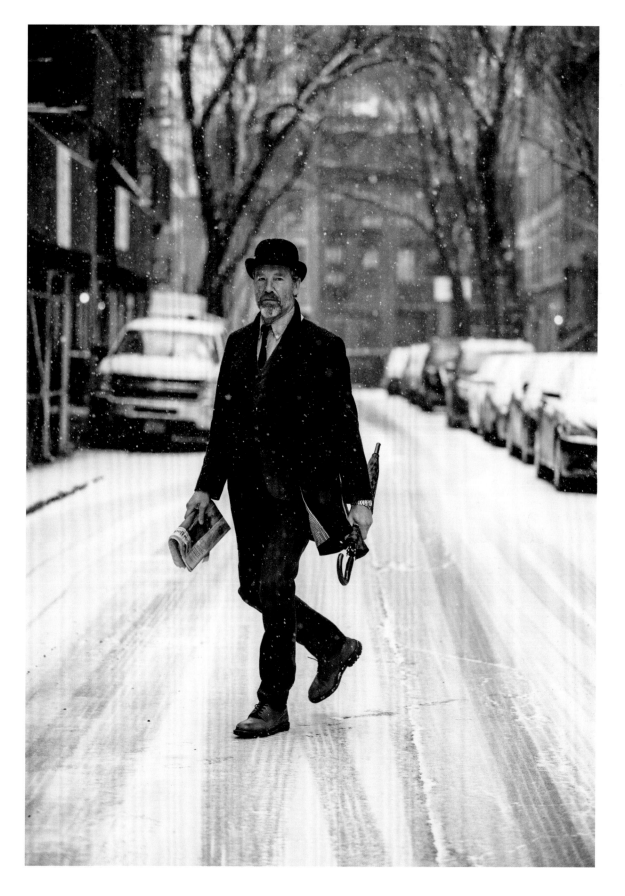

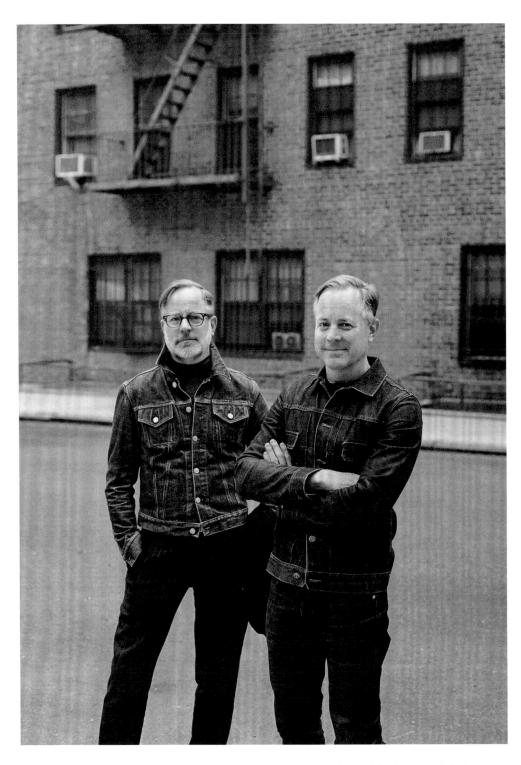

ABOVE - Brothers Mr Bruce Pask and Mr Scott Pask share a love of denim. Scott's jacket is by A.P.C., while Bruce wears a vintage jacket by Helmut Lang, designed in 1998. It's Bruce's favourite, meaning he only takes it carry-on when he travels, never in the hold.

East 3rd Street

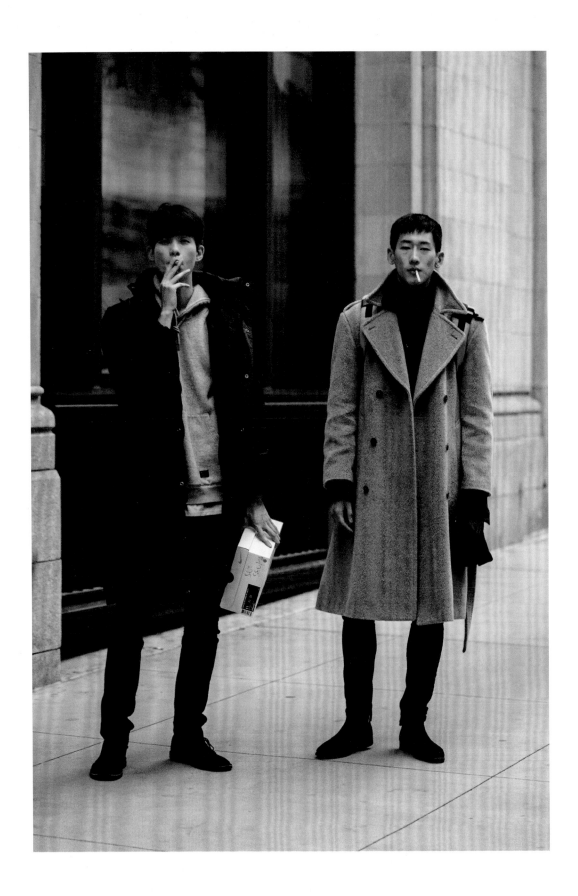

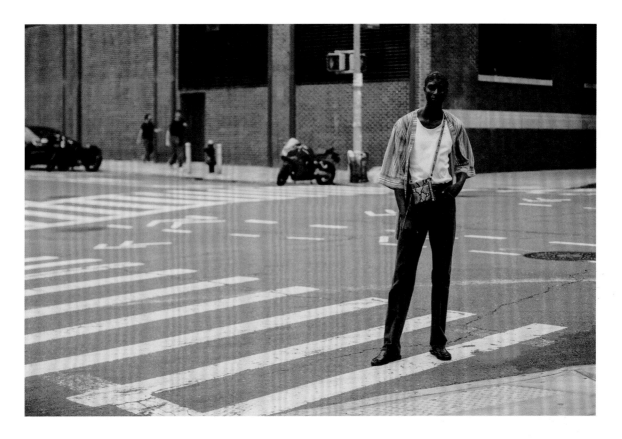

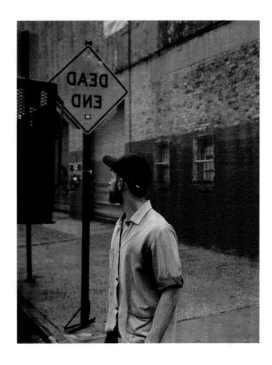

TOP - Mr Aly Ndiaye's outfit is composed entirely of vintage clothes given to him by friends from around the world.

Washington Street

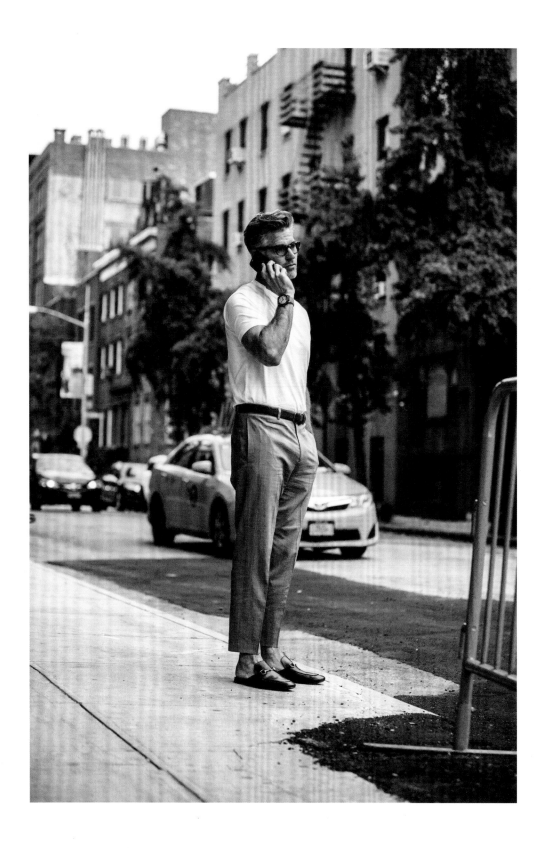

Mr Eric Rutherford completes his outfit with classic Gucci loafers.

West 13th Street

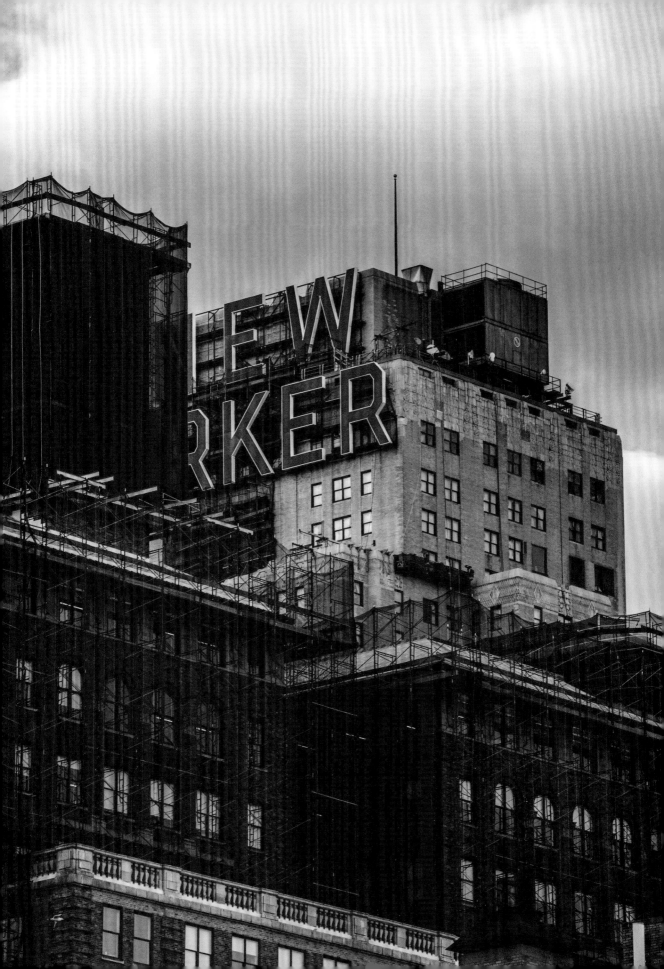

Mr Andrew Livingston

FOUNDER OF THE KNICKERBOCKER COMPANY

Down an industrial road, behind old factory doors in Brooklyn, lies the headquarters of Andrew Livingston's menswear brand, Knickerbocker. Walking up to the given address, I wondered if I was in the right part of town. It feels quite remote, but also inviting.

I found this factory in an outdated hat directory. I had a few clients in Japan who were looking for caps and had no source for production. The phone number didn't work and there was nothing else other than an address, so I went in person and was greeted by Felix Pantaleon, the master hatter of the factory and one of my greatest influences. It was part of a 60-year-old family business. We worked on caps together for about seven months before the factory owner approached me about buying them out. I was only 19 at that time and not sure what would come of this, but I knew I wanted to be more hands-on with the process. I also knew I wanted to keep goods in the States and, with a dying supply chain, I now had an opportunity to do something about it. The owner offered up the business for only $15,000. After a successful Kickstarter campaign, Knickerbocker was born.

The impact of Andrew's surroundings can be seen in the aesthetic choices for his brand, which reflect both the youth culture of today and a love of nostalgia.

America is a young country with a landscape for new ideas and opportunities. Some of my favourite clothing comes from a time when it was either made as a symbol of class or for strict utilitarian purposes. There are overalls, which were born during the Industrial Revolution, jeans from Levi Strauss during the Gold Rush, pea coats and flight jackets from the World Wars. When it comes to applying

that American aesthetic to Knickerbocker, I always look to the 1940s and 1950s. It was a time when soldiers returned to their blue-collar jobs, and there was more recreational time and disposable income. A new youth movement in music and film created subcultures like rockabilly. After such a traumatic war, the 1950s made for a beautiful and exciting time.

I asked Andrew how it felt to still be so young and have a brand and business on his shoulders.

My greatest asset is my youth. The older you get, the more there is to lose. Taking risks becomes a much more calculated action rather than instinct. It's a funny thing, but skateboarding has helped me to maintain a childhood feeling of curiosity and invincibility. I think there are many parallels between skateboarders and entrepreneurs. You take risks, you build a community, you don't let the bruises get the best of you, and you learn to make the best of things. I bet Martin Luther King, Jr., would have been a great skateboarder.

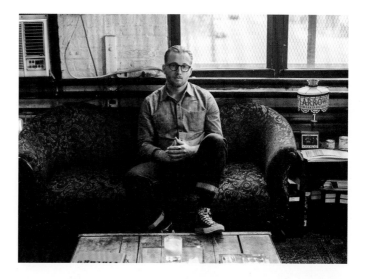

I used to ride for Billabong when I was younger. I would visit them at their California warehouse and pick out whatever clothing I could find in my size, which wasn't much since I was a small kid. Being overexposed to clothing, I began to crave simplicity; something timeless. The graphic print with the fire-breathing dragon, spewing out the word 'Billabong' across my chest, just wasn't something that resonated with me. As I'd walk out of the Billabong warehouse I would see a sea of designers working away and that's when it clicked. I wanted to create something of my own. Not just clothing but also the culture around it. For me, it'd be a dream if I could create something that meant as much to someone else as it does to me. Hopefully it would inspire them to go and do the same.

The factory was quiet – a day off for the staff, but not for Andrew. We walked the aisles and looked at the old machinery. He showed me samples from the collection and told me lessons he'd learned along the way.

I heard something [medical researcher] Jonas Salk said, which really resonated with me. He spent all his hours studying and working towards being part of this notable laboratory, which ultimately rejected him. He said, 'There are only two great tragedies in life: to get what you want or to not get what you want. If I had gotten what I wanted it would have been a greater tragedy than my not getting what I wanted, because it allowed me to get something else.' The loss led Salk into working on vaccines, where he then developed the first polio vaccine. A lot of things seem unfortunate until you change your perspective.

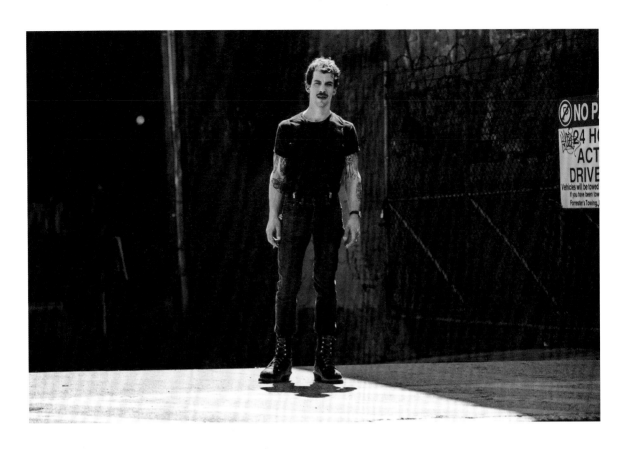

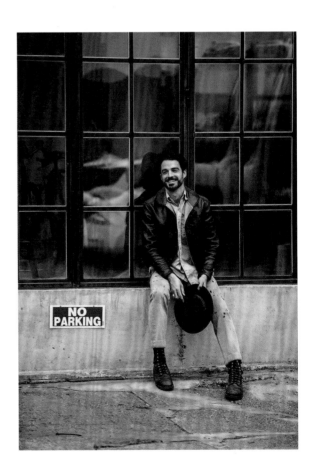

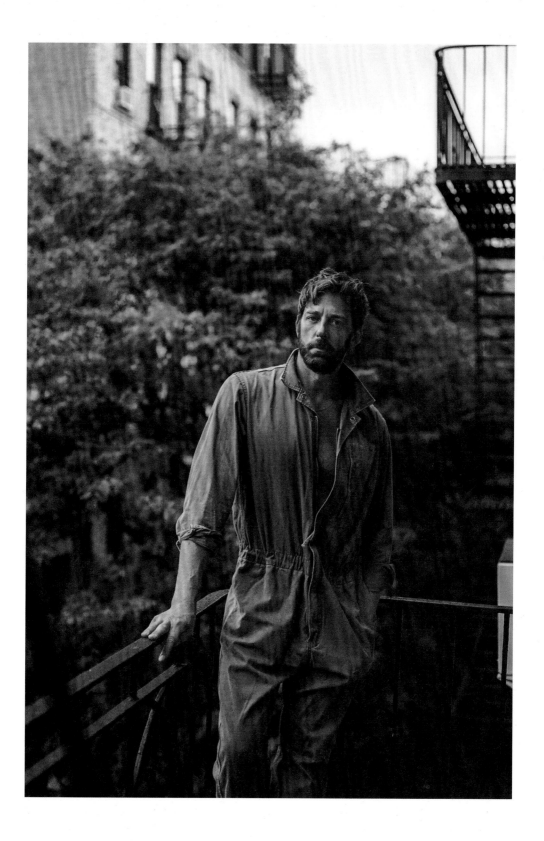

ABOVE - Mr Ken Barnett owns these overalls by Engineered Garments in every colour.

West 4th Street

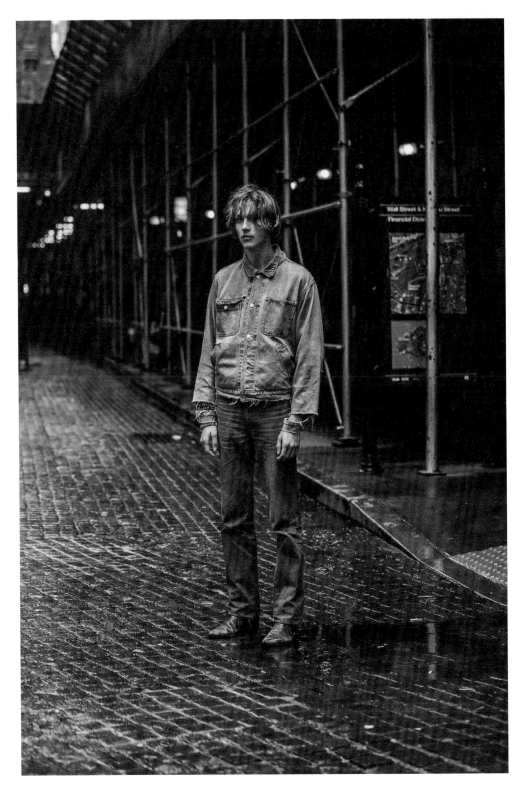

ABOVE - Mr Samuel Wilken in his lucky Ralph Lauren jacket and Wrangler 13MWZ cowboy-cut jeans. He bought his vintage Florsheim shoes in rural Missouri for $7. A handkerchief from a hotel that had employed his father 30 years earlier was stuffed in the toe.

Wall Street

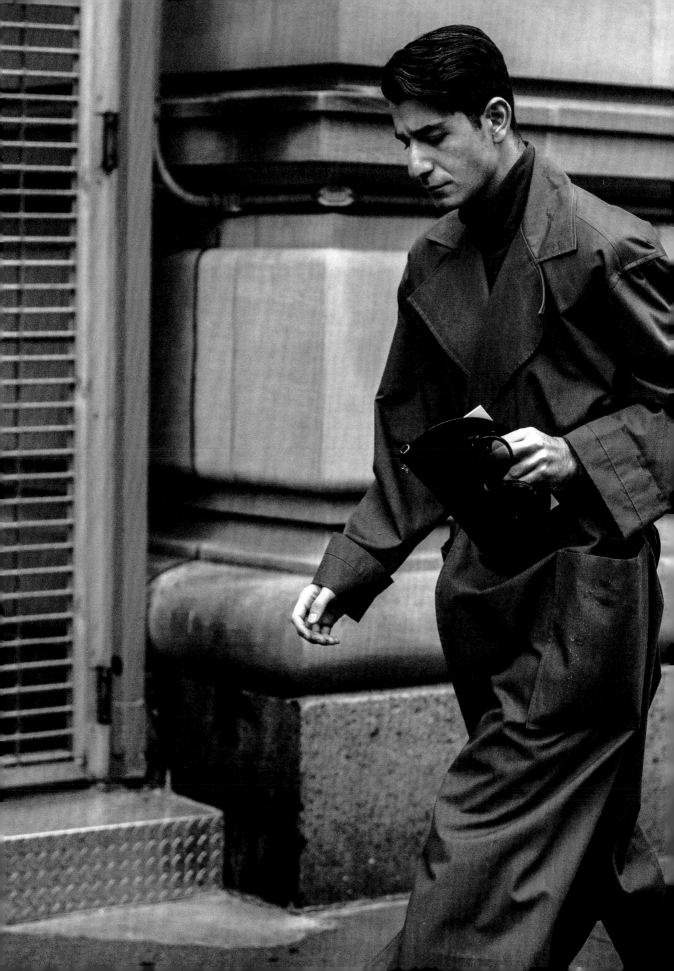

Mr Edward Barsamian wears his mother's vintage trench coat and carries a 'half-moon' bag by Victoria Beckham, his favourite.

East 91st Street

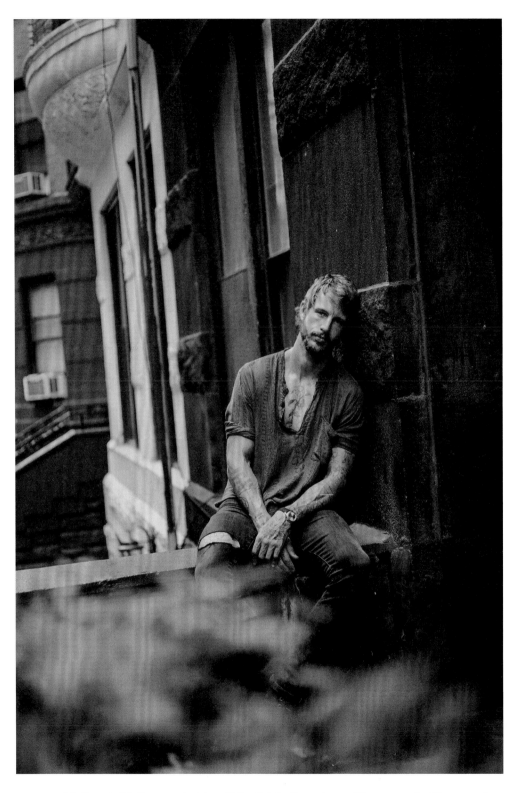

ABOVE - Mr Dennis Klaffert taught himself English by listening to 90s rap music. These music idols all had one watch: the Rolex Day-Date President 1803, which Dennis bought as soon as he was able to. His chest tattoo was inked by his friend at Daredevil Tattoo, on the Lower East Side.

West 73rd Street

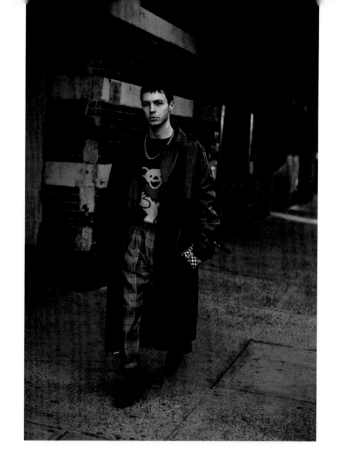

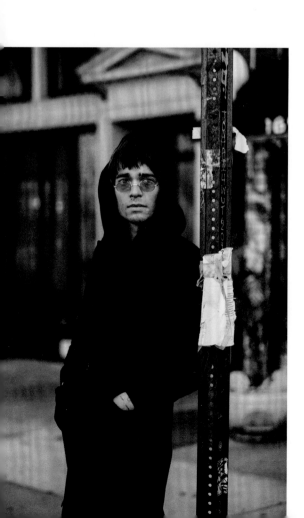

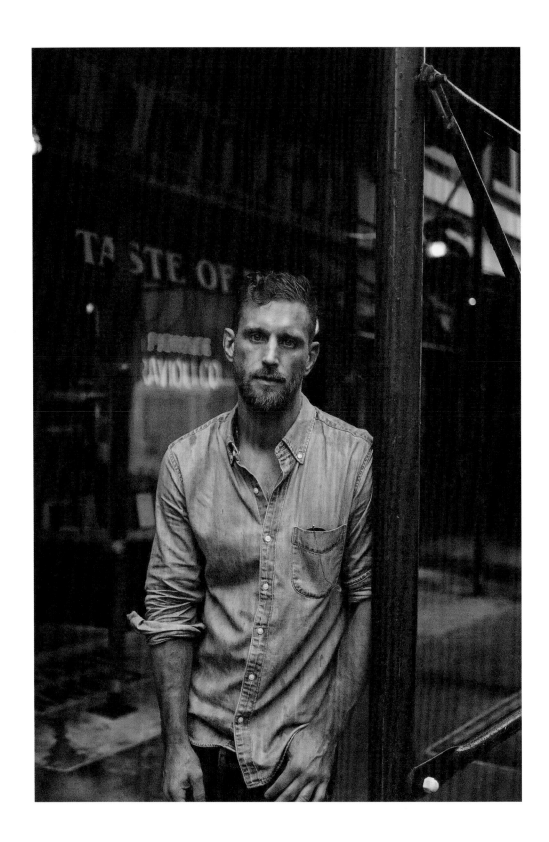

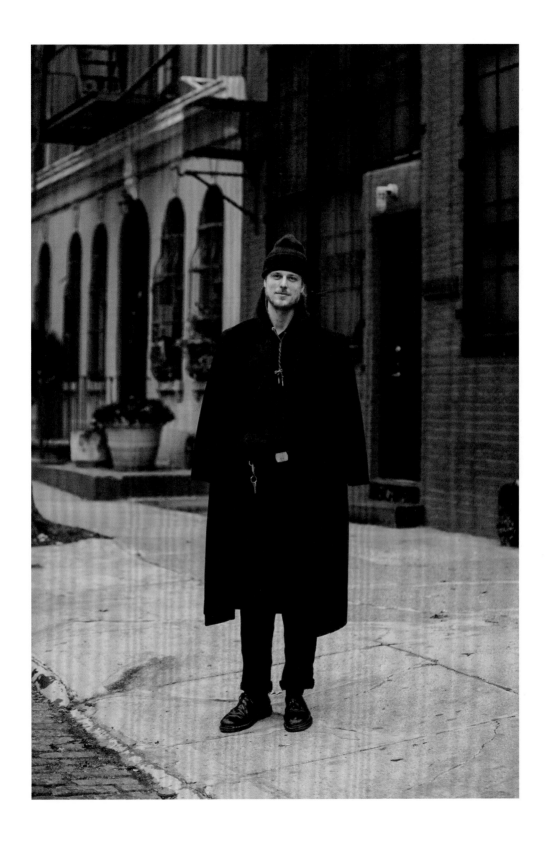

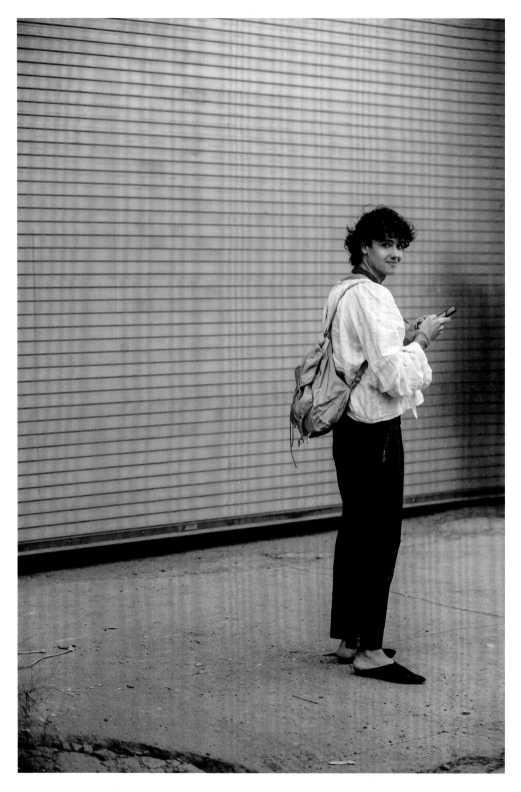

ABOVE - Mr Matthew Domescek's shirt was custom-made by David
McCarthy with linen Matthew bought at Hermès in Paris. He wears
it here with trousers by Kolor, shoes by Barneys and a Prada bag.

Scott Avenue

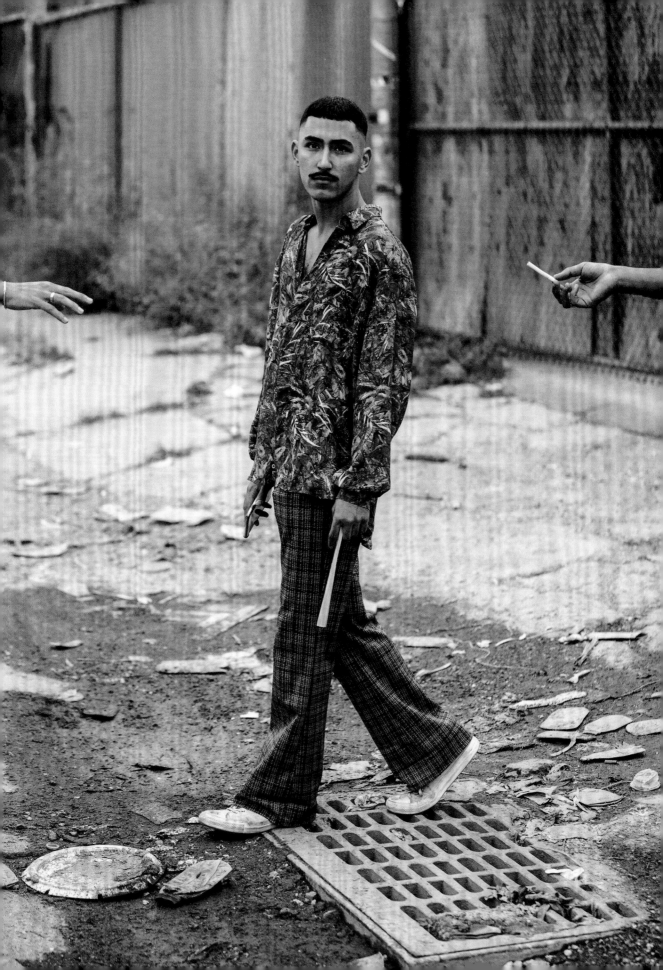

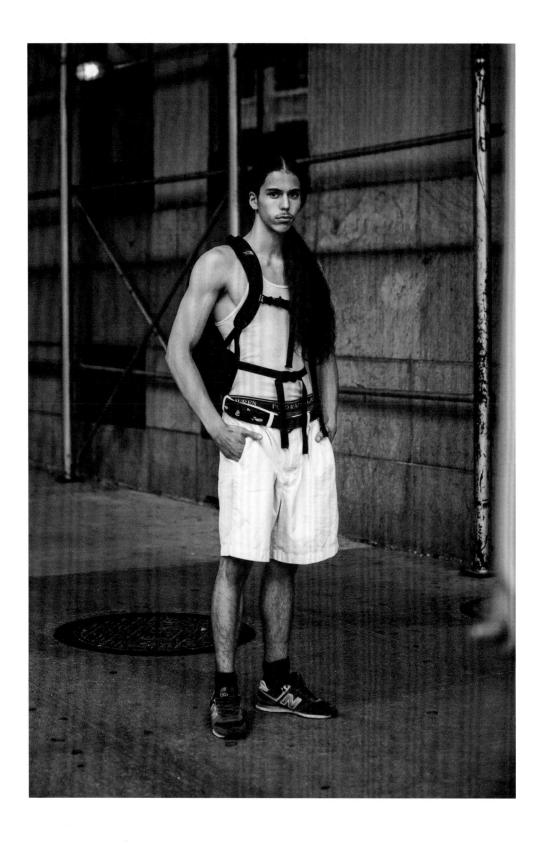

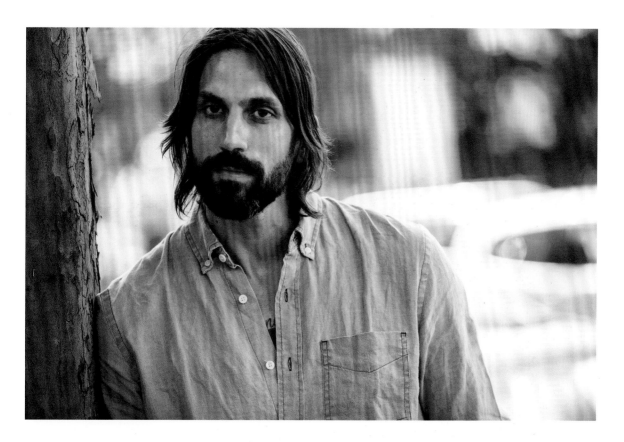

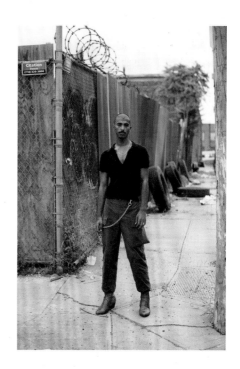

BOTTOM RIGHT - Mr Saint Auden pairs a shirt by Dries van Noten with vintage trousers created by the U.S. Air Force in the 1940s.

Scholes Street

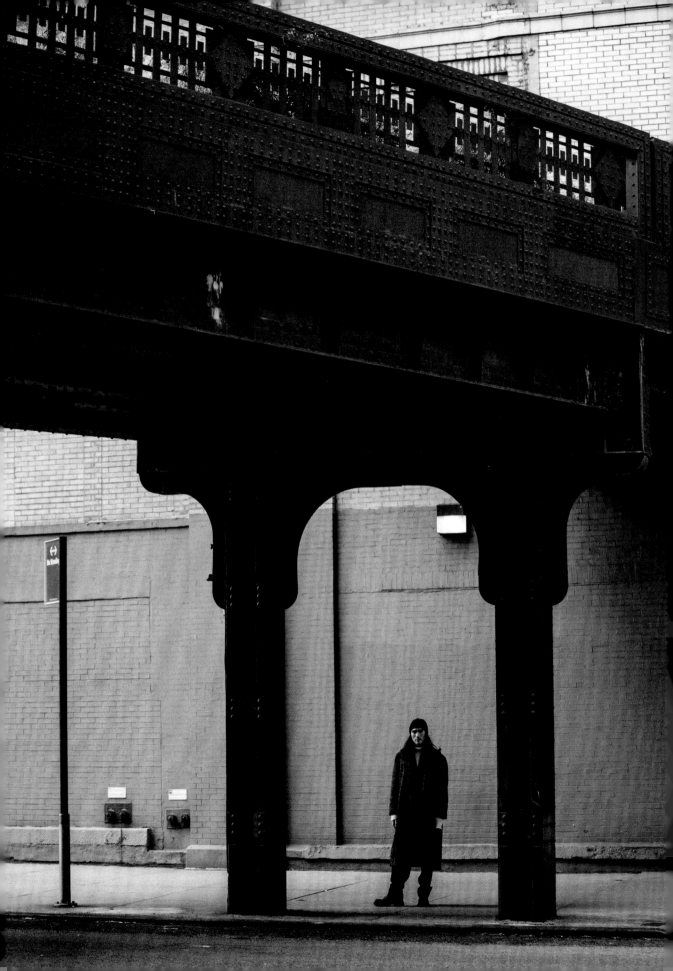

Mr Blake Abbie

ACTOR & EDITOR

My first encounter with Canadian-born Blake Abbie was during London Fashion Week. I spotted his acid-wash denim jacket with black and blue patches. It had an extra-long collar and was a few sizes too big. Worn over an all-black outfit, it packed a sartorial punch. When I asked him for a photograph, he caught my accent and asked where I was from. Sensing a Scottish connection, he told me his father is from Edinburgh. Over the years, we've frequently bumped into each other in various cities, and I have witnessed his career as a fashion editor blossom. It's unusual to have career success so early in life, but even more so to have two different career paths unfold at the same time. In fashion, he is the editor-at-large of *A Magazine Curated By* and, in the entertainment industry, he acts in the Netflix series, *Meteor Garden*.

We arranged to meet in Chelsea, New York, on a frigid January afternoon for a photoshoot. Sirens rang in the distance as we walked towards his new apartment in Chinatown. After an acting hiatus, Blake had just returned to finish shooting the TV series for Netflix. I asked him about the parallels between his two worlds.

As an editor I help tell stories through the written word and images. Developing a specific voice, a point of view, a narrative. It's the same as acting – but there you use your body, voice and gesture to create a character, allowing the audience to escape into your new life. Both are about fantasy and escapism.

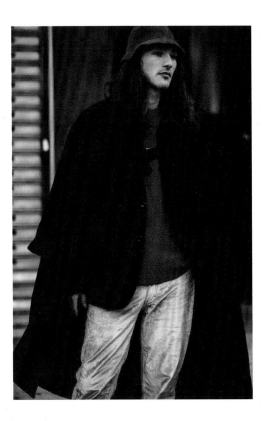

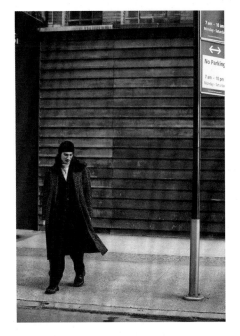

When we arrived at Blake's building, he smiled and said something in Mandarin to a woman with a young child coming out. With most of his possessions still packed away in suitcases, the apartment was bare. He unzipped some bags to show me what he'd brought to the city. Pulling out a Giorgio Armani coat, Sies Marjan sweater, Yohji Yamamoto suit and Eckhaus Latta velvet jeans, he was able to tell me which season each of the designs came from.

As an industry insider, I wondered how his personal style has changed over the years.

There was a period when I was only wearing black. I was travelling so much it just made it much easier to pack. I don't really believe in maintaining a particular style, though I do like exploring silhouettes, larger, looser fits and lots of layers. You'll never really find me wearing fewer than two layers, even in the height of summer.

Blake's self-assurance made me curious about how he views his own character. 'I'm open-hearted and curious. Also perceptive.' I would add 'optimistic' to that list. His positivity is present in every encounter we have: he mirrors American ideology – hard work leads to success. Is he ever nervous about taking so much on? 'You have to take a risk in life. Just jump, trust your instincts and go. Even if you land with a thud, you'll sort yourself out and get back up.'

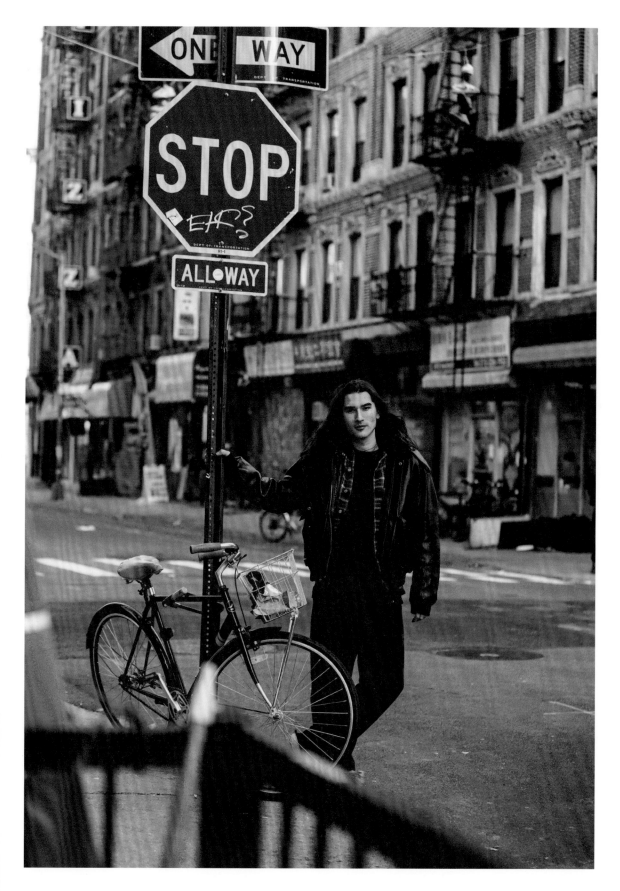

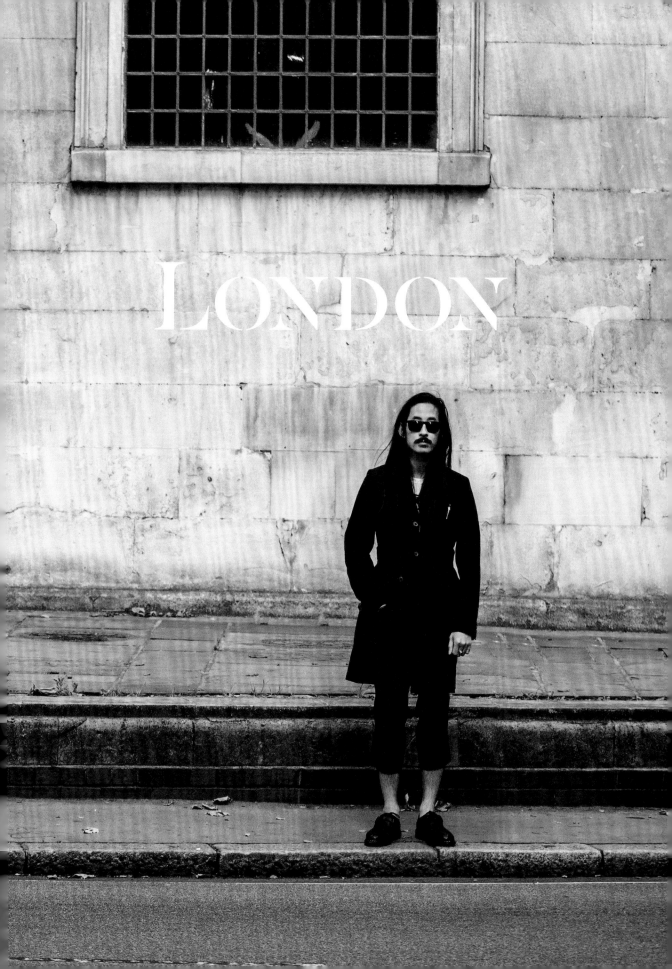

'London has always offered both tradition and irreverence. Look beyond its steel cathedrals and suburban multiplexes and you'll see how dress code gives no clue as to postcode. It's a city that even 50 years ago saw pinstripes and safety pins share the sartorial limelight. Today that mix is even more intricate and intertwined.'

Jeremy Langmead
Brand director at *Mr Porter* and
London resident for 34 years

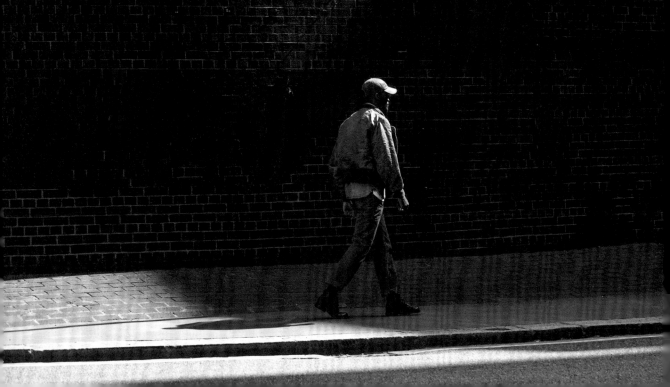

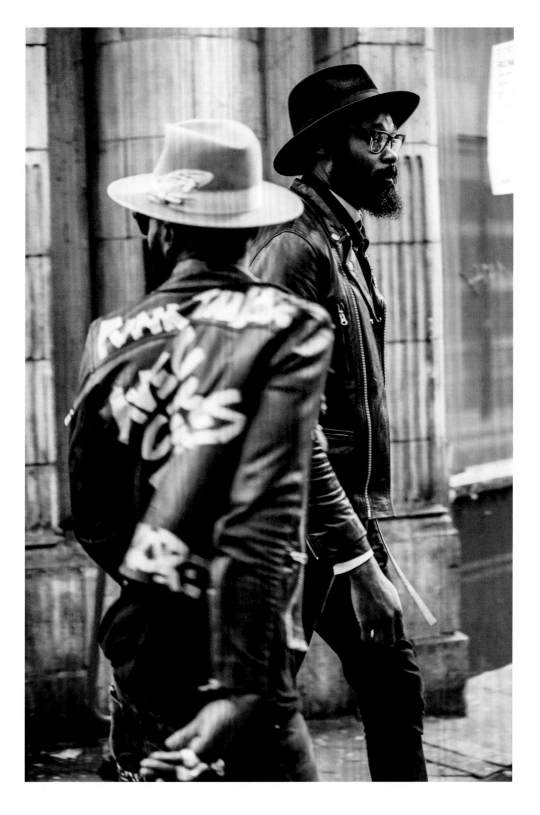

ABOVE - Mr Sam Lambert and Mr Shaka Maidoh both wear designs from their
brand Art Comes First. Sam painted his leather motorcycle jacket by hand.

New Oxford Street

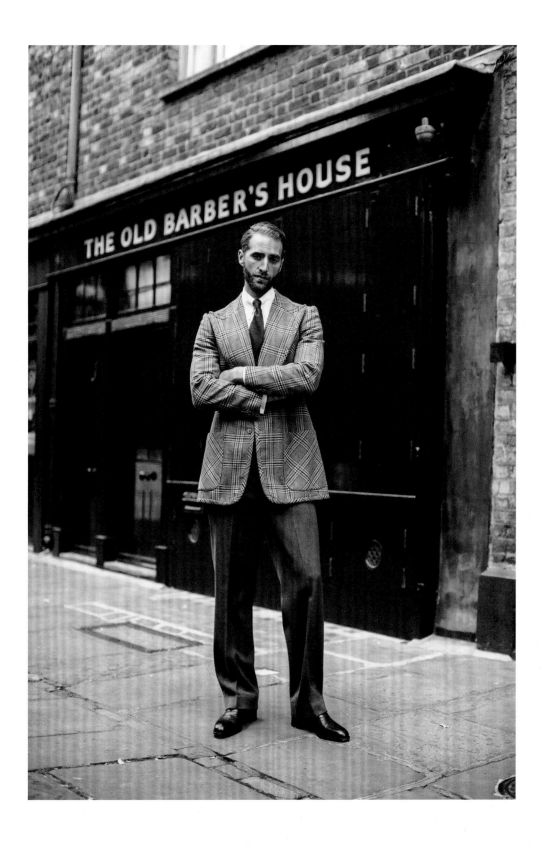

ABOVE - Mr Max Hearne wears a vintage Edward Sexton suit from 1974.

Puma Court

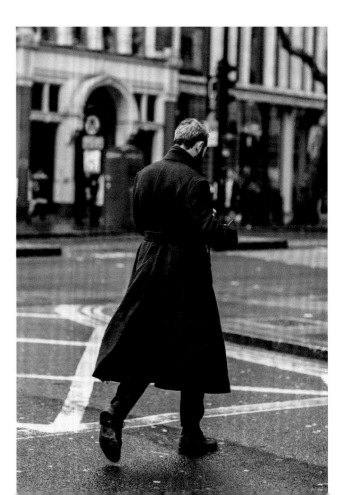

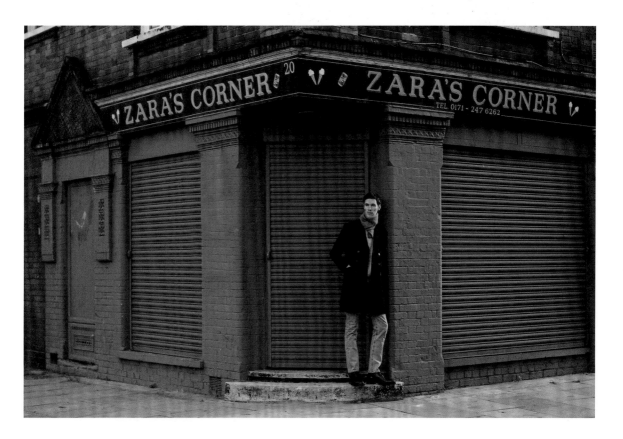

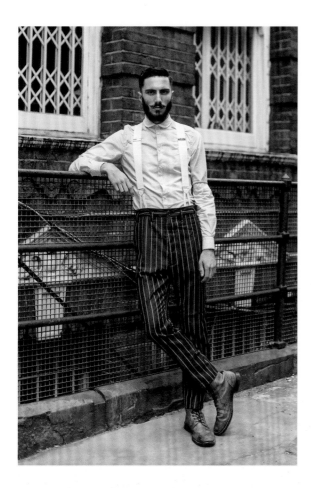

LEFT - Mr Sam Keelan borrowed these vintage Vivienne Westwood trousers from his ex.

Bloomsbury Way

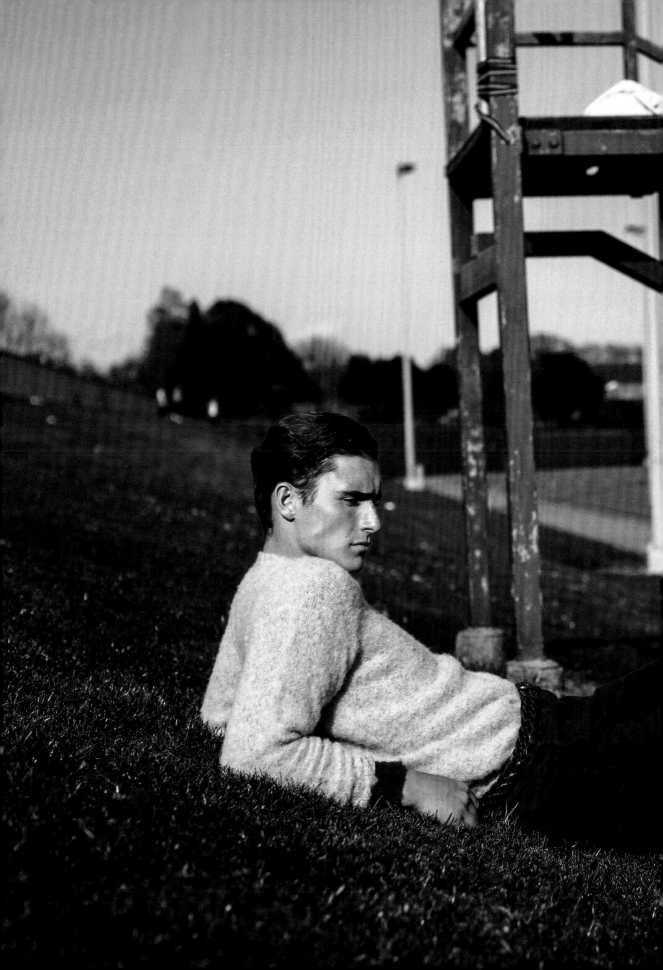

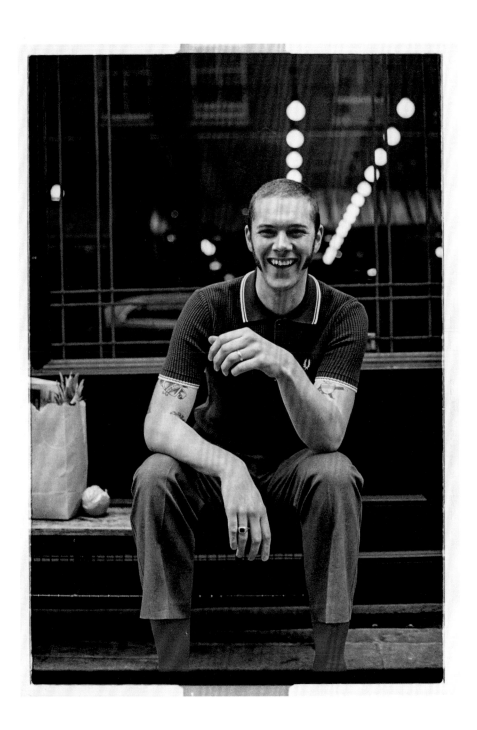

Mr Gregory Farmer in vintage Fred Perry.

Henrietta Street

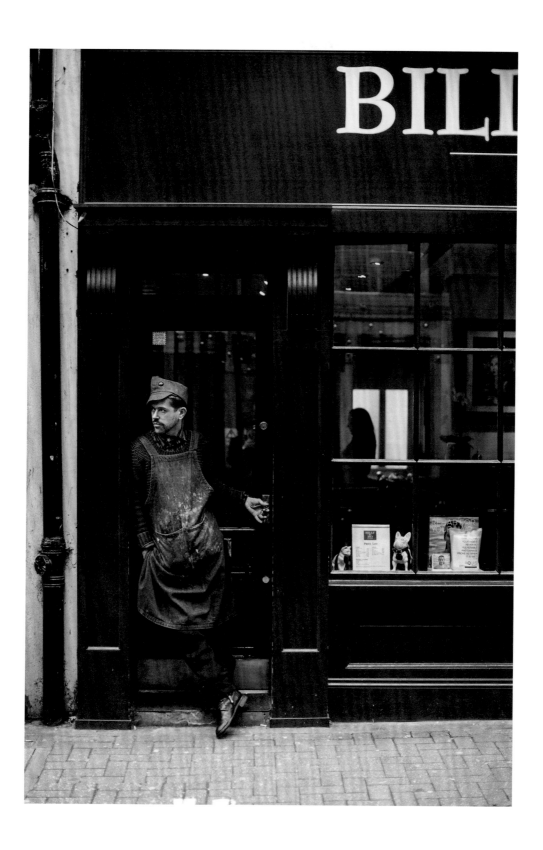

Mr Jayson Gray stands outside his barbershop wearing a denim apron.

Great Windmill Street

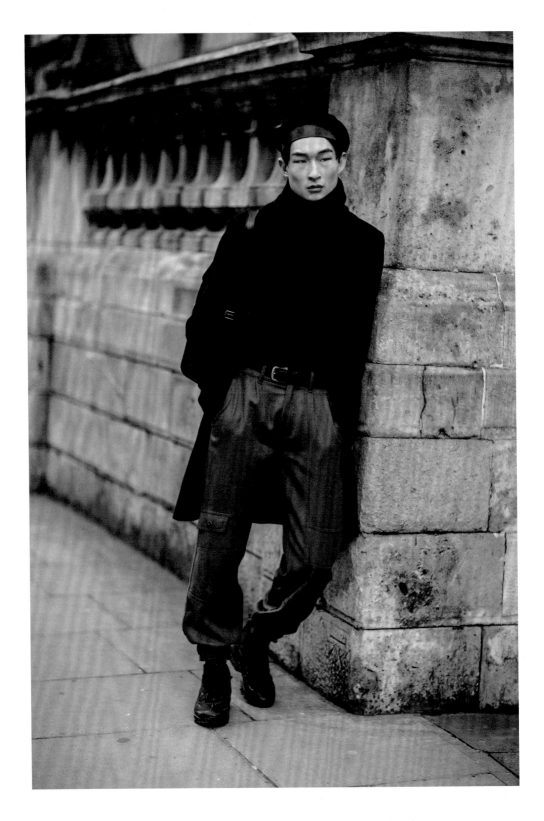

ABOVE - **Mr Sang Woo Kim wears a military beret from The Vintage Showroom and trousers designed by Gosha Rubchinskiy.**

Pall Mall

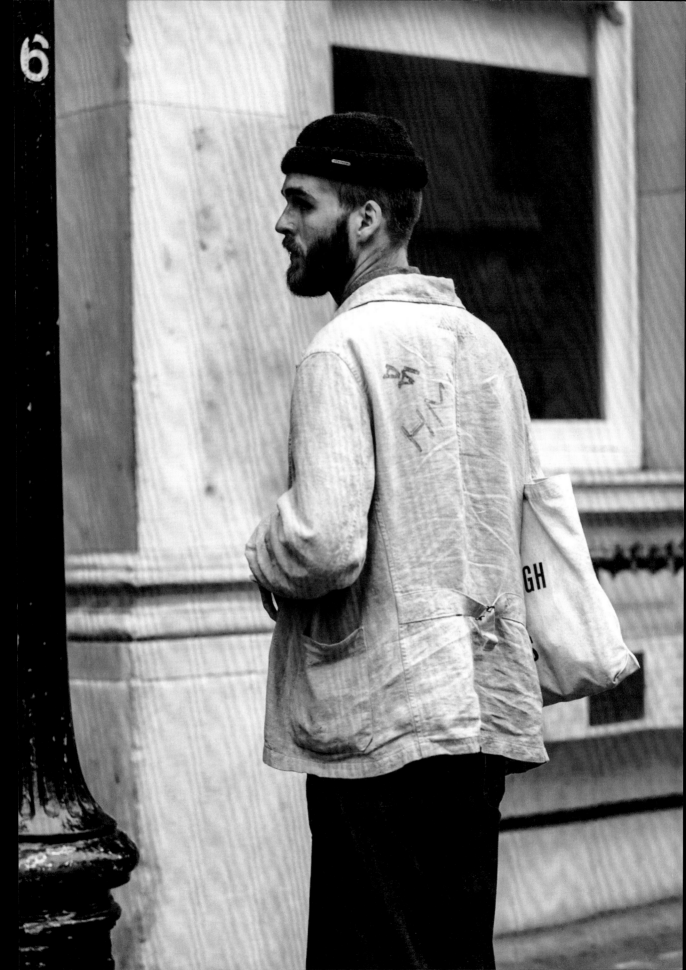

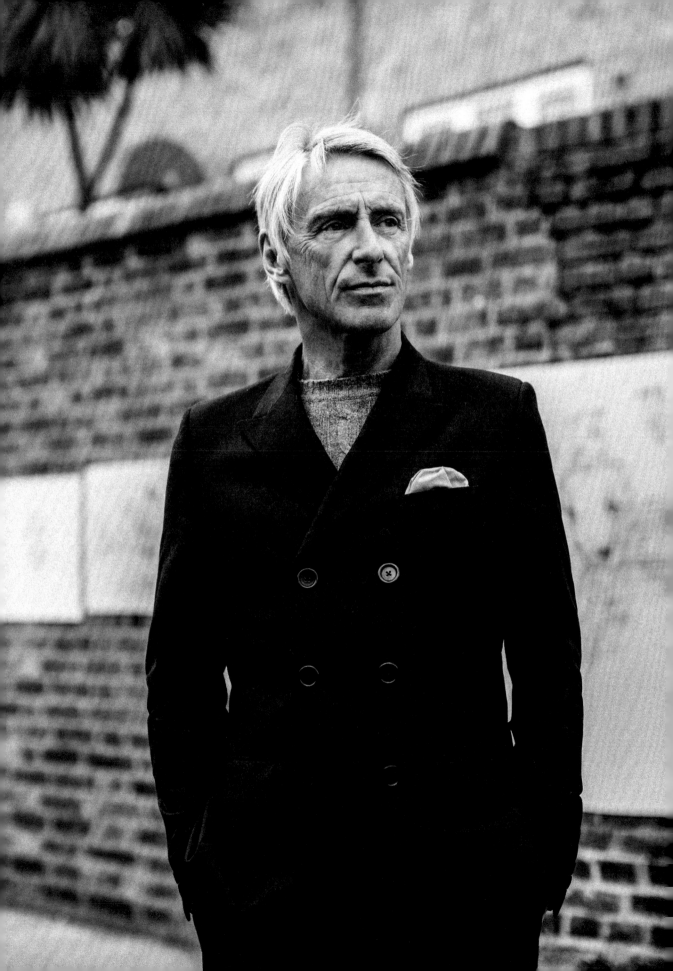

Mr Paul Weller

MUSICIAN

I met Paul Weller in a men's shop on Portobello Road. The sun was bright, but the air still had a distinctive British chill. As is so often the case with rock stars and their media personas, Paul Weller is more down to earth in real life than one would imagine. His face is lined with character and his eyes are piercing. As soon as he spoke, his distinctive voice felt so familiar to me. Paul got talking about Notting Hill: 'I love the mixture of cultures around this area. I used to live very close by and it felt like everyone was here. It's a real melting pot.'

On my first trip to London, my focus was Notting Hill – an area of West London with an epic musical heritage and the classic London iconography of Tube signs and quirky market stalls. It felt like the centre of the cultural world. As Paul and I strolled, a man waved from across the road. I presumed an old friend, but then he yelled out, 'I'm your biggest fan, Paul!'

It's a sentiment I identify with: as a child, I often sat looking at my parents' record collection. I recall seeing photos of Paul Weller, and his iconic clean haircut and distinctive sharp tailoring. He looked so well considered, so fully formed. I asked Paul what has influenced his looks over the years.

Style is cultural, it's just something I grew up around. I was a kid in the 1960s, a decade when Britain was changing dramatically, and by the early 1970s I was immersed in street culture. Music and clothing were inseparable. There's only a few things that define you when you're a kid and clothing did that for me.

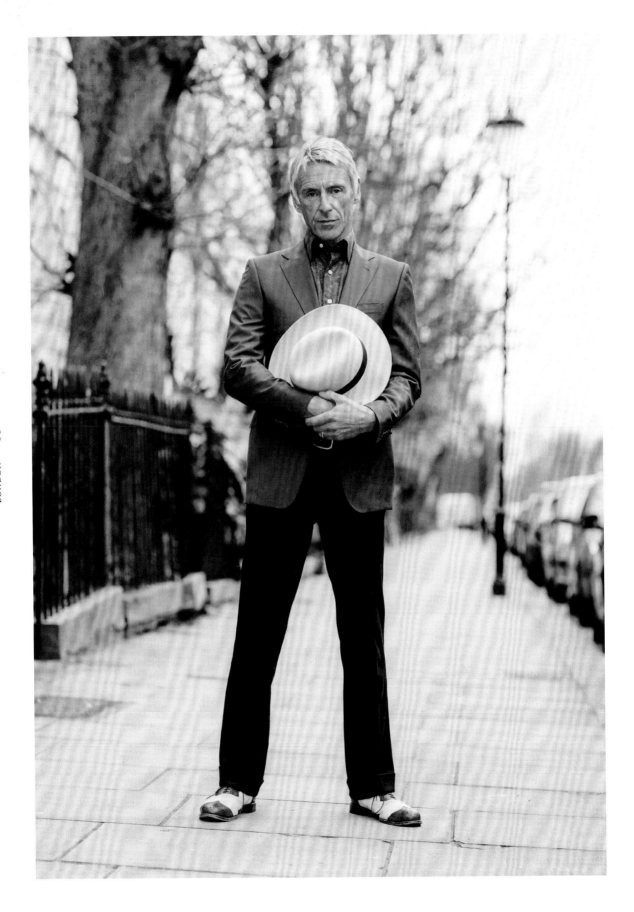

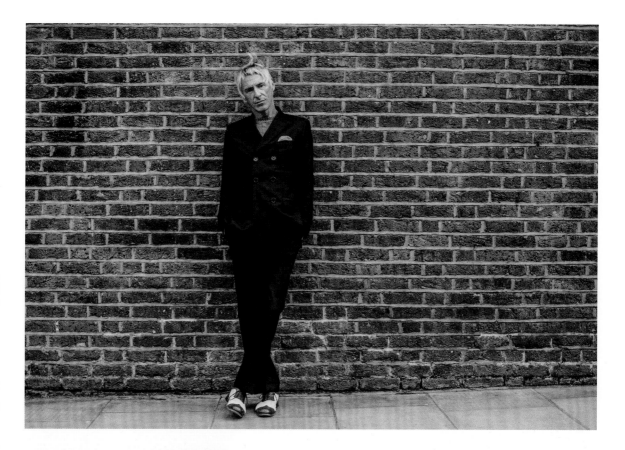

I was about 12 with the post-skinhead, suedehead movement. It had a huge impact on me. It was before 'designer' labels became a thing, so I was seeing authentic, street-led style. All the fashions I was influenced by came directly from the young people.

The day we met, Paul was wearing a navy double-breasted jacket. At first glance traditional, the classic-peak lapels had been shortened for a contemporary contrast to his grey knit sweater underneath – an irreverent combination in keeping with what I've come to expect from Paul's style choices.

My style changes all the time as I change as a person; as I grow older, I adapt. Where I am now may be different to me in a year. Having said that, my style has always been quite mod-centric and that's the core of everything.

As we continued to take photos, more people called out to Paul. To my surprise, a number of people considered themselves Paul's 'Number 1' fan. Each time, he responded with sincere gratitude. It must be difficult to retain a grounded humility after such success, but this was not always the case apparently – as I discovered when I asked what he'd say to his younger self. 'Be nicer to people, be kind. But at 18 I would've just said: "Fuck Off!"'

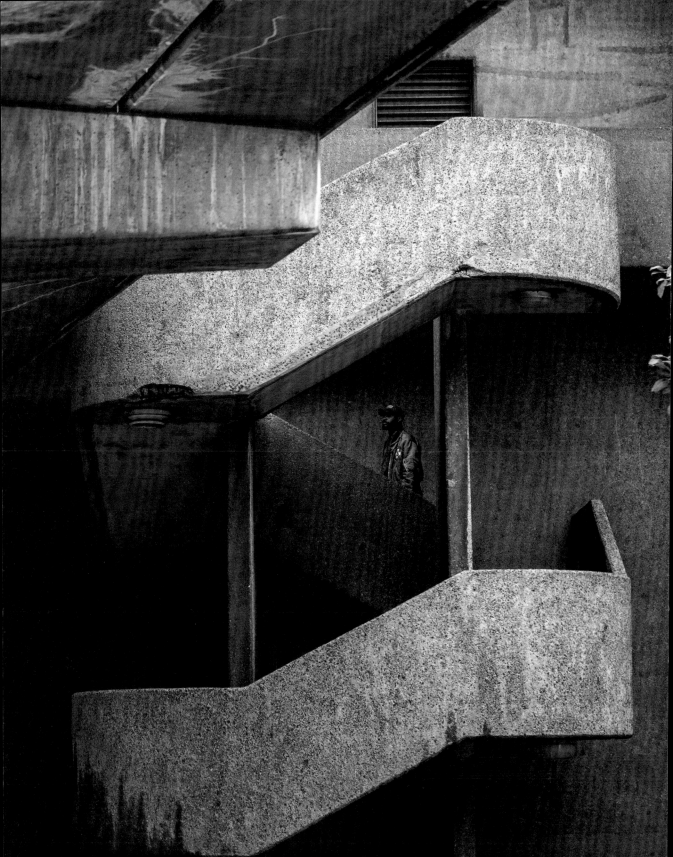

ABOVE - Mr Robert Spangle wears an overcoat by Kent & Curwen
with an Observer Collection bag of his own design.

The Strand

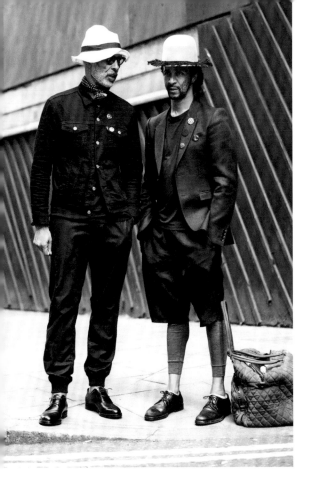

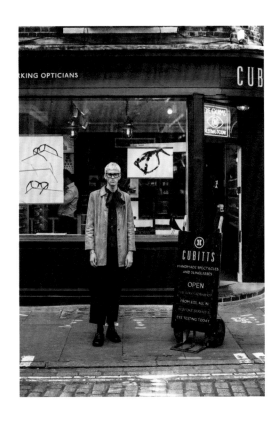

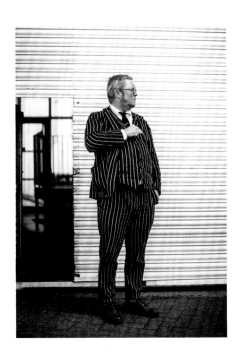

BOTTOM RIGHT - Mr Fergus Henderson, the chef behind St. John, stands in front of his restaurant in a pin-striped suit.

St John Street

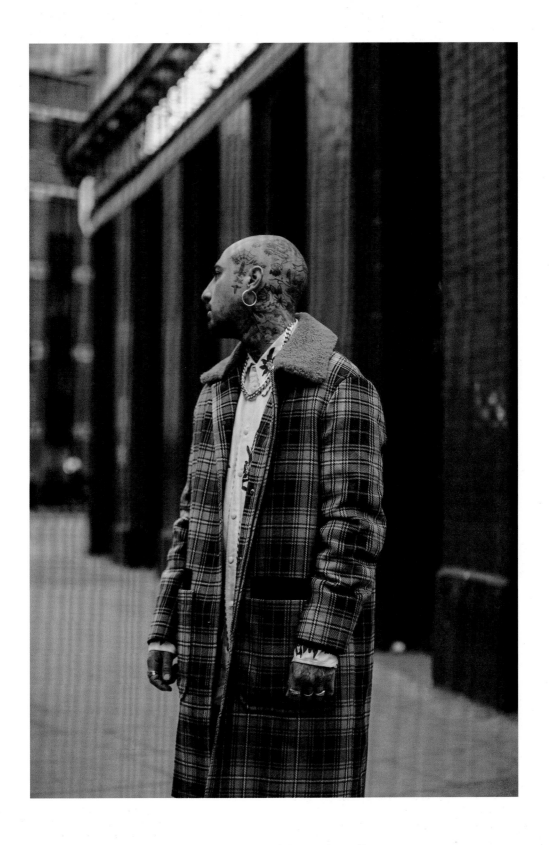

ABOVE - Mr Roberto Malizia wearing Bally.

Hanbury Street

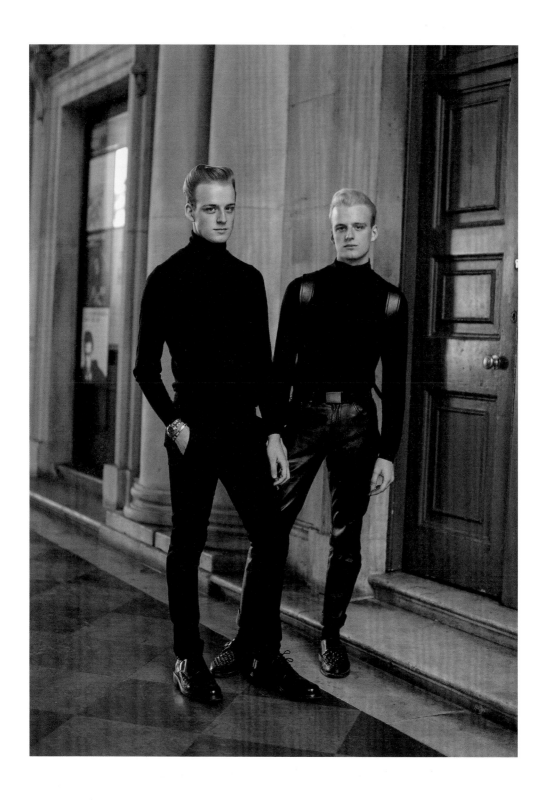

ABOVE - Mr Sam Lucas and Mr Nathan Lucas. Sam has borrowed Nathan's wool sweater from COS, while Nathan wears second-hand leather trousers from Oxfam.

Somerset House

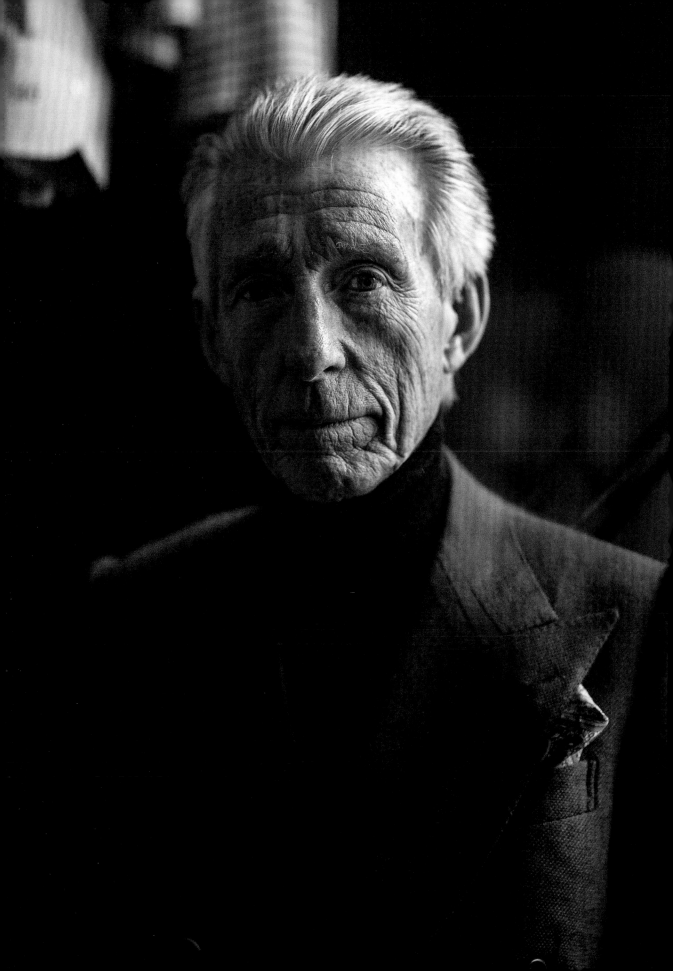

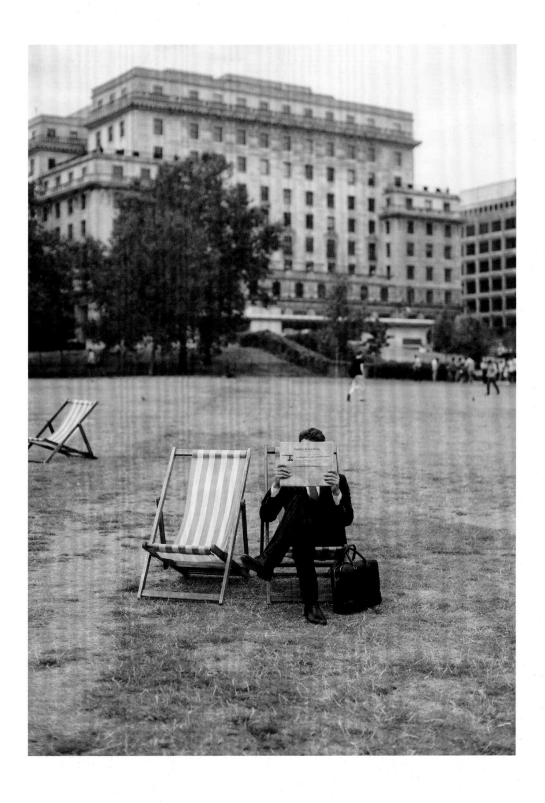

ABOVE - Mr Guy Robinson sits on a deck chair, wearing
a finely tailored suit from Dunhill London.

Green Park

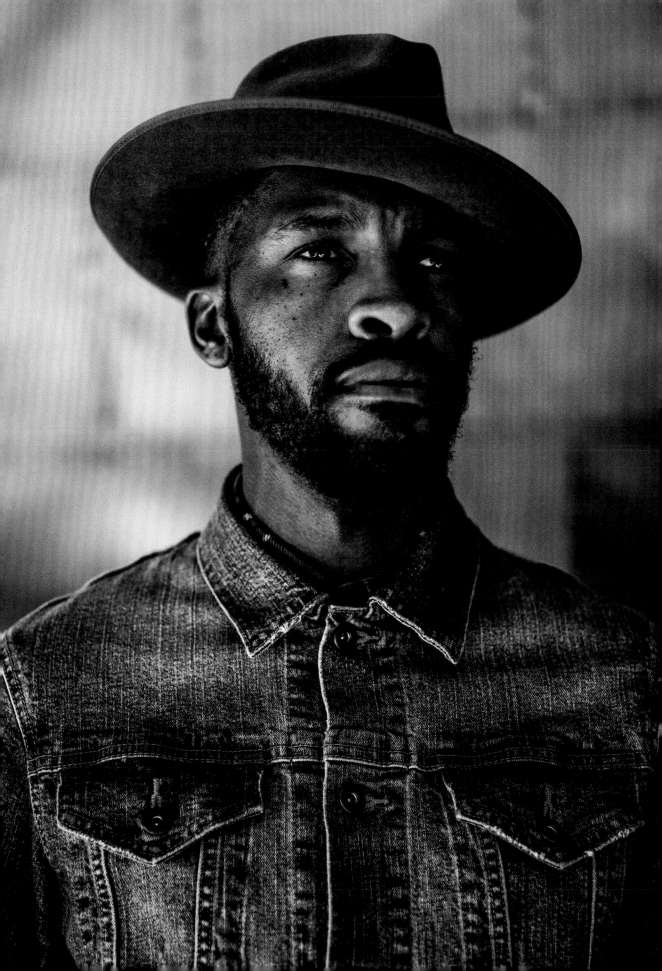

Mr Raashid Hooks

TAILOR

I rarely meet Americans who live in London, despite the city's diversity. Having been a British resident for a few years, Raashid has an interesting mix of the confidence and direct style of communication typical in the US and an old-fashioned gentlemanly charisma with British manners. This panache is also found in his style: part Americana workwear, part slick British suiting.

I was born in Chicago and became a man in New York City. Many people ask me how New York and London compare now that I've moved to the UK. My response is that they don't.

Turns out, Raashid is full of complexity and contradictions. I've known him for several years now, and photographed him a number of times, each in an ensemble of impeccable taste. On a casual day, you're likely to find him wearing denim by Ralph Lauren's RRL, but on most occasions he's in a three-piece suit, cut to fit perfectly by his very own hands. With each encounter, I can see more of the reasoning behind his career choices – running a tailoring business while also being an actor. Raashid gave me an insight into his background.

I was born an artist. Because my childhood was perilous, I was forced to focus on reality and my imagination became a place of refuge. Very early on I wanted to be an illustrator, then I began to make these awful blazers for my friends. I would do Hip Hop graphics on the back, inspired by old NYC B-Boy crews. That was the start of tailoring in my life.

Tailoring was never something I'd considered. I had a great respect and appreciation for it, but didn't think I had the skills. I knew it would be very time-consuming to learn the trade and that there is no way to mask bad tailoring. If you screw up, it's very clear. These two things almost kept me from making it over the hump, but I had a great mentor. He would always say, 'There is no such thing as a master tailor; the minute you believe you're a master is the minute you stop learning – and once you stop learning, you're dead in this business.' It's something I'll never forget.

It's the history of the craft that I love the most. If ever I'm searching for inspiration there is almost always a historical reference I can uncover to stoke the fire. Moving to London actually didn't influence my tailoring style much, as I have such a reverence for the past. Now I live here, my shopping habits have changed, though. For shoes, I always go to Crockett & Jones on Jermyn Street. For hats, Bates Hatters is my first choice, as they have a great selection of brims. A wander through Piccadilly Arcade will nearly always result in me finding a little treasure.

I photographed Raashid over a few summer days. We met by the Thames and climbed to the rooftop of the imposing Mondrian Hotel, looking out over to St Paul's Cathedral. The sun beat down on a row of tiny cars lined up on Blackfriars Bridge, and I asked Raashid how he'd like his work to be perceived by others. 'I hope to be known for being selfless with my creativity and producing art that truly moves people.'

As we parted ways, he shared a piece of advice from the British philosopher, Alan Watts: 'Better to have a short life that is full of what you like doing than a long life spent in a miserable way.'

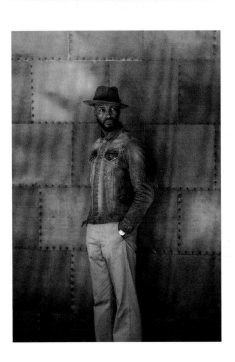

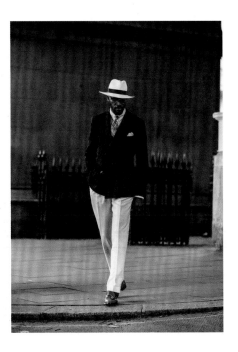

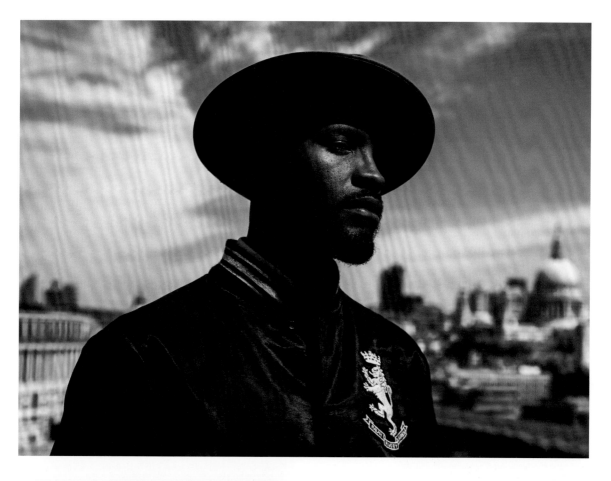

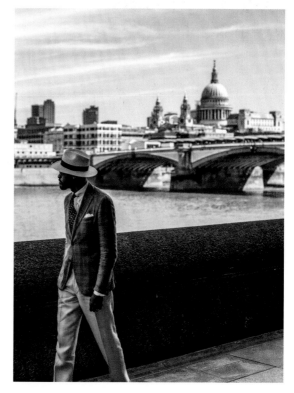

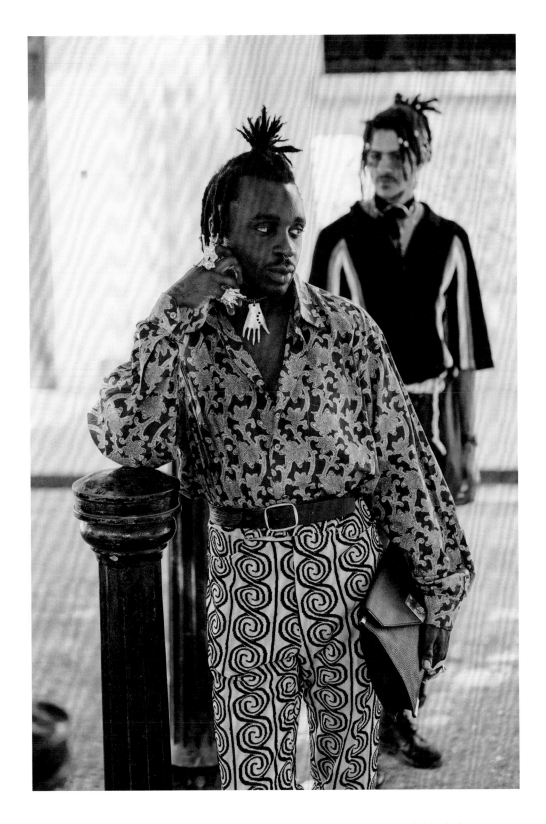

ABOVE - Mr Ramario Chevoy and Mr Edward Flaherty. Ramario's patterned shirt is from Cow Vintage in Manchester, UK, which he wears with jewellery created by Lucky Little Blighters.

Pall Mall

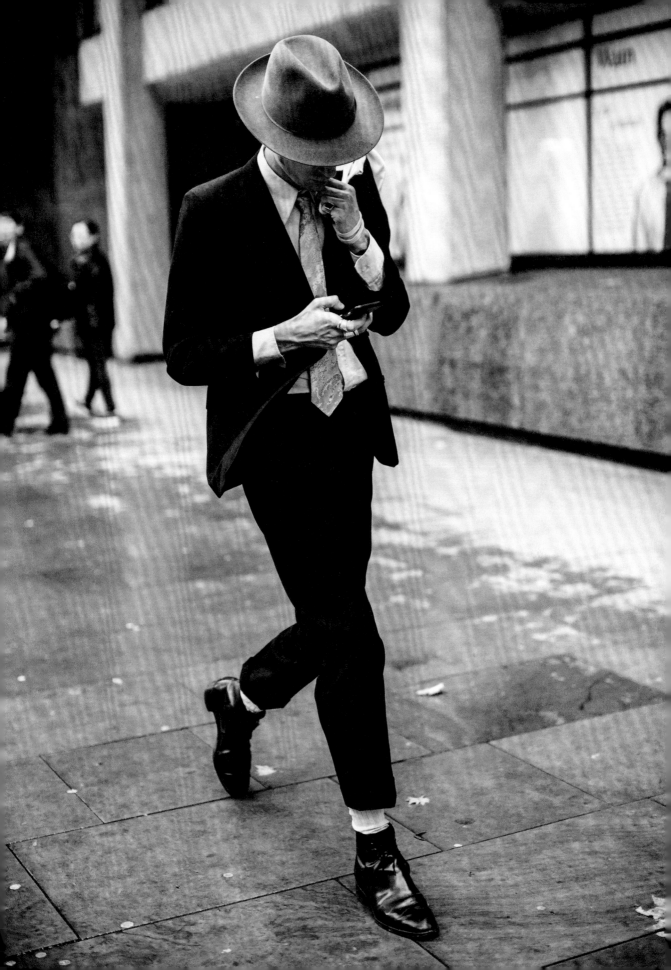

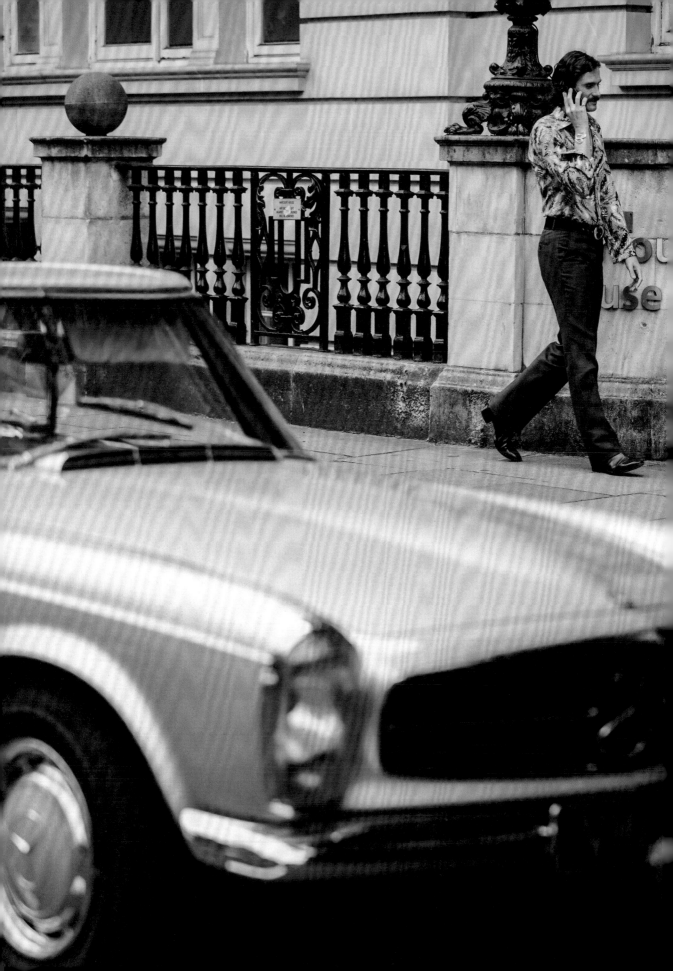

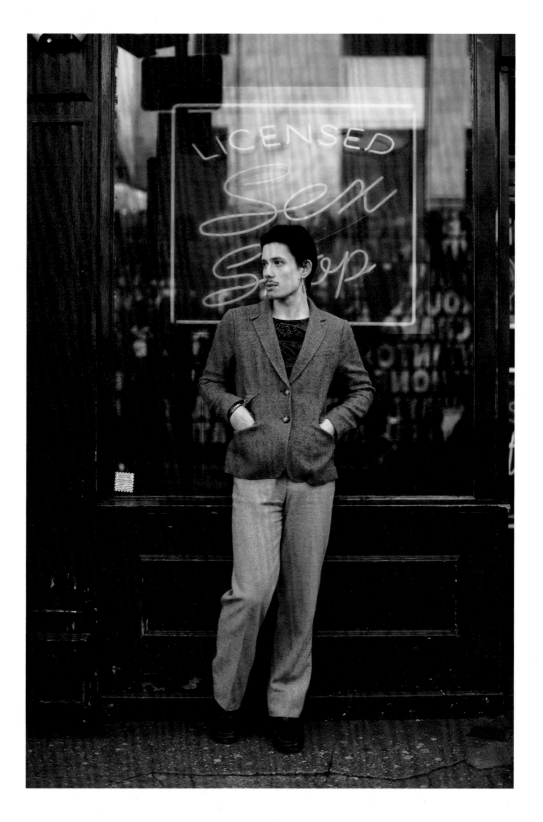

ABOVE - Mr Eden Loweth, the designer behind Art School London,
found this entire outfit at Kiliwatch, a vintage store in Paris.

Brewer Street

Mr Mats Klingberg on the way to his menswear store Trunk Clothiers.

Chiltern Street

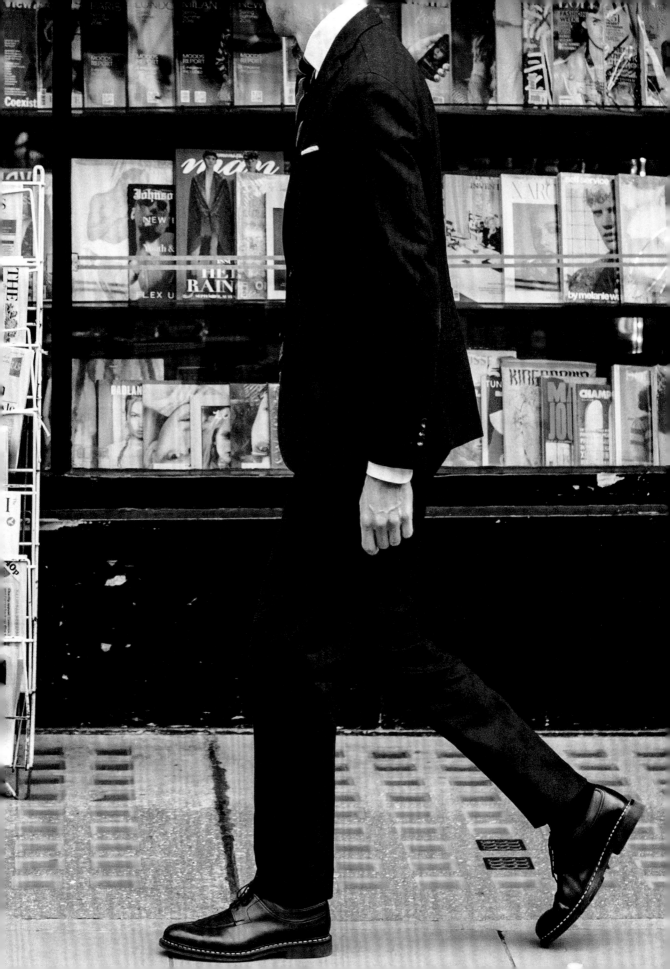

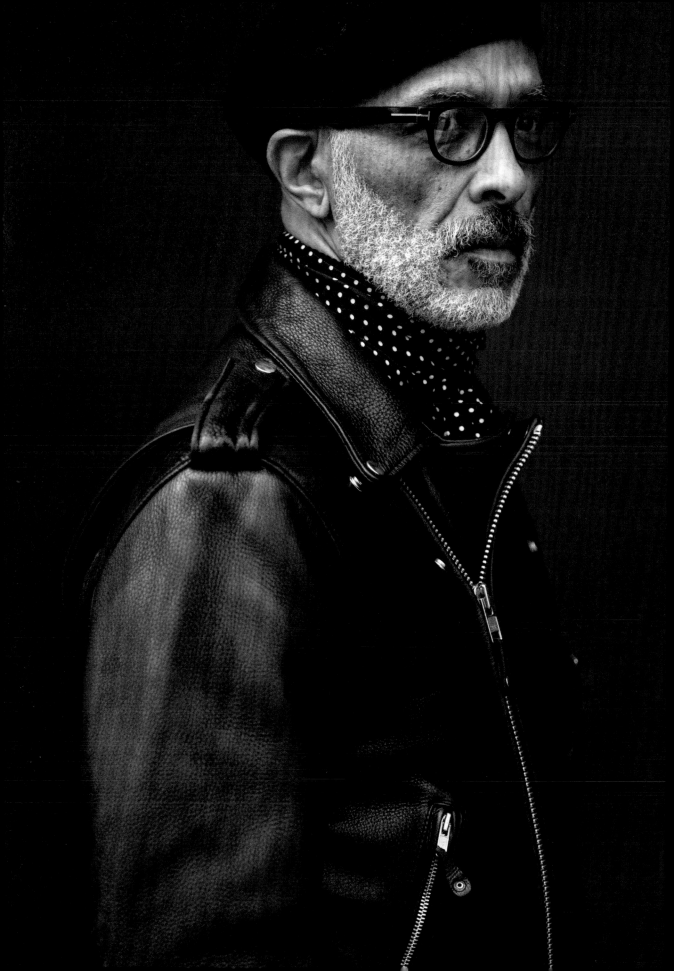

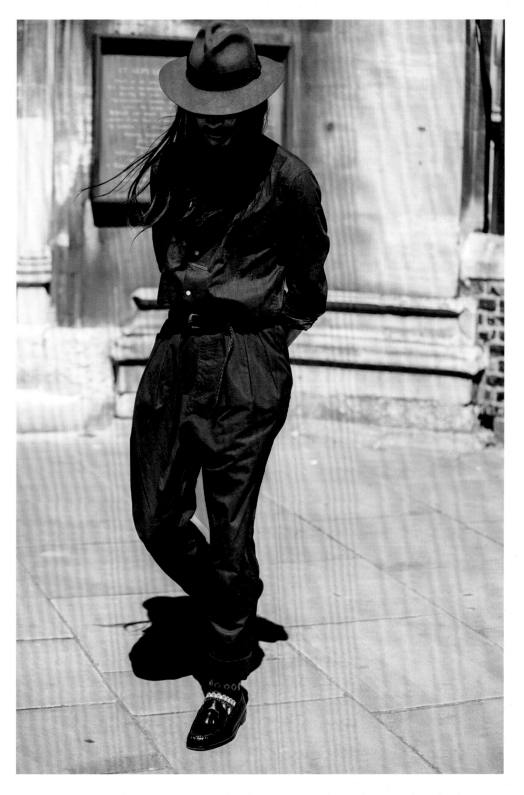

ABOVE - Mr Karlmond Tang wears a hat from Laird London and trousers by Balmain.
The money clip attached to his Sasquatchfabrix shirt was bought from Spitalfields
Market when he first moved to London – it's now his good-luck charm.

Temple Church

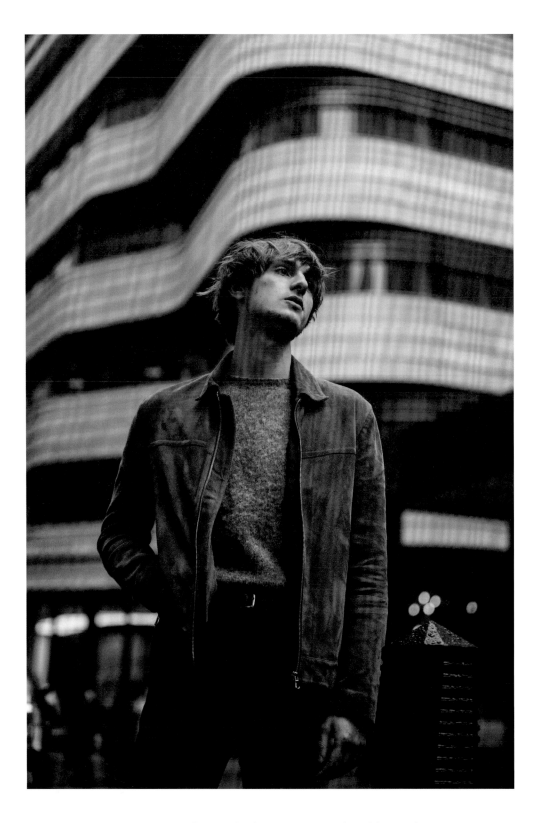

ABOVE - Mr Haydne Camina interrupts a grey day with a suede
jacket from Sandro Paris, a gift from his mother.

Carlton Street

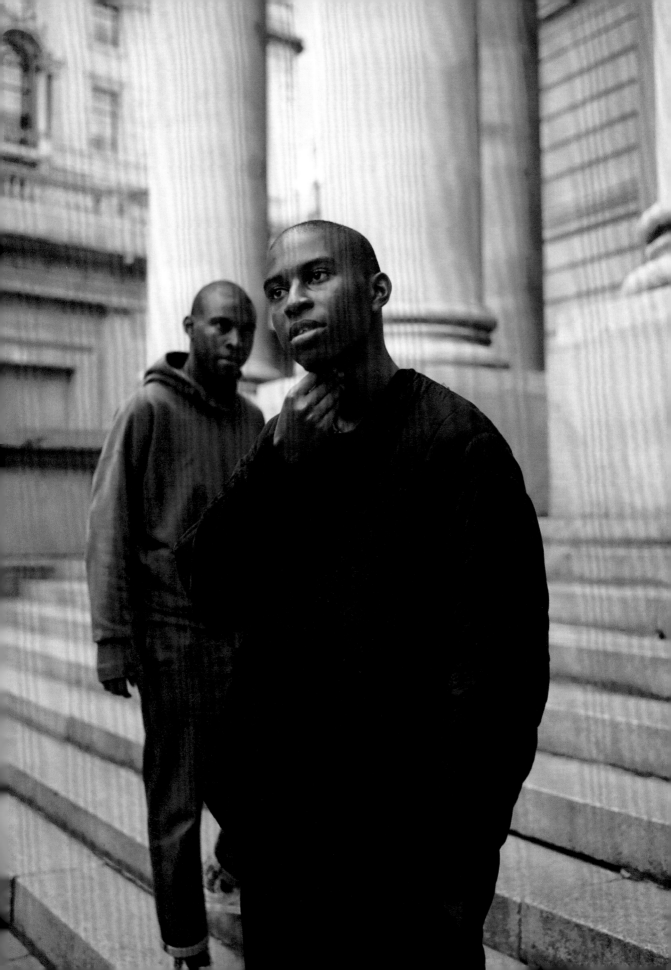

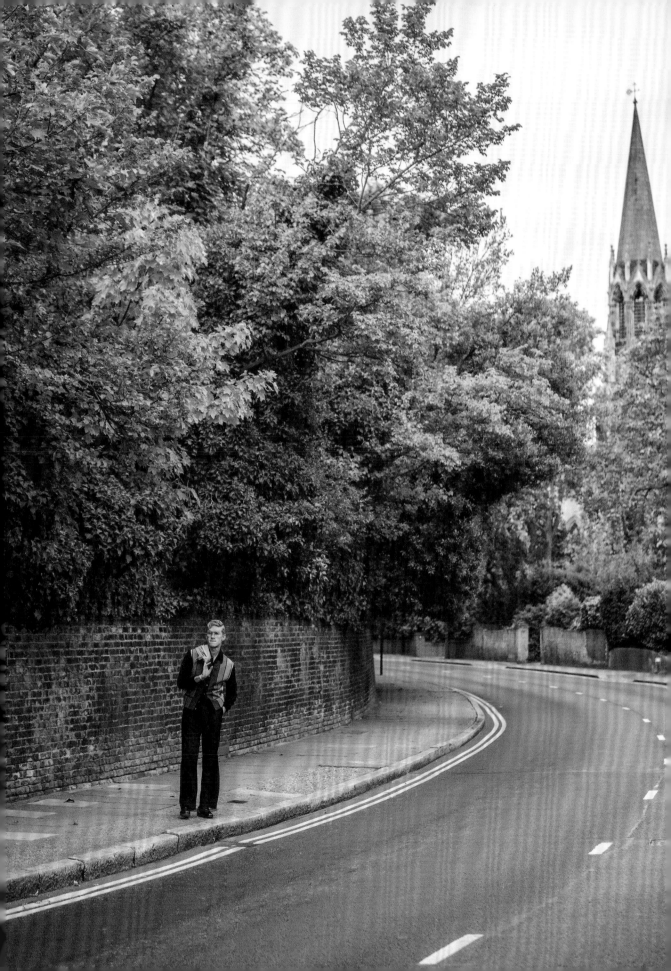

Mr Scott Fraser Simpson

VINTAGE COLLECTOR

When I photographed Scott, we lived near each other in a creative pocket of South London. I rode my navy-blue Vespa over to his 1930s apartment complex and parked it beside his garage. Inside, Scott revealed his impressive collection of vintage scooters.

It started out as a practical way of getting to and from college every day when I was 16 and grew into a love affair. My first was a 1980s Vespa 50 Special. In the last ten years, I've built scooters from boxes of parts and tried to sell them, but they're almost impossible to let go of. I currently have seven in my fleet.

Scott's love of vintage *accoutrement* spans more than transport. Over the years, I'd run into him around town, and each time he'd be wearing an ensemble of impeccable taste – each detail well-considered and often surprising. I recall driving in the opposite direction to Scott one winter's afternoon, both on our scooters. He didn't recognize me, but I couldn't miss him in his grey wide-leg box-pleat trousers. I considered a U-turn just to take a closer look. The next time we met up, I asked how he was able to amass so many great finds.

You have to invest time and energy. Vintage is getting harder and harder to find in London. I grew up in Hong Kong until I was 13, then moved to Brighton, England. Living on both sides of the world has made me more inquisitive. Growing up, I was fascinated by Asian style and the fastidious detail they put into everything.

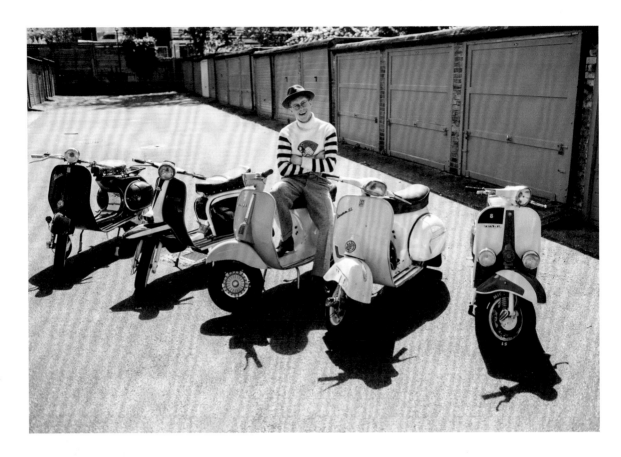

When I moved to England, I was exposed to British subcultures, and the depth of history and culture that came out of these scenes has kept me busy since.

When I was 14, for instance, I discovered the 1960s Modernist movement. I couldn't help but be influenced by it, living in Brighton. I went to a small shop called Ivy's in The Lanes and scored my first piece, which was a donkey jacket – a navy-blue wool coat with tartan lining and leather patches on the shoulders and elbows, most commonly used by binmen in the 1970s. Days later I returned to pick up some macs, leather double-breasted coats and shirts with elongated collars. I was hooked – everything cost £5.

I admire people who dedicate themselves to an aesthetic, to a life that brings forth and animates the past. It takes strength of character not to be swayed by modern marketing. For Scott, however, it turns out it's not that difficult. 'Fashion is momentary, style is timeless. Understand and respect what has come before, and you'll never look back with any regret.'

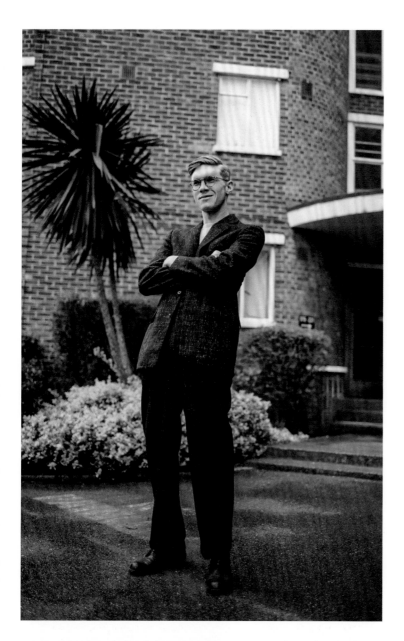

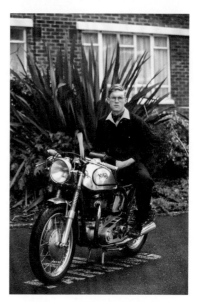

RUSKIN PARK HOUSE

NOS 222 - 241 NOS 1 - 221
 NEXT ENTRANCE

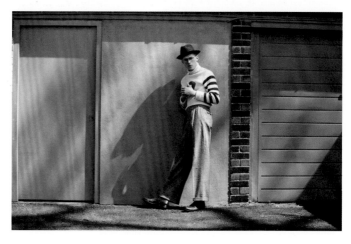

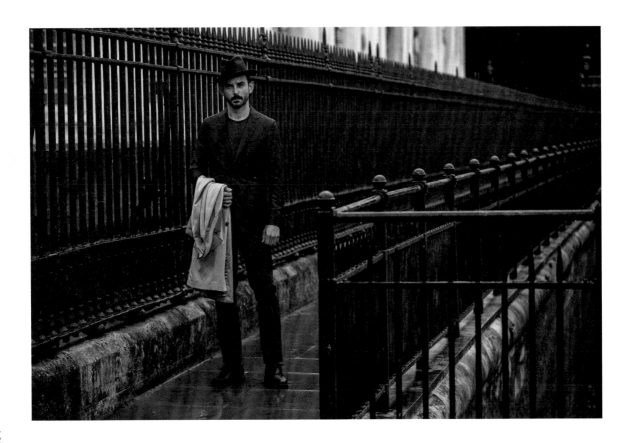

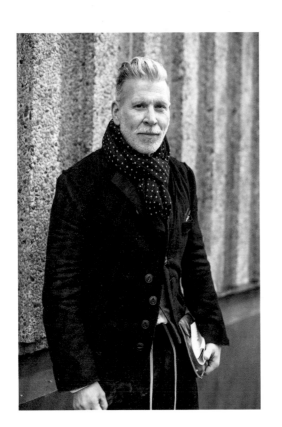

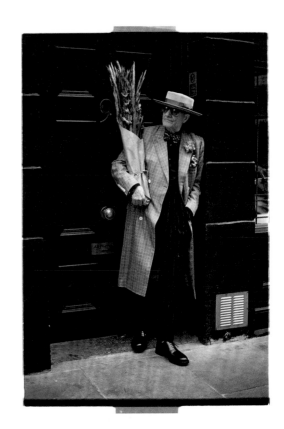

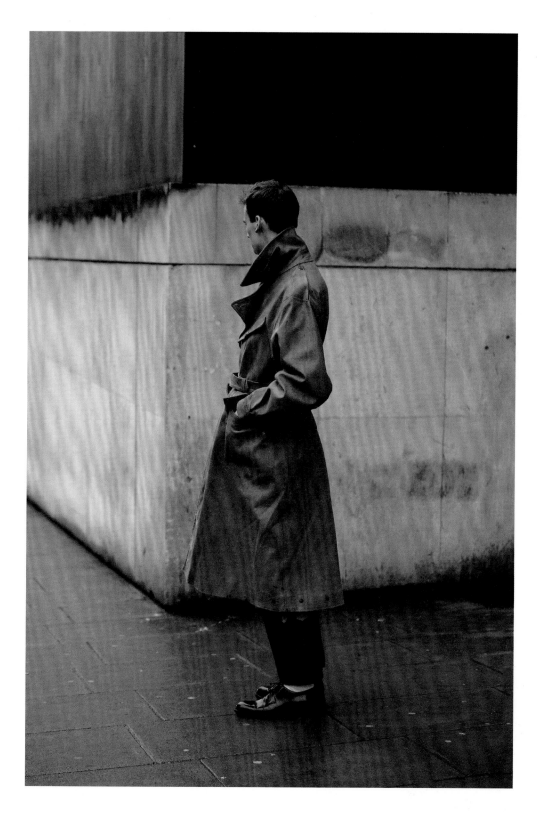

ABOVE - Mr Luke Derrick repurposes a dispatch rider's coat from 1944, made
by the British military. He wears it here with shoes by Raf Simons.

Arundel Street

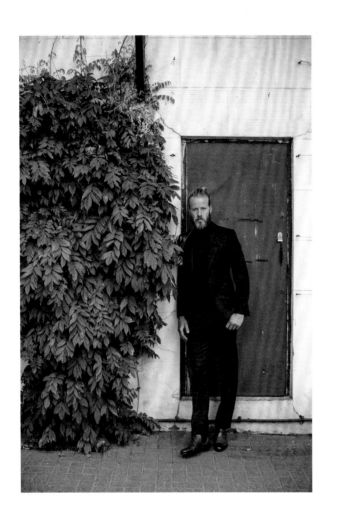

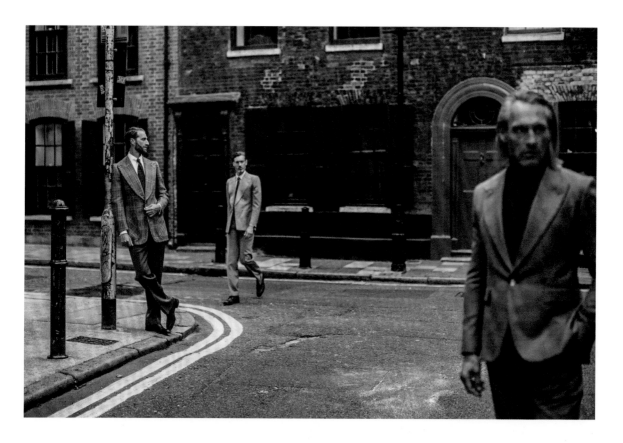

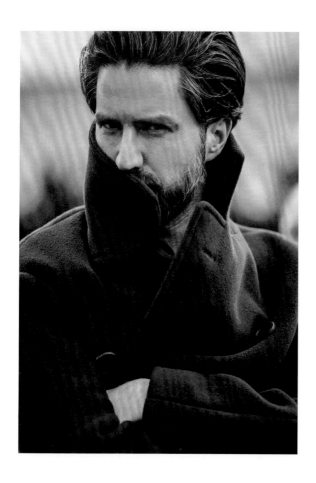

LEFT - Mr Jack Guinness keeps warm in a Burberry overcoat.

Kensington Gardens

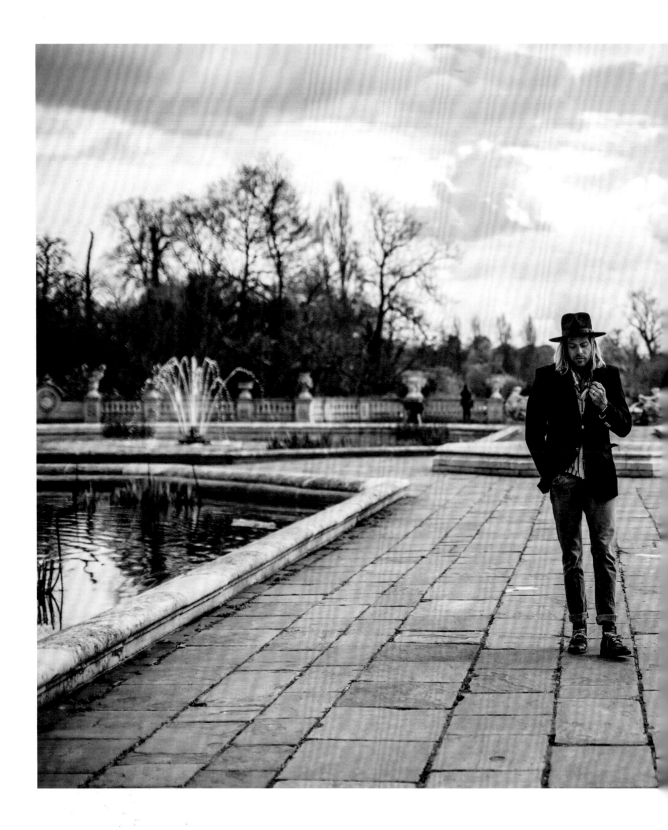

Milliner Mr Nick Fouquet wears a
hat of his own design, made at his
studio in Venice Beach, CA.

Kensington Gardens

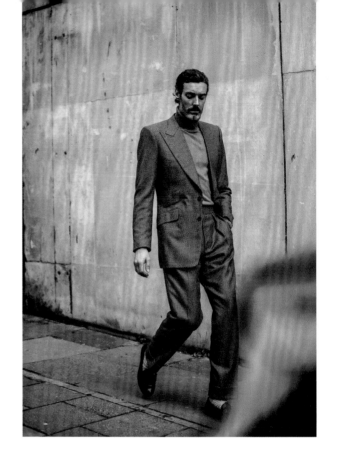

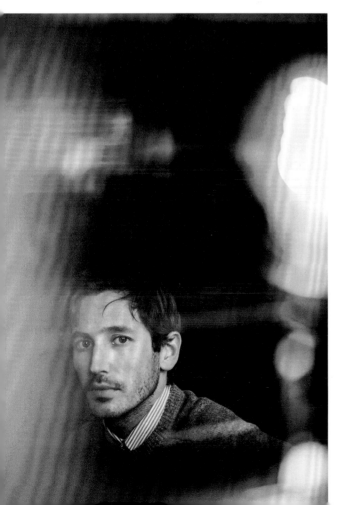

BOTTOM LEFT - Mr Jamie Wright at his local pub, The Eagle. The shirt just visible underneath his jumper is from Brooks Brothers.

Ladbroke Grove

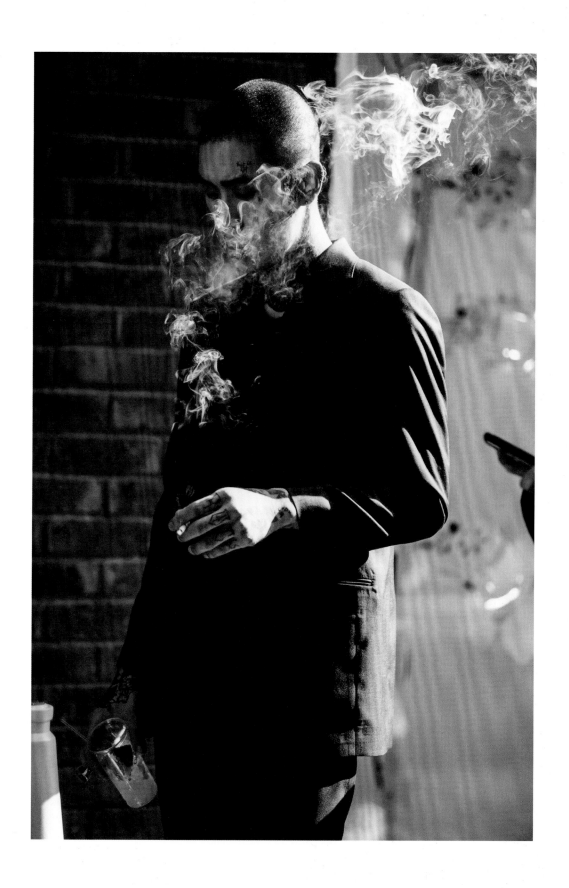

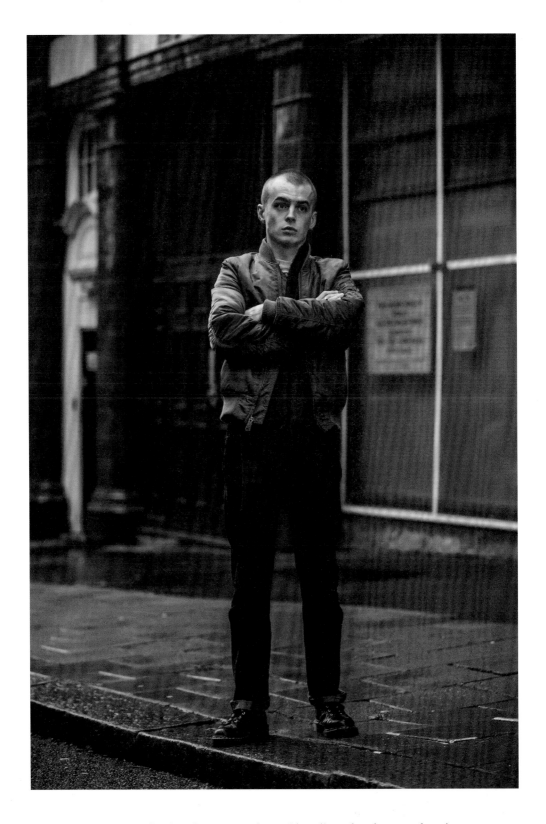

ABOVE - Mr Alistair Osbourne stands outside a disused underground station wearing an Alpha jacket, Levi's 501 jeans and Dr. Martens church boots.

The Strand

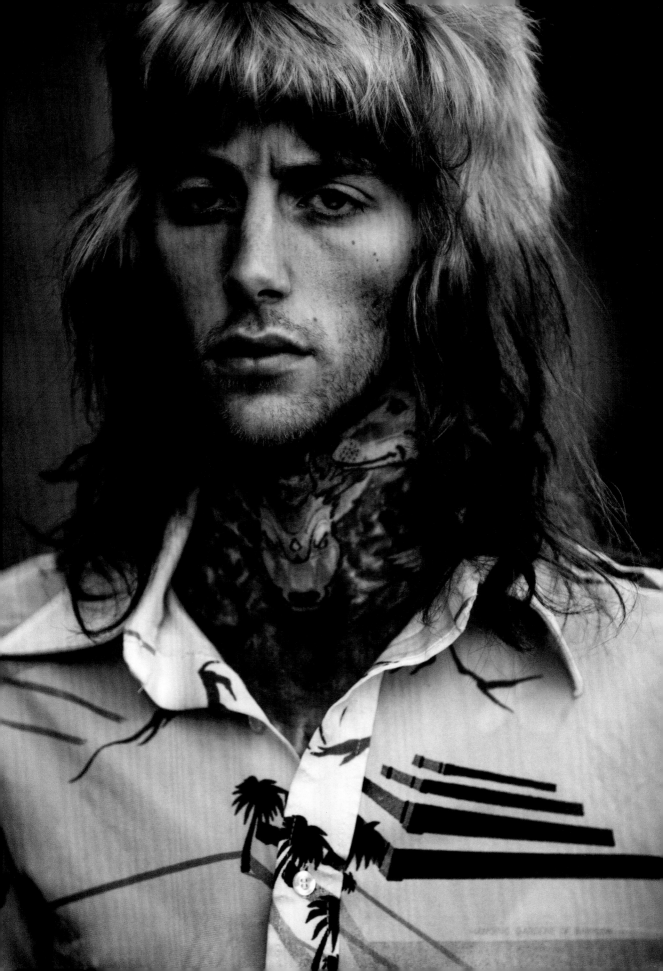

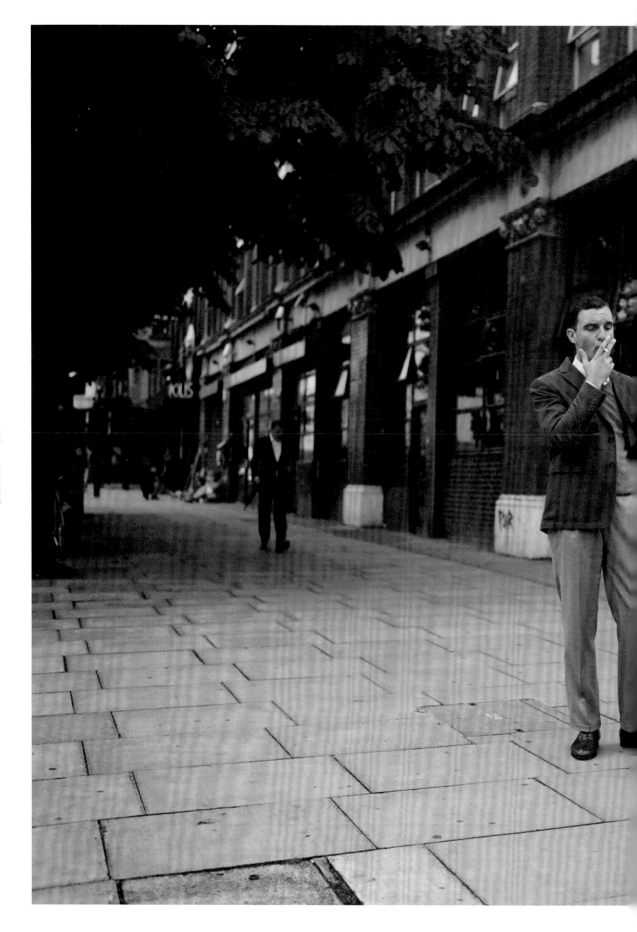

Mr James Jonathan Turner, a taylor,
in an outfit of his own design.

Cambridge Heath Road

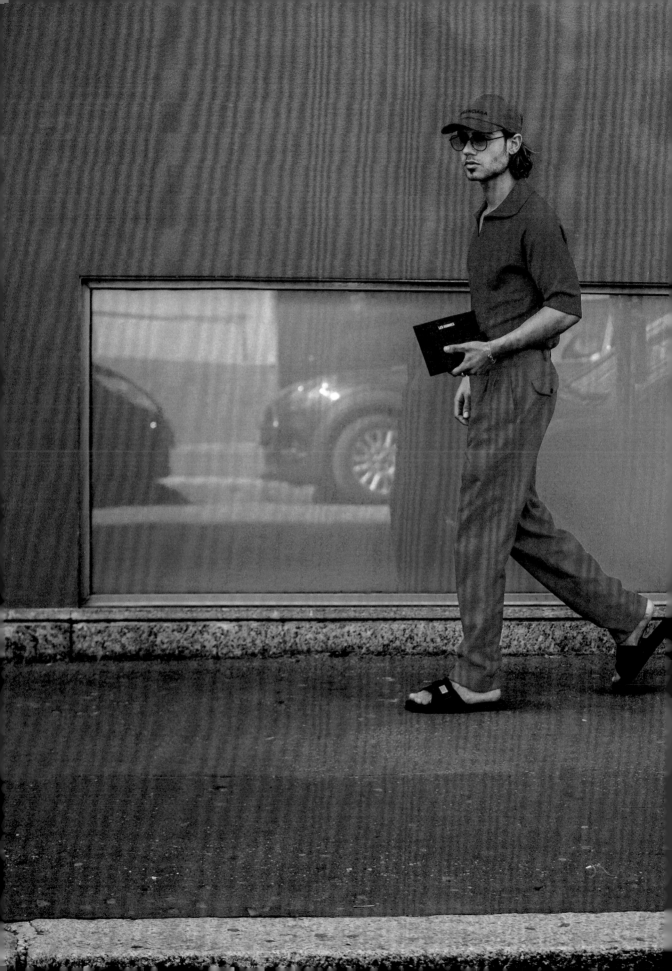

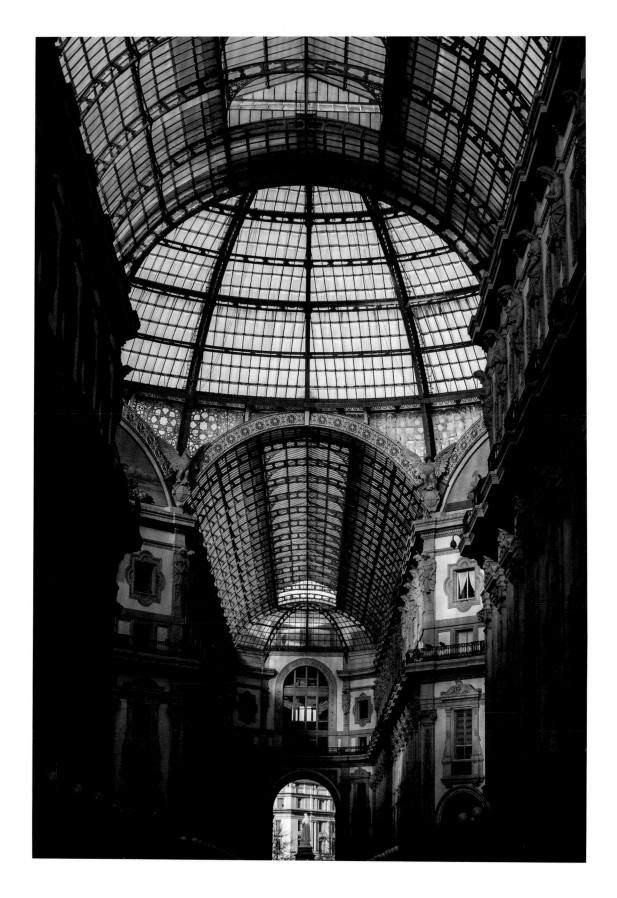

'The undisputed Italian capital of business and style, Milano is an austere city that asks you to be patient and discover the treasures for yourself. The understated elegance of the city's denizens hides an unmistakable brand of exuberance. But nothing flashy, be warned: Milano is no Roma – it merges the bold with the reserved.'

Angelo Flaccavento
Fashion critic at *The Business of Fashion* and Milan resident for 15 years

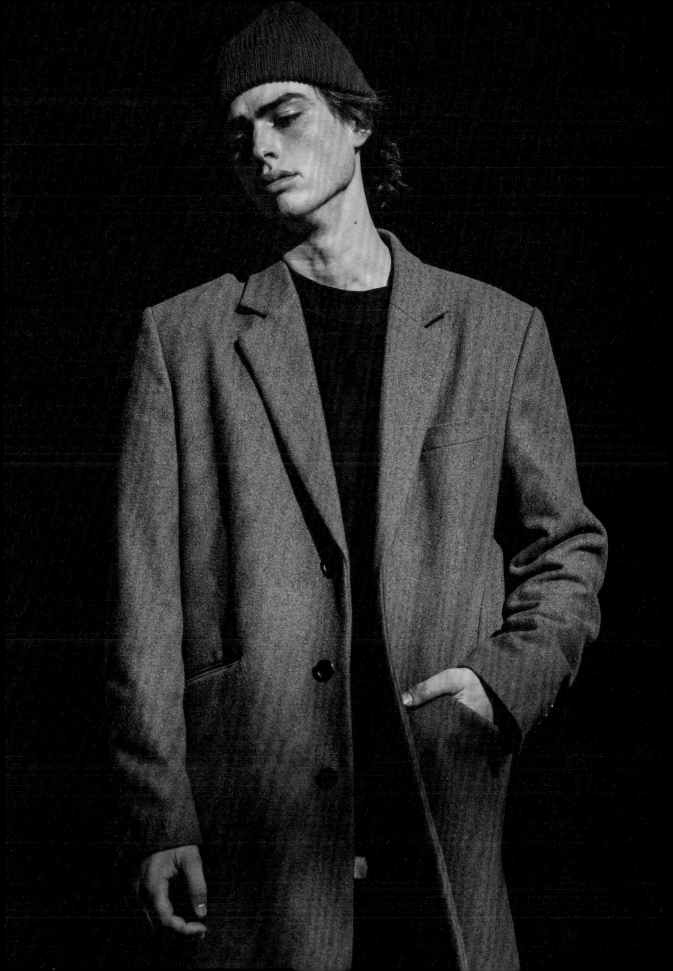

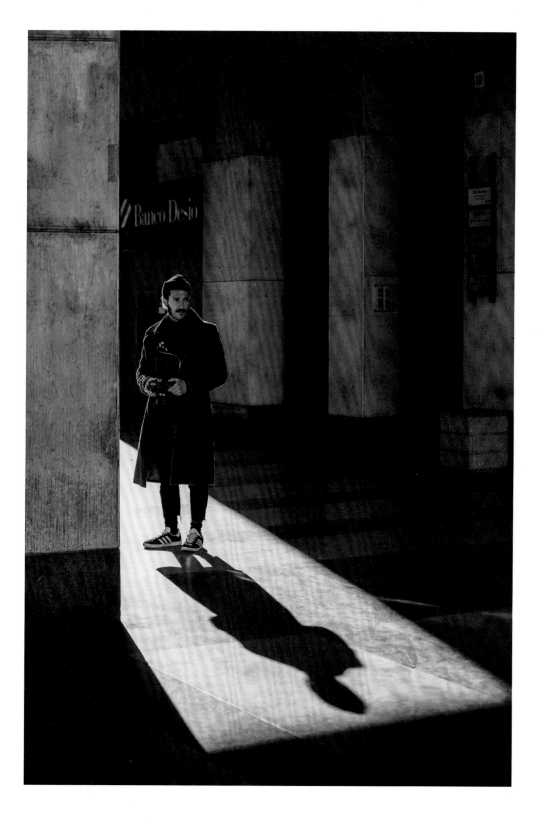

ABOVE - Mr Antonio Giacometti wears a Perfecto motorcycle jacket by Schott NYC under a long corduroy coat he found at a vintage street market in Florence.

Corso Giacomo Matteotti

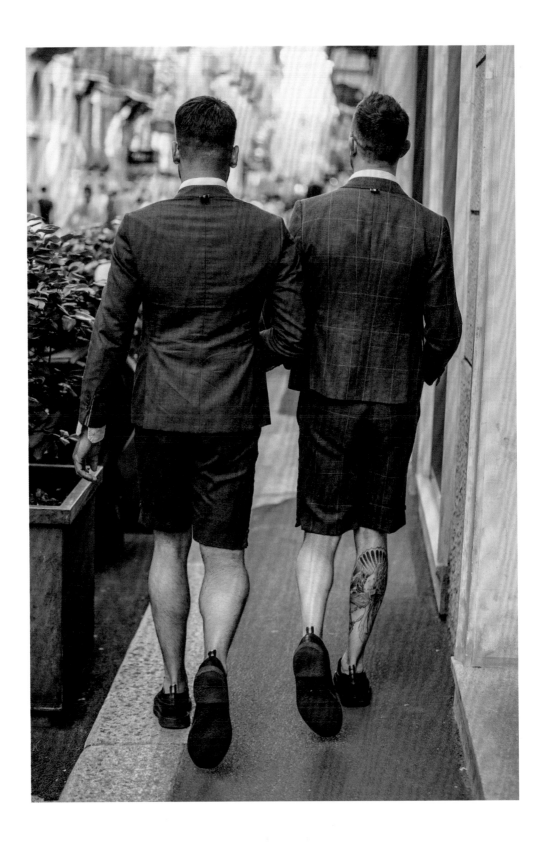

Mr Luis Diaz and Mr Lucas Langellier complement each other in Thom Browne.

Via Gesù

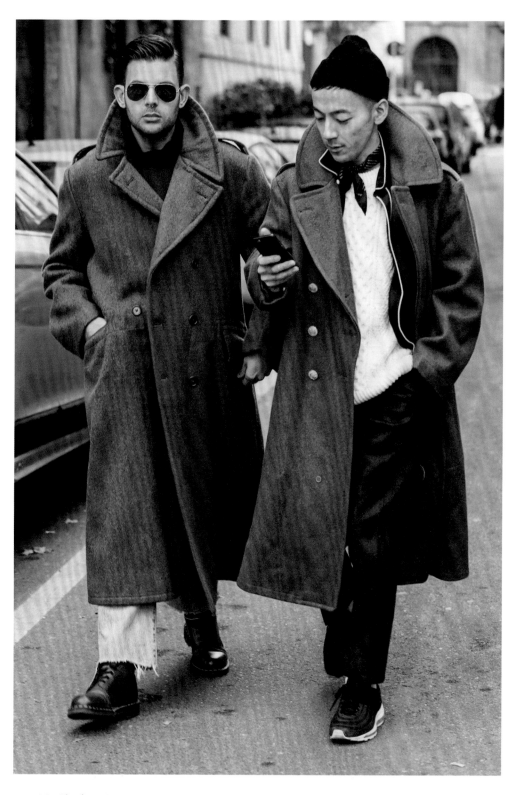

Mr Gianluca Senese wears a vintage wool overcoat from the British military with Levi's 501 jeans and Dr. Martens 1460 boots. Mr Kensuke Takehara is also wearing a vintage military coat, along with a vintage Yves Saint Laurent scarf and custom-made trousers.

Viale Piave

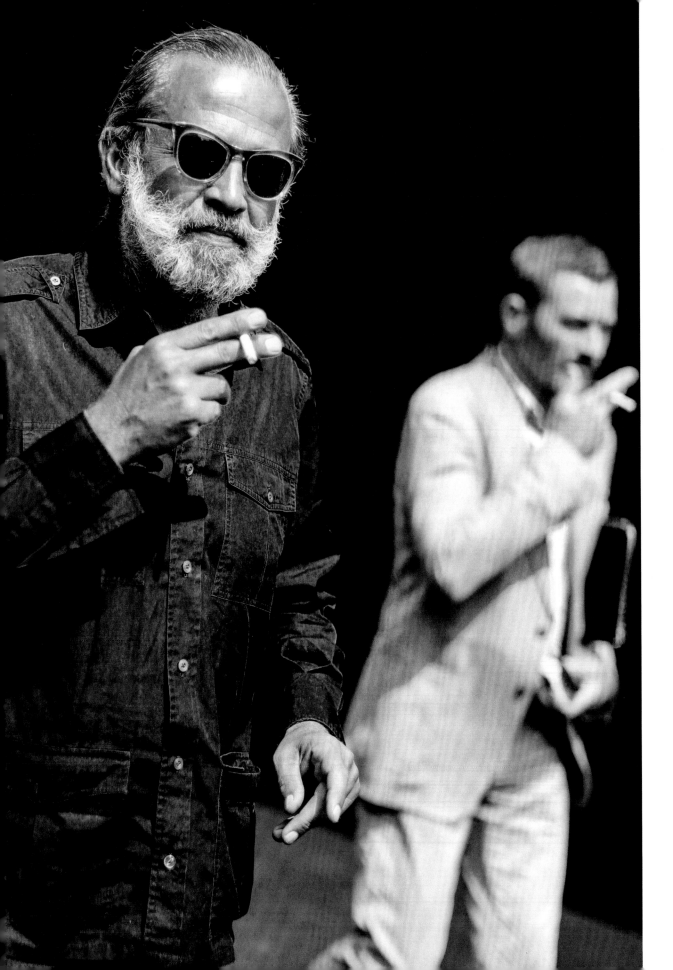

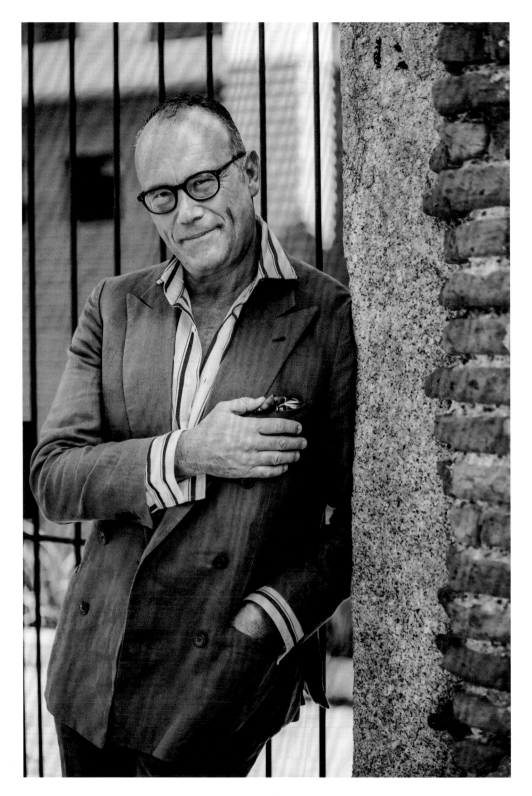

ABOVE - Mr Cesare Cunaccia wears a bespoke double-breasted tobacco suit made from Irish linen, designed by Santerasmocinque in Milan. His glasses, created in collaboration with Boudoir Venezia, are made from natural bone.

Via San Vincenzo

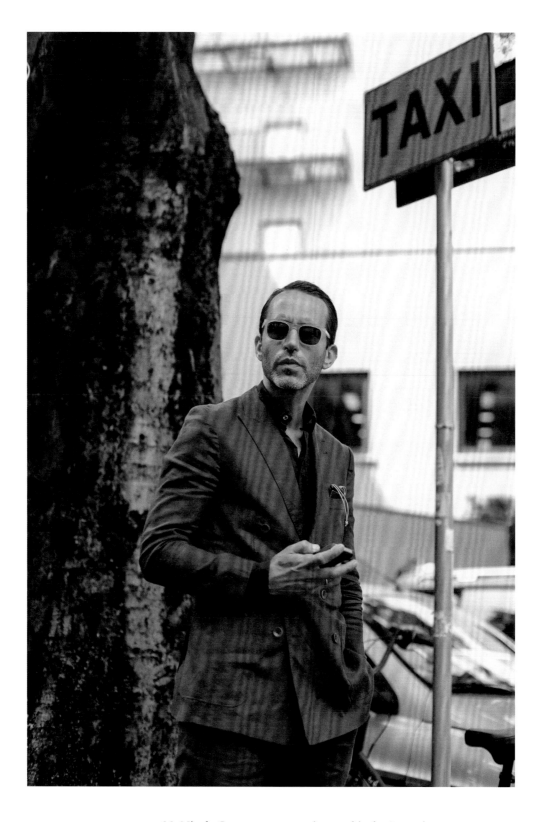

OPPOSITE - Mr Nicola Cuppone wears a vintage shirt by Armani
and leather trousers he bought in a market in Rome.

Largo delle Culture

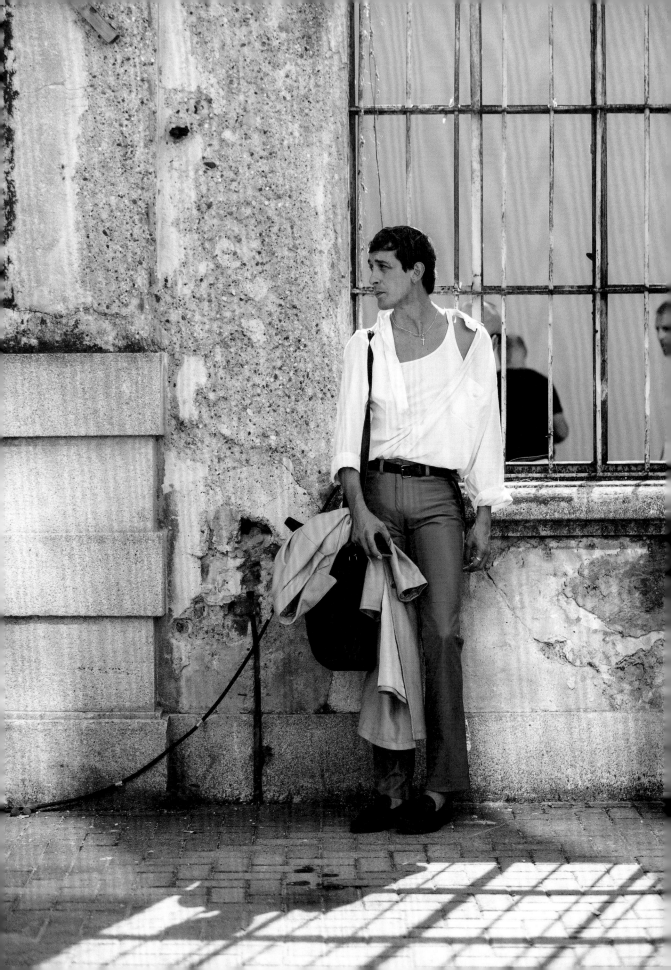

Mr Ko Hooncheol

PHOTOGRAPHER

Ko and I met when he lived in London. He asked to take my photograph because he thought my look was distinctly British. We quickly bonded over a love of analogue and shared tips on shooting with the Leica M6. Walking along a side street in Shoreditch, he told me of his struggle assimilating to a new life after leaving South Korea.

Surviving in London was more difficult than I'd ever imagined – the language barrier, the cultural differences and, of course, financial issues. The largest hurdle was finding my own identity.

Since then, he's made a new home and business in Milan. Having seen him in canny, well-tailored outfits on multiple occasions, I was curious to look in his wardrobe. We met at his apartment in the north of the city on a frosty January afternoon, where he explained what informs his style.

I need practical clothes that don't annoy me when I work. Clothes also need to be easy to care for, as I travel so much. For this reason, I love vintage. Styling with vintage clothes all depends on my mood. I don't like trends; in any case, my body never goes well with trendy fits. I am 158cm and 85kg. That is not a standard fit. But if you have a tailor, your body size does not mean anything. I love the tailored suit, which is why living in Italy is so much fun as there are so many experts here.

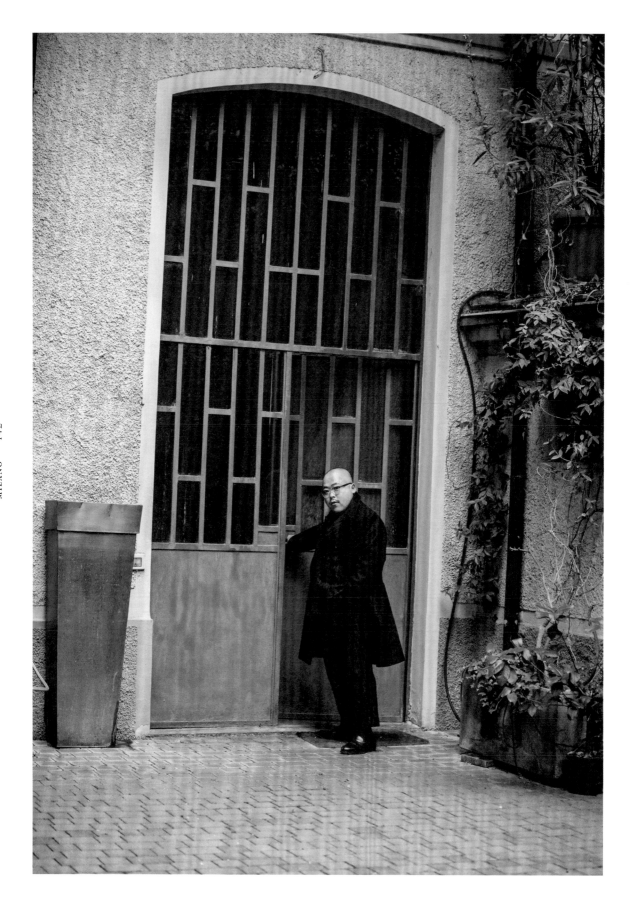

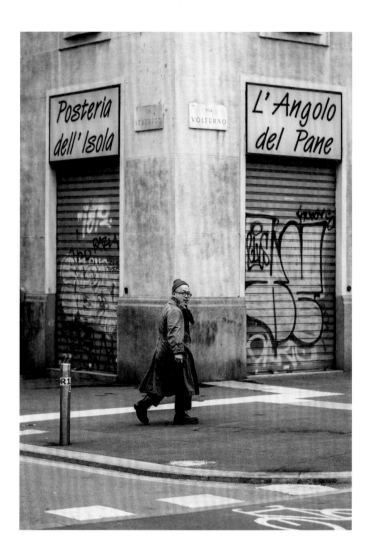

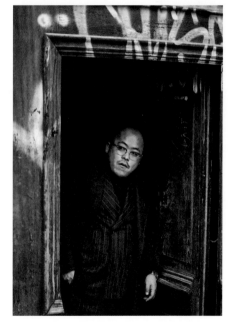

I wondered where someone who eschews trends looks for inspiration?

I look up to the people who do not have a beautiful body shape but still have a great style. I once saw a photo of Aristotle Onassis in an impeccable double-breasted suit and it gave me the confidence to experiment with tailoring myself.

Ko has succeeded in creating a wardrobe that is the perfect fit for his body and his identity. It seems that this sartorial honesty is what he is most interested in: 'I always tried my hardest to be authentic. As Mark Twain once said, "If you tell the truth, you don't have to remember anything."'

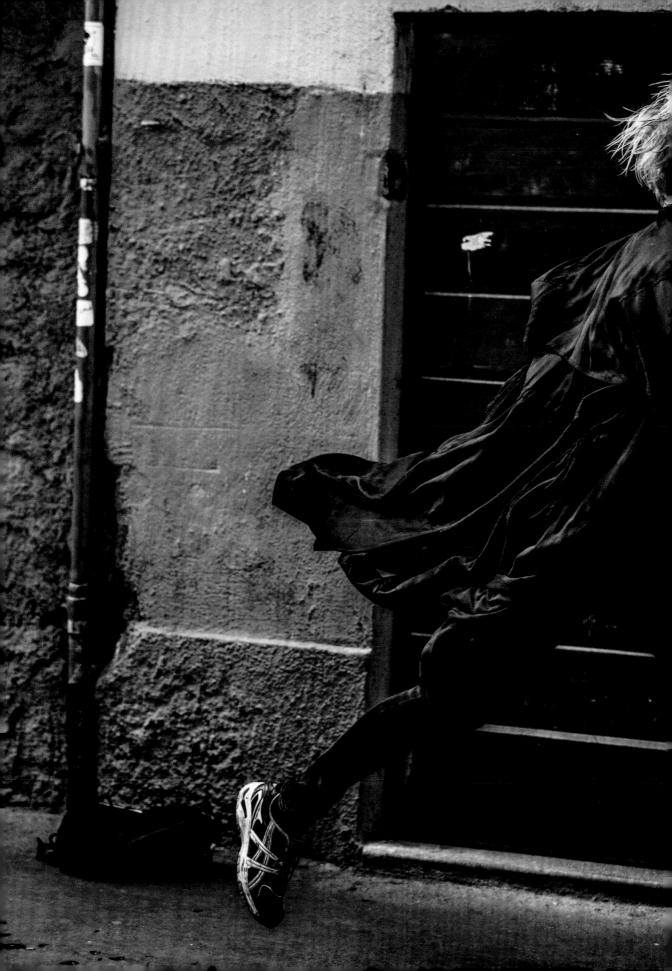

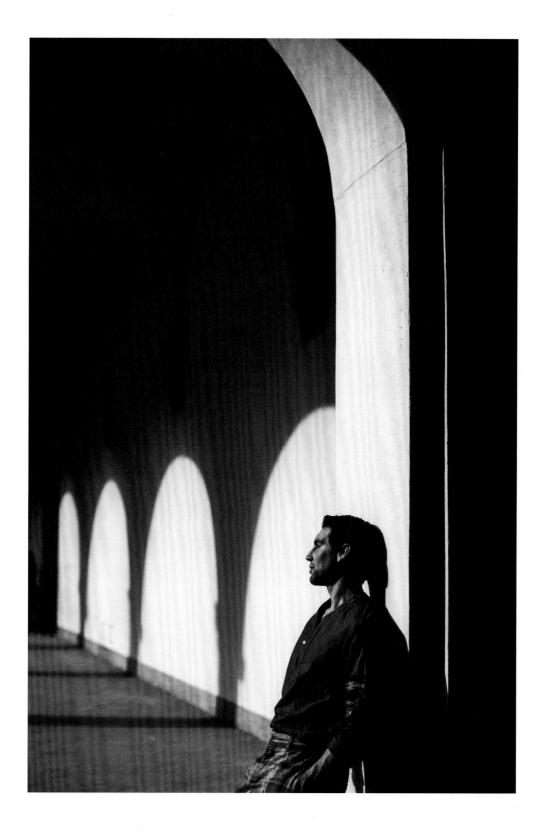

ABOVE - Mr Ivano Marino reclines in an outfit by Missoni.

Castello Sforzesco

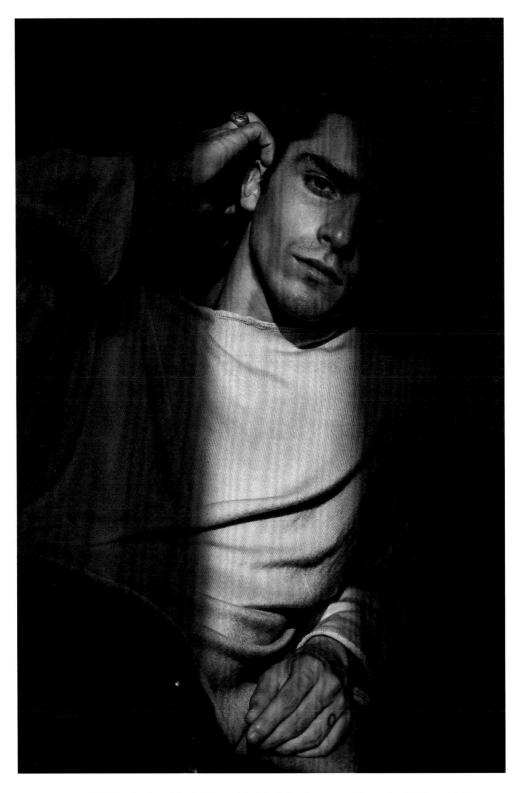

ABOVE - Mr Brando Pacchiani pictured in his father's sweater from the 1980s, which he updated by cutting the sleeves and removing the turtleneck. He wears it here with a gold ring he bought the day he realized he was in love for the first time.

Via Solari

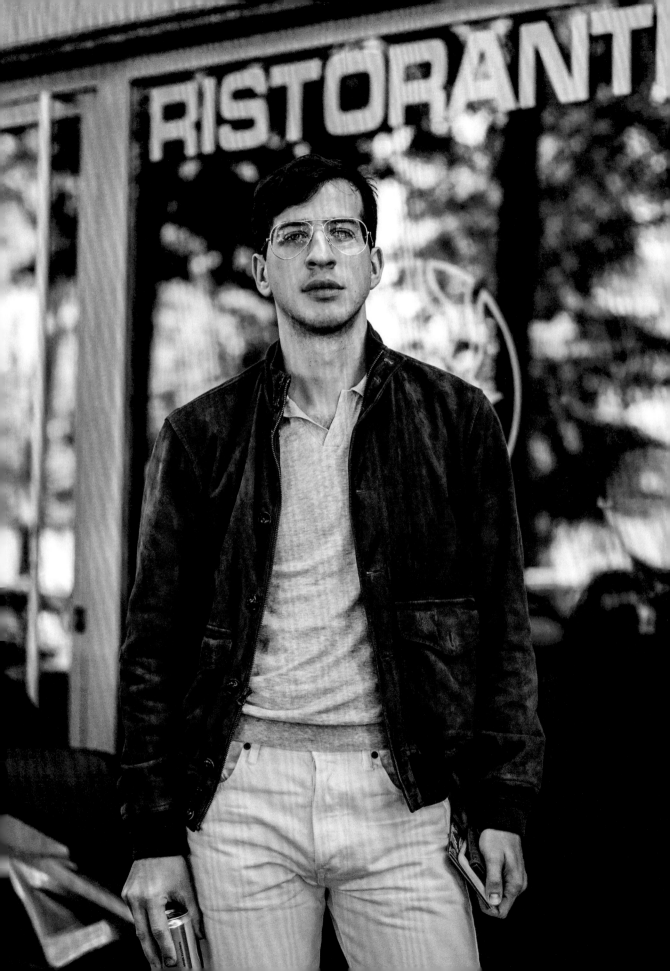

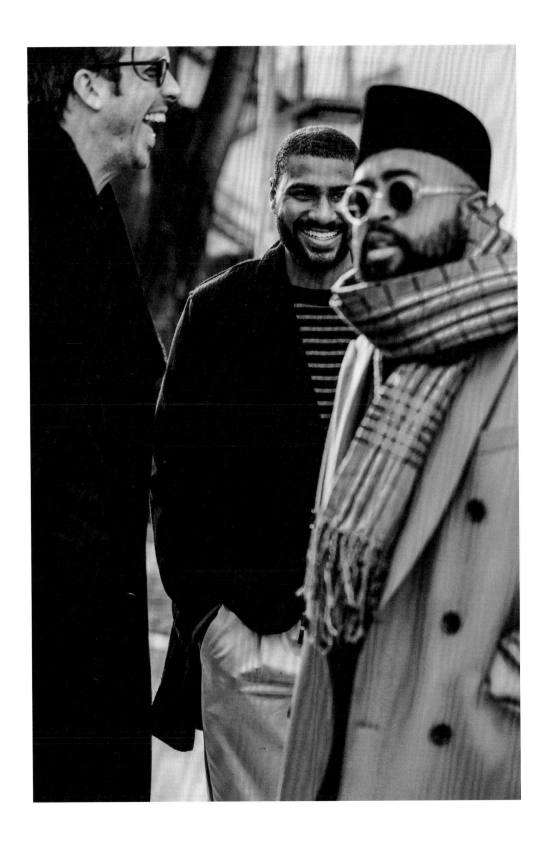

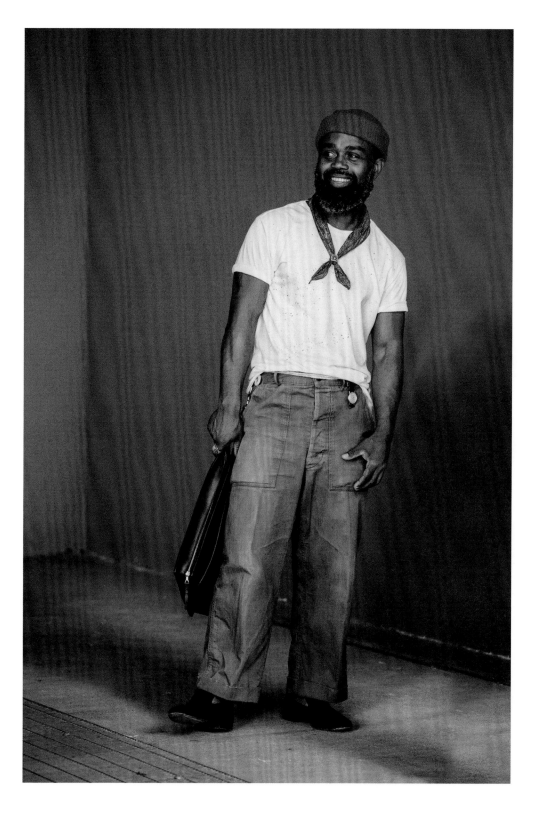

ABOVE - Mr Ouigi Theodore designed these cargo pants for the
Brooklyn Circus. He picked up the necktie in Paris.

Via Tortona

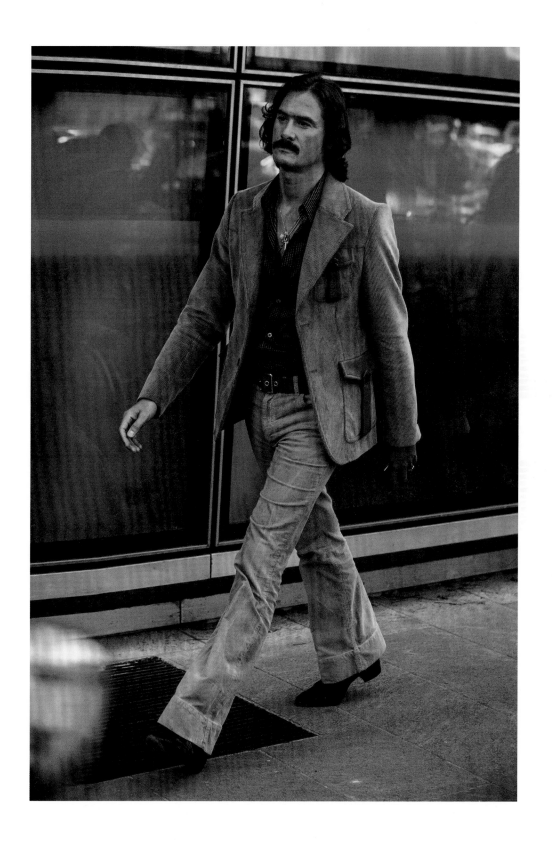

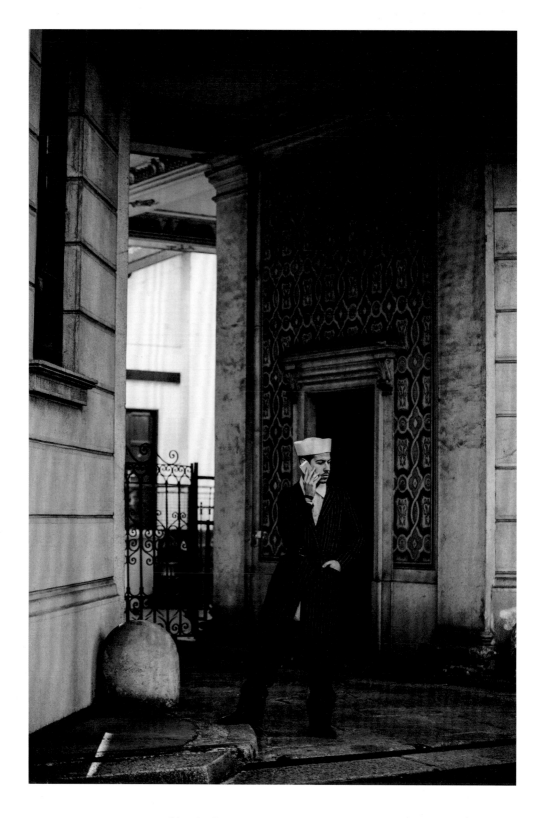

ABOVE - Mr Fabio Pittalis combines a vintage sailor's hat from Bivio
Milano with a pinstripe wrap suit from Cavalli e Nastri.

Via Piranesi

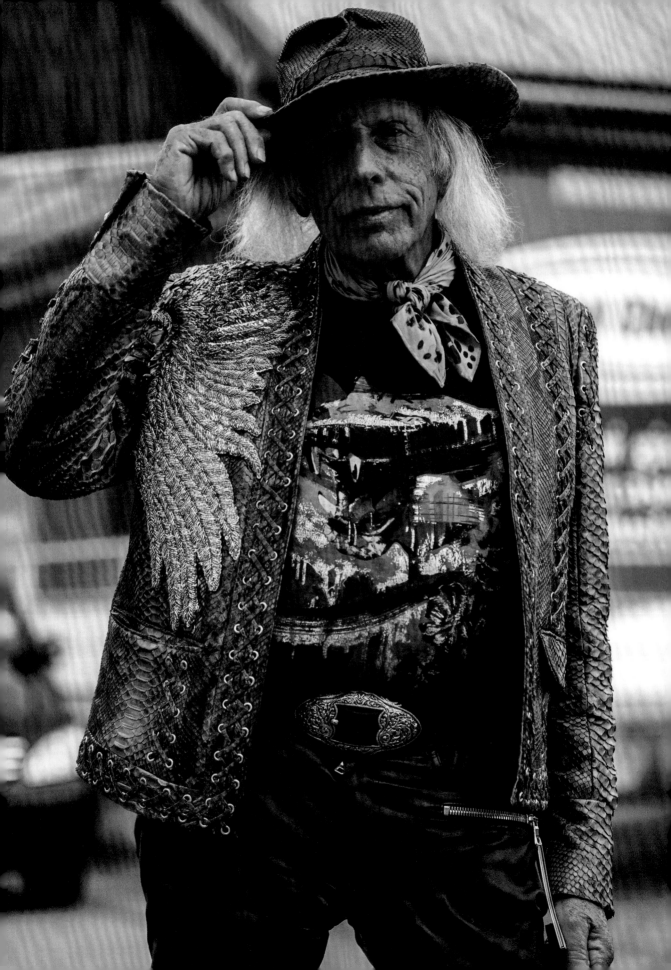

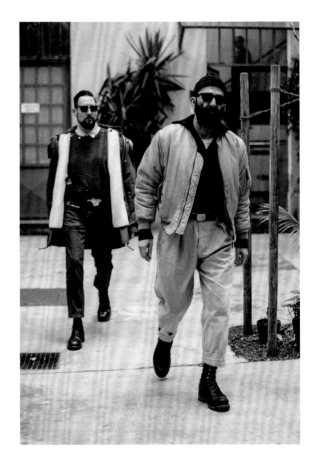

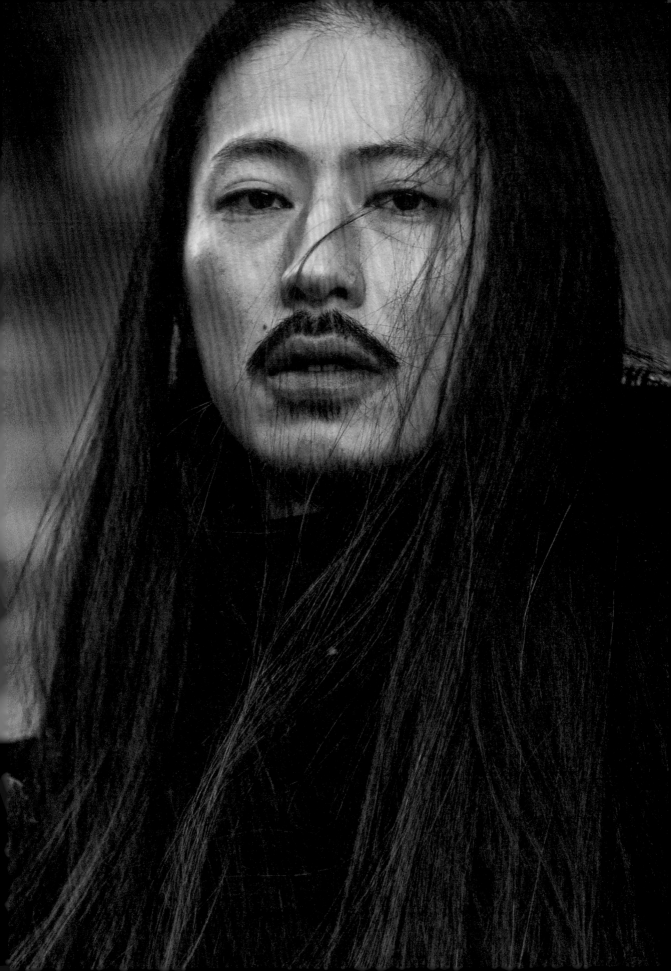

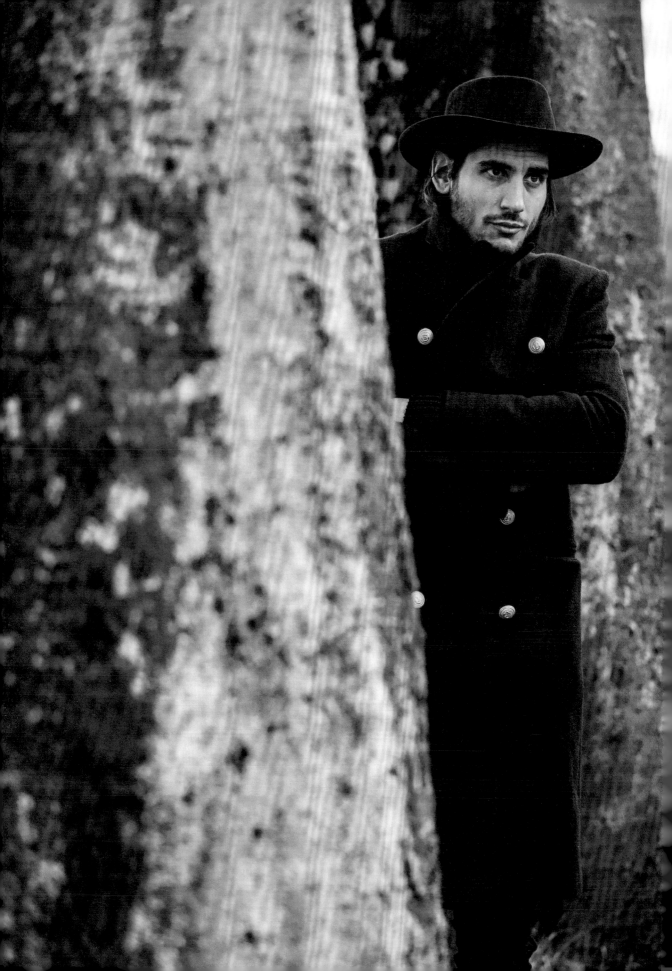

Mr Sergio Guardì

CREATIVE DIRECTOR OF BARBANERA

Sergio's apartment looks like a musician's studio. Guitars and tapestries line the walls, and records lie on the floor. Given that he is the creative director of a menswear brand, I found such an homage to music surprising. It quickly became clear, however, that for Sergio style and music go hand in hand: 'Jimi Hendrix is a style icon. His star will never fade. I feel the same about Johnny Cash. These men are the epitome of cool.'

We met on a cold Sunday morning. The air was damp, giving Sergio an excuse to dress up.

I love to layer shirts, jackets and scarves. Winter is the best season to showcase my clothing collection. I always thought I was born in the wrong century. Even though I'm very Italian, I feel like my biggest influence has been twentieth-century Americana. Hollywood actors like Gregory Peck and Montgomery Clift always looked impeccable. I even look to Western cowboys for styling tips.

This aesthetic is clear to see and one that seeps into his brand Barbanera – a mix of vintage American workwear and Italian fabrication that reflects his personality perfectly. Sergio co-owns the brand with his older brother, a man he credits with balancing his rock 'n' roll madness with classic Italian taste. As we walked through the quiet streets in the south of Milan, it became clear that family holds great importance for Sergio, and that his strongest familial memories are often linked to style.

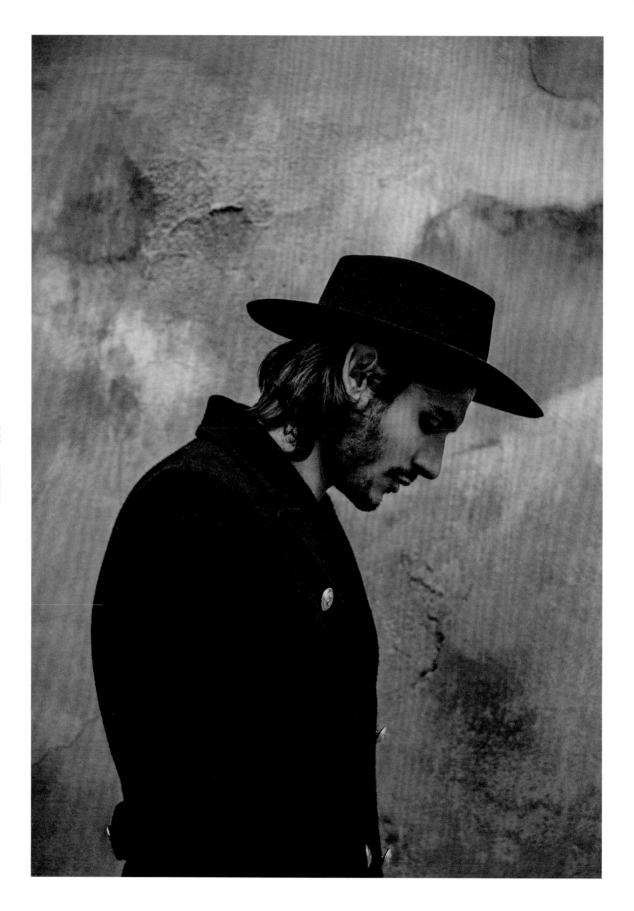

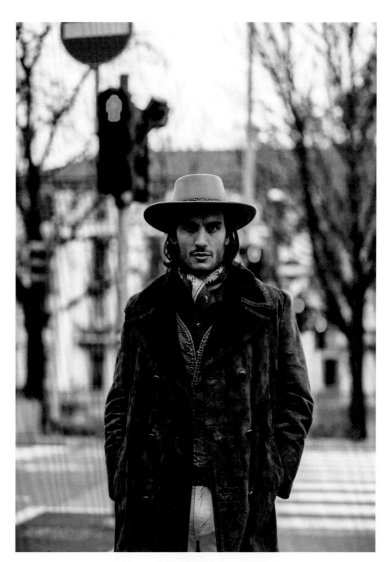

I may have lost my dad at a young age, but he influences me to this day. I remember watching him get dressed, head to toe in only black and grey. I remember he would buy clothes and cut off the labels of these great brands. For him, it wasn't about designer labels – it was about creating a uniform of quality design. At that time, I couldn't understand, but I do now. I grew up with a big sense of the past in my life, making me nostalgic in many ways. This has informed me as an adult. I would choose a 1965 Mustang Fastback before a new Ferrari any day.

Sergio's Italian heritage is evident in his warmth and expressive conversation. When asked about style, he gave a passionate response: 'Clothing is very important. Clothing tells people who you are and helps to make you feel good. When you're not sleeping or making love, you're wearing clothes.'

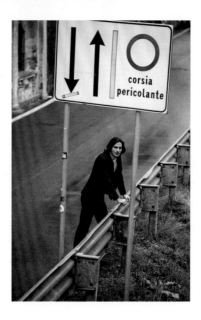

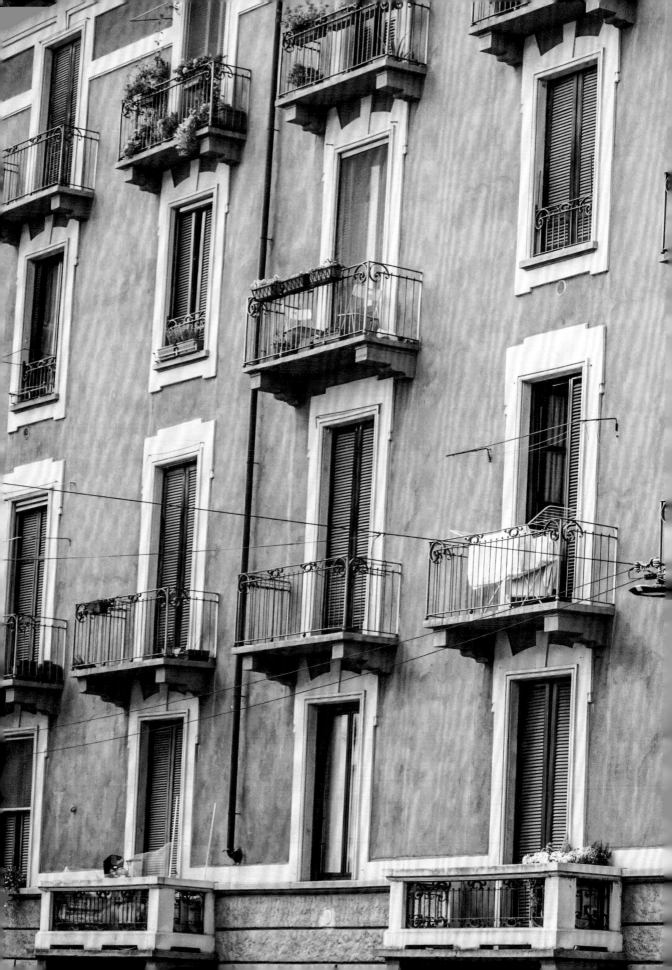

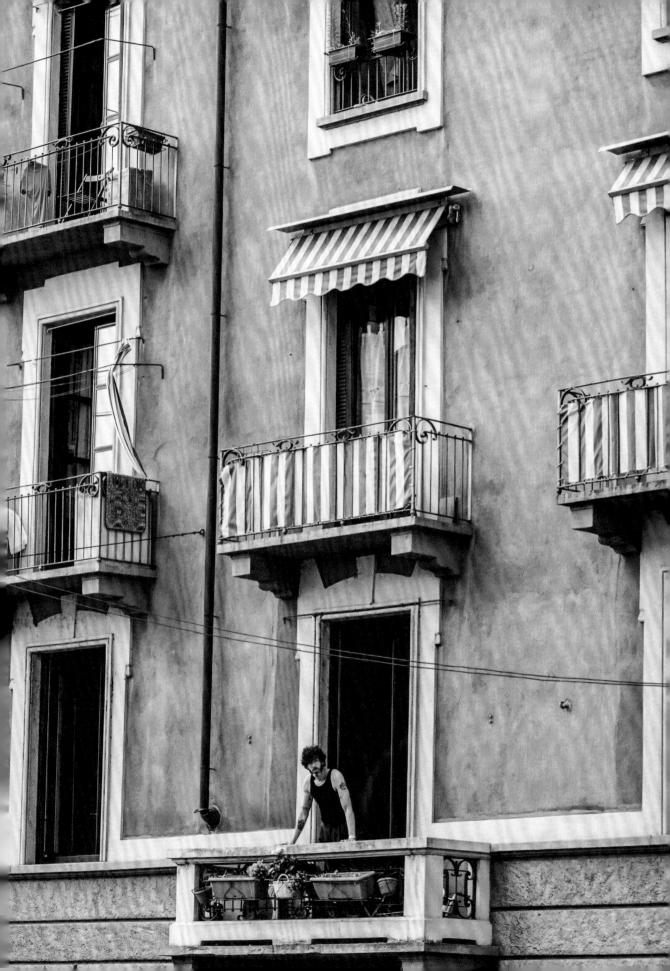

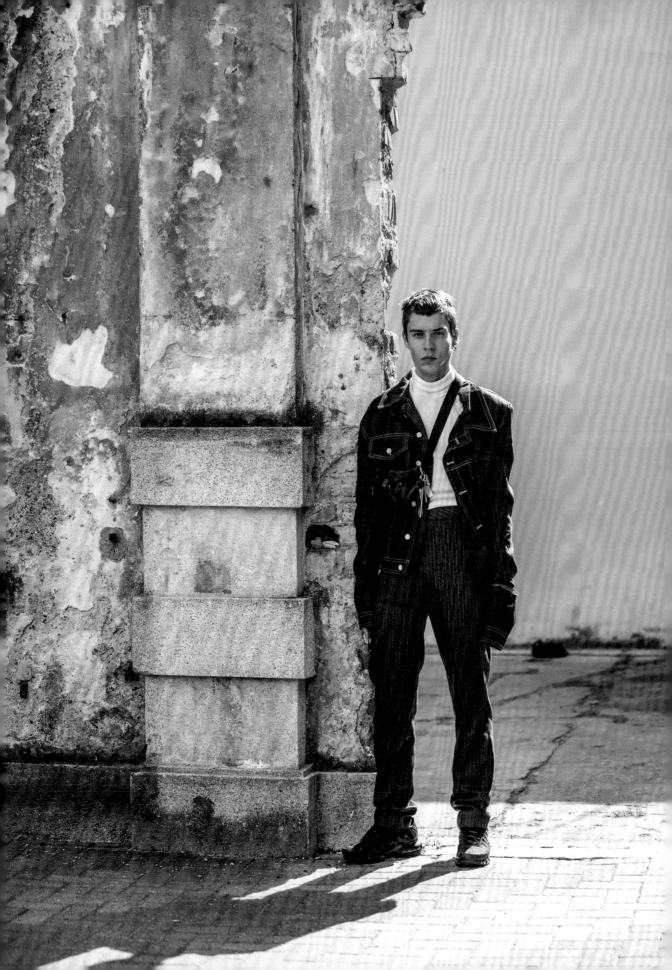

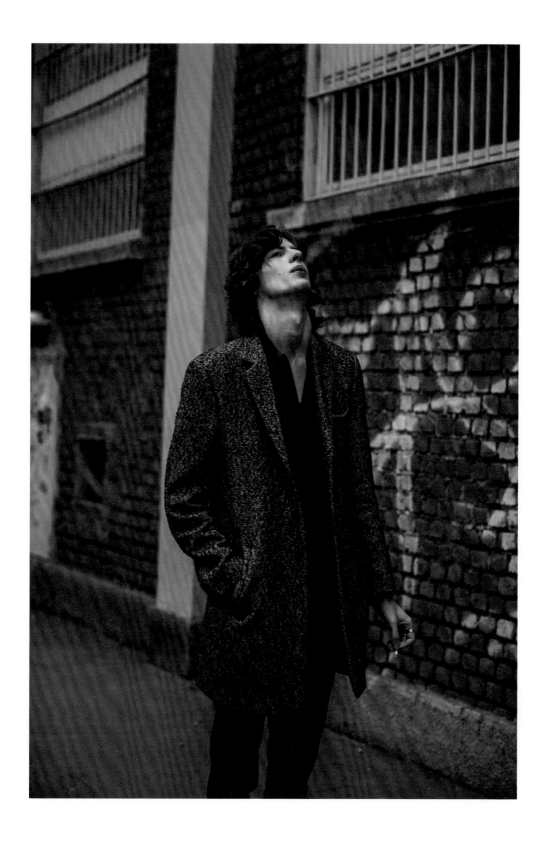

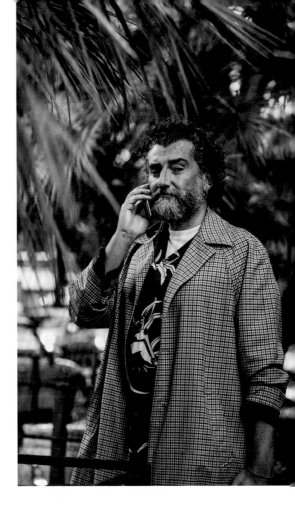

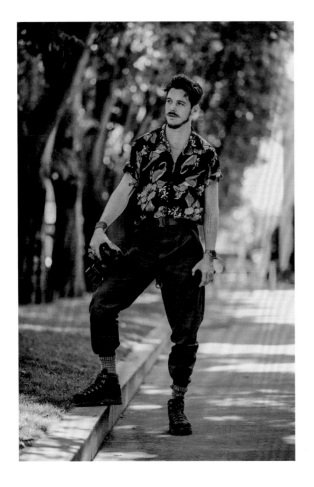

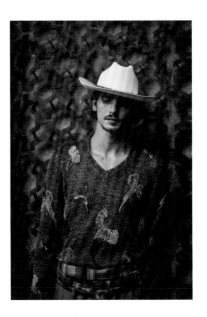

OPPOSITE - **Mr Simone Monguzzi** pairs a shirt by Prada with tailored trousers by Umit Benan.

Via Sant'Eufemia

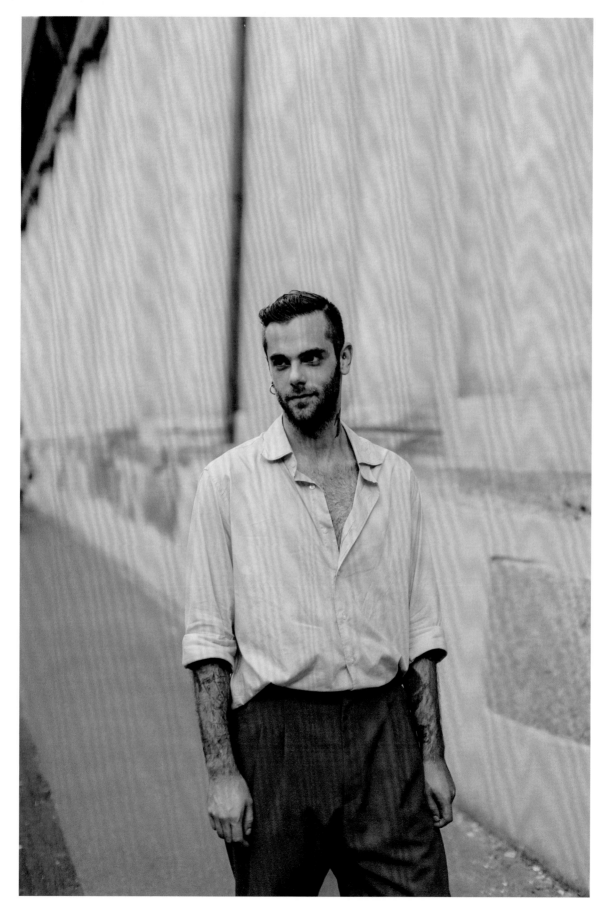

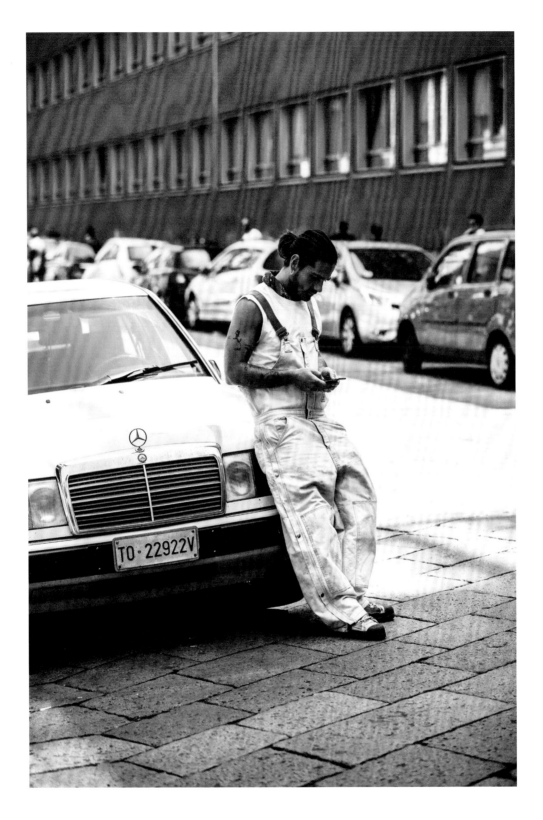

ABOVE - Mr Giotto Calendoli combines overalls from Carhartt, shoes
by Acne Studios and his girlfriend's vintage bandana.

Via Tortona

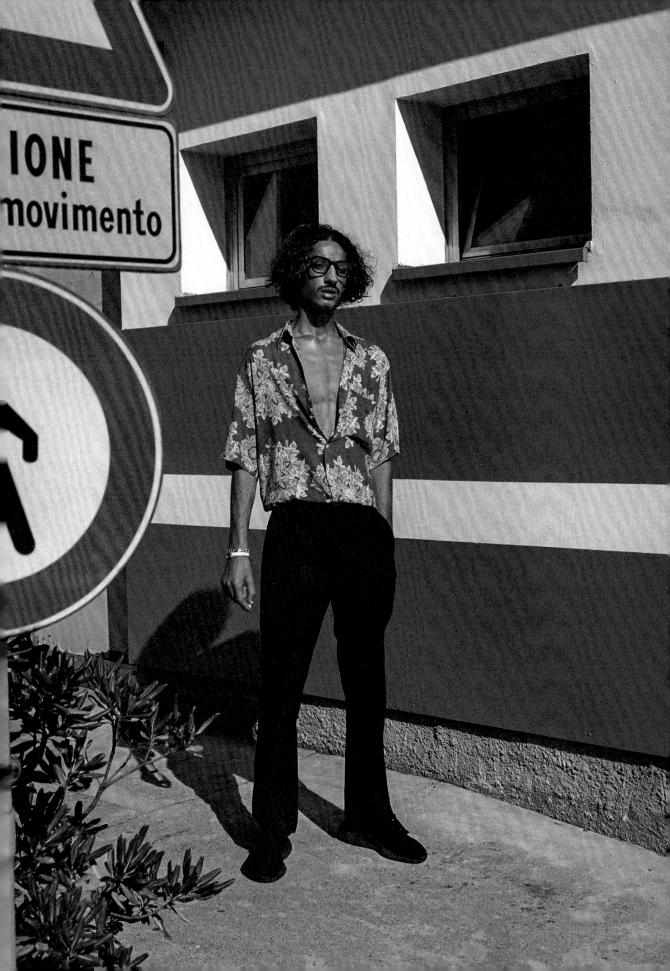

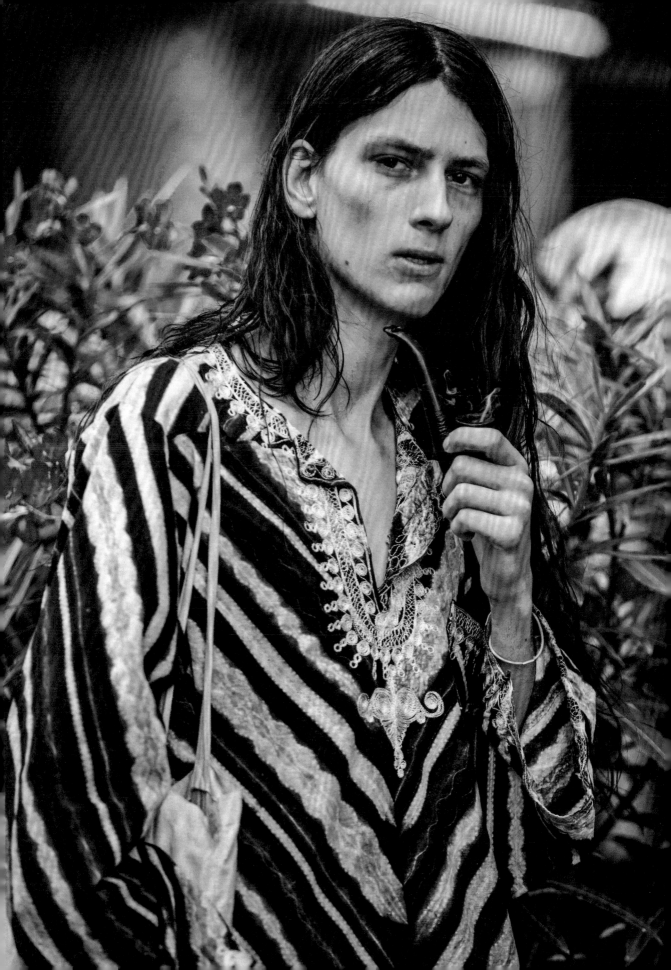

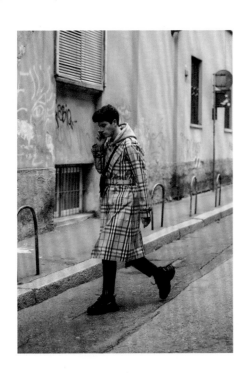

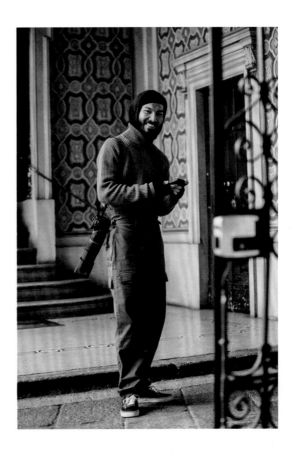

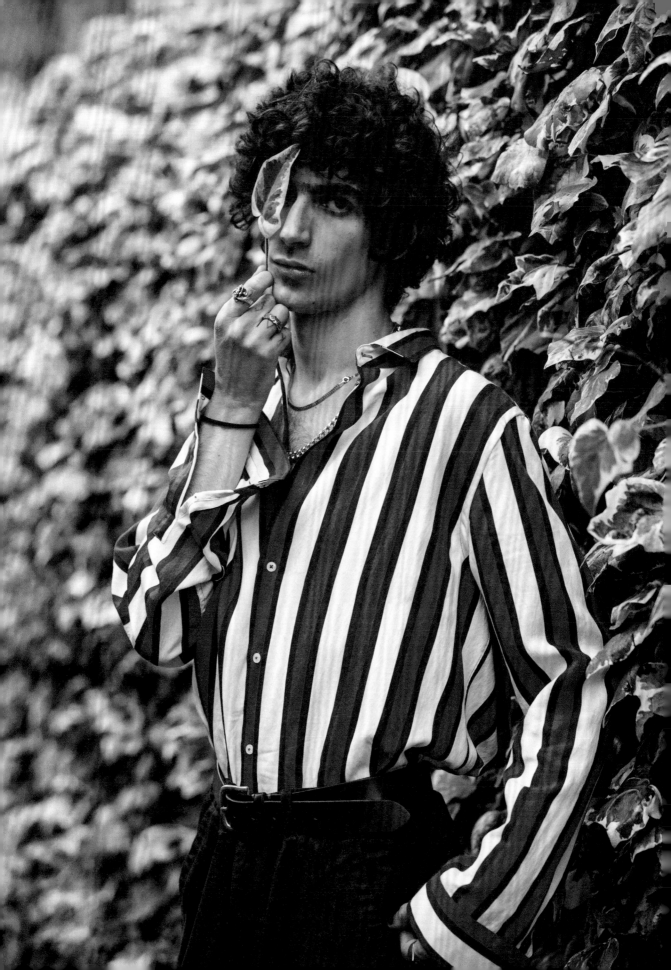

Mr Francesco Neri

ARTIST

Ask Francesco Neri to describe himself and he doesn't drop a beat: 'I'm eccentric, eclectic and rebellious.' Born in Sicily, with a childhood spent in Florence, he now lives in Milan – Italian through and through. I first met him in Florence at a fashion show. I noticed a statuesque young man with striking features: thick eyebrows and even thicker sideburns. His appearance gave him an air of authority which did not match a man just out of his teen years. He wore basic blue jeans and managed to make them look simultaneously retro and contemporary. He was leaning against the wall and laughing with a group of young men holding skateboards as I approached to take a photograph. We got talking about his family in Florence and his career aspirations as an artist. When we arranged to meet again in Milan a few months later, the sideburns were gone but his wild personality was as present as ever.

I dress however I feel. One time I went to a party in a woman's dress, which was refreshing. Clothes shouldn't be there to create your personality – that should come from within.

We spent an afternoon together in a trendy, residential area of the city. Francesco wore a bold red-and-white striped shirt from

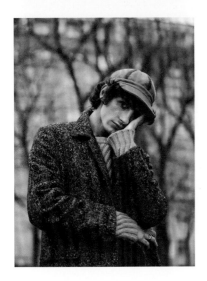

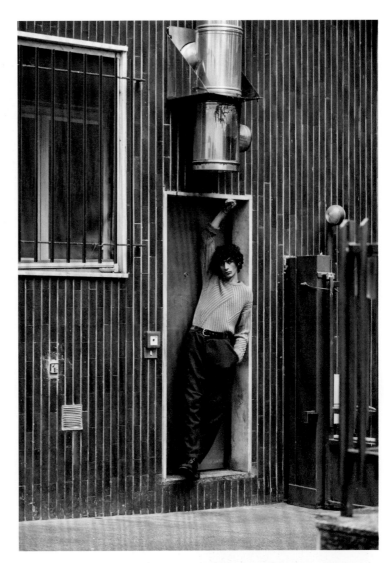

Vivienne Westwood and paired it with navy-blue oversized Margaret Howell trousers. Two very British brands on a very Italian man. A delivery truck pulled up beside us and a man began to off-load fruit. 'Do you have any money? I'll get us a box of strawberries.'

By dusk, Francesco had made friends with every dog-walker and shop-keeper on the block. Gesticulating and laughing as we went, he told me his biggest self-realization: 'Never care about what other people say. Your opinion of me is none of my business.'

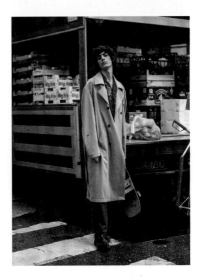

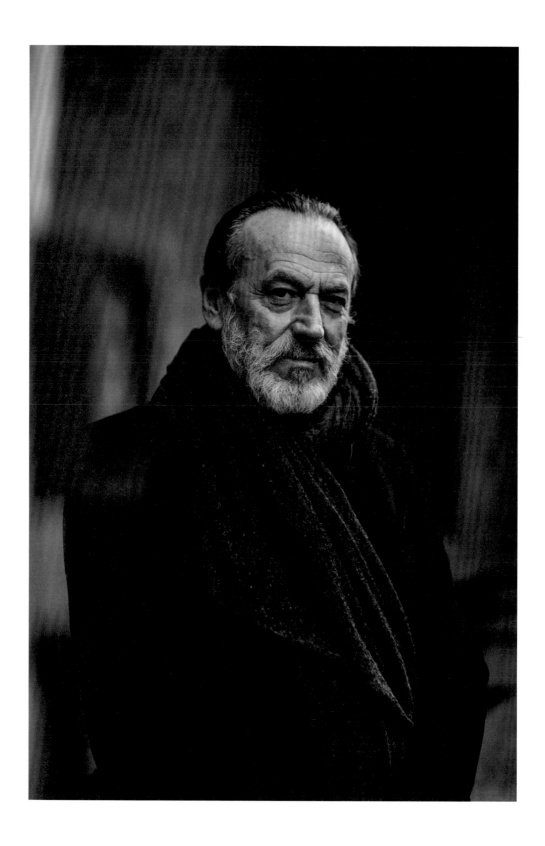

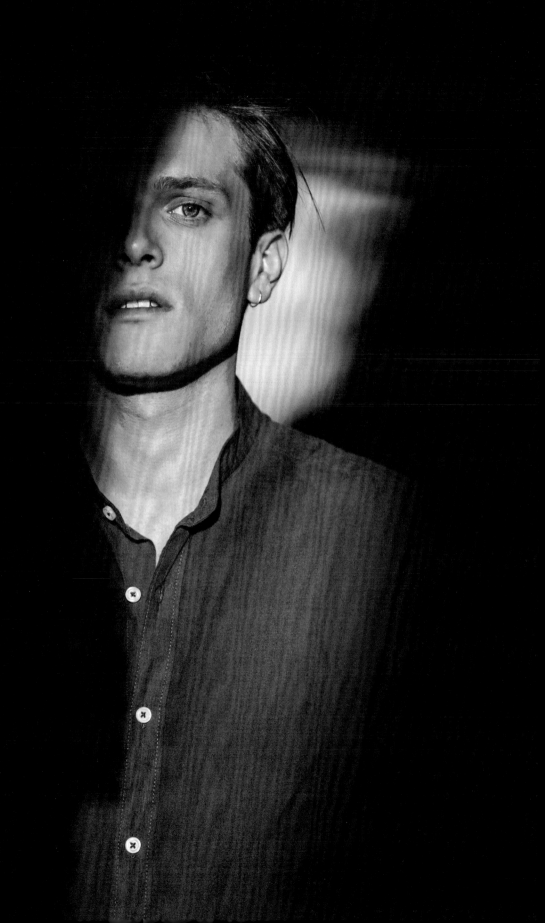

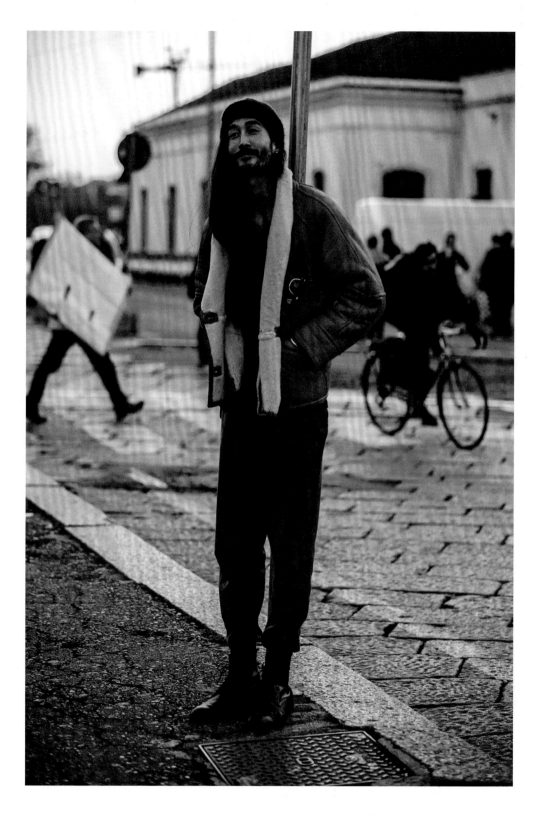

ABOVE - Mr Tony Thornburg bought this vintage sheepskin shearling jacket for €10 at Barbar Vintage in Zurich, Switzerland. He wears it here with Chanel women's trousers from the 1990s.

Porta Genova

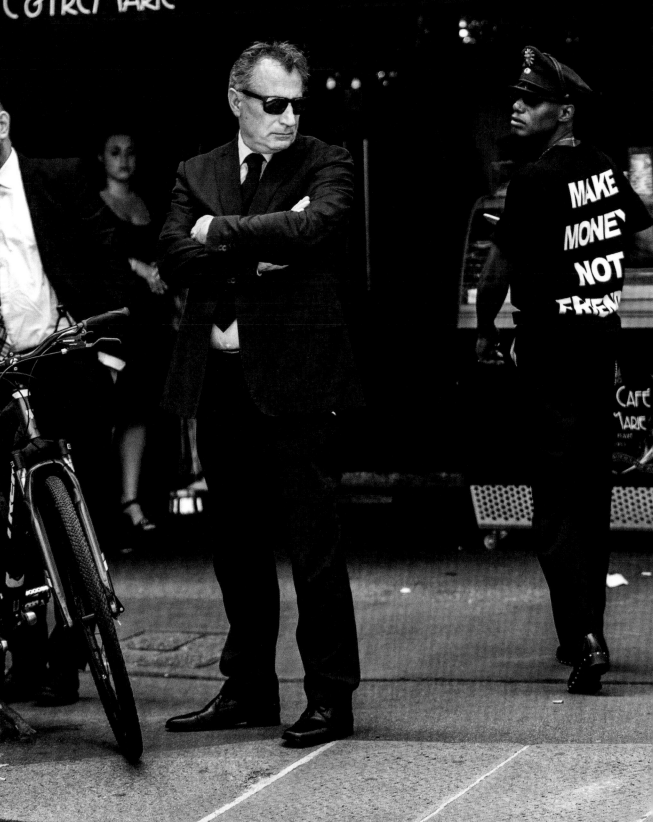

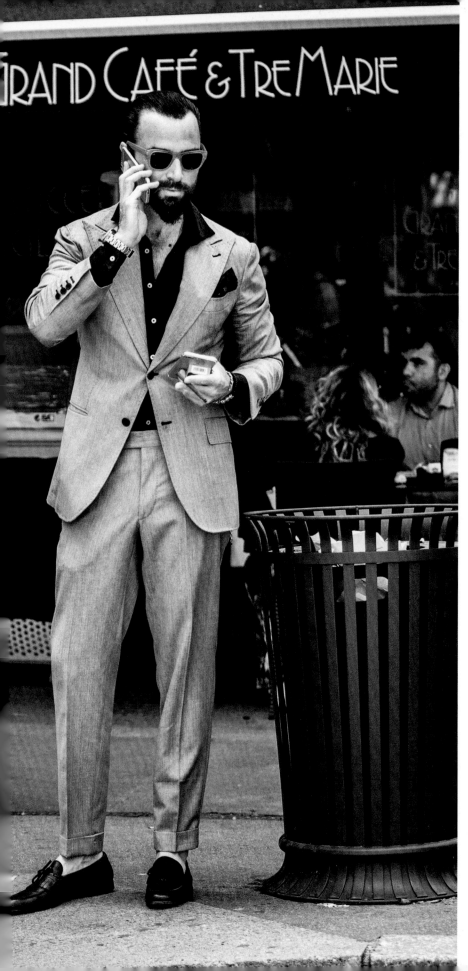

Mr Yoanne Mobengo is photographed in a T-shirt from Make Money Not Friends, while Mr Fadi Koteiche wears a bespoke suit by Gant Blanc 1959.

Via Carlo Farini

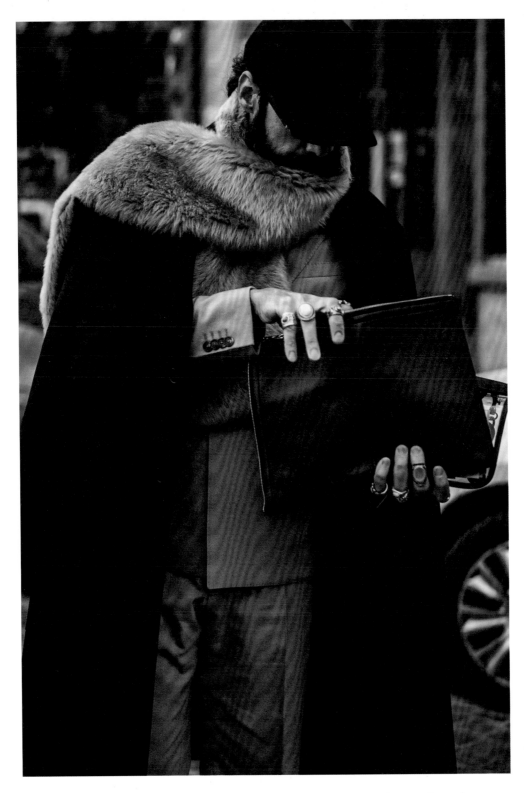

ABOVE - Mr Graziano Di Cintio in a suit by Hugo Boss, overcoat by Lemaire and
his grandmother's fur scarf. Graziano is prone to losing small items so buys
all his rings from street markets, never paying more than €5 for them.

Foro Buonaparte

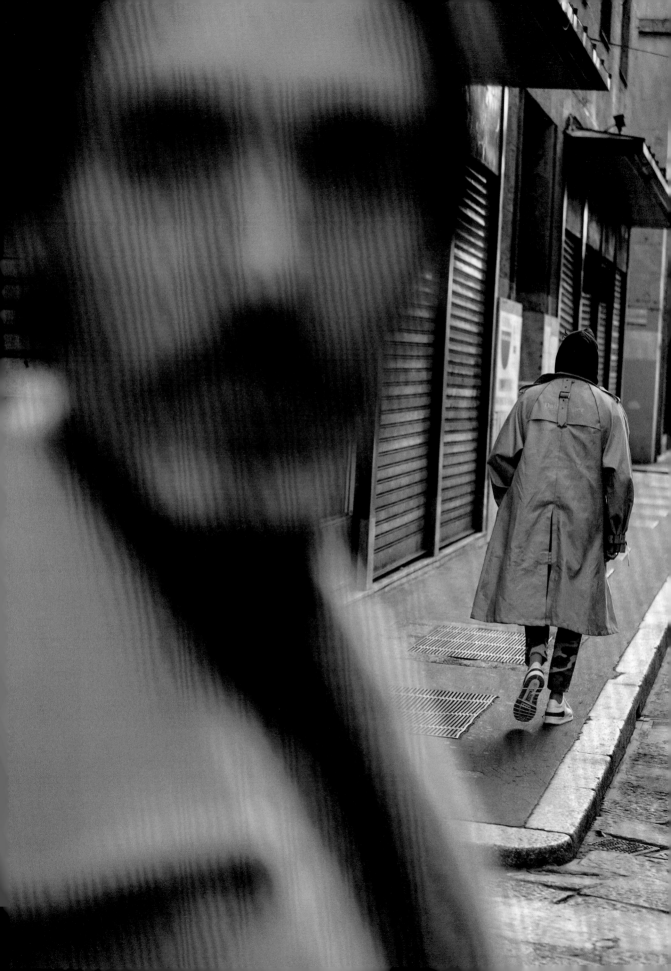

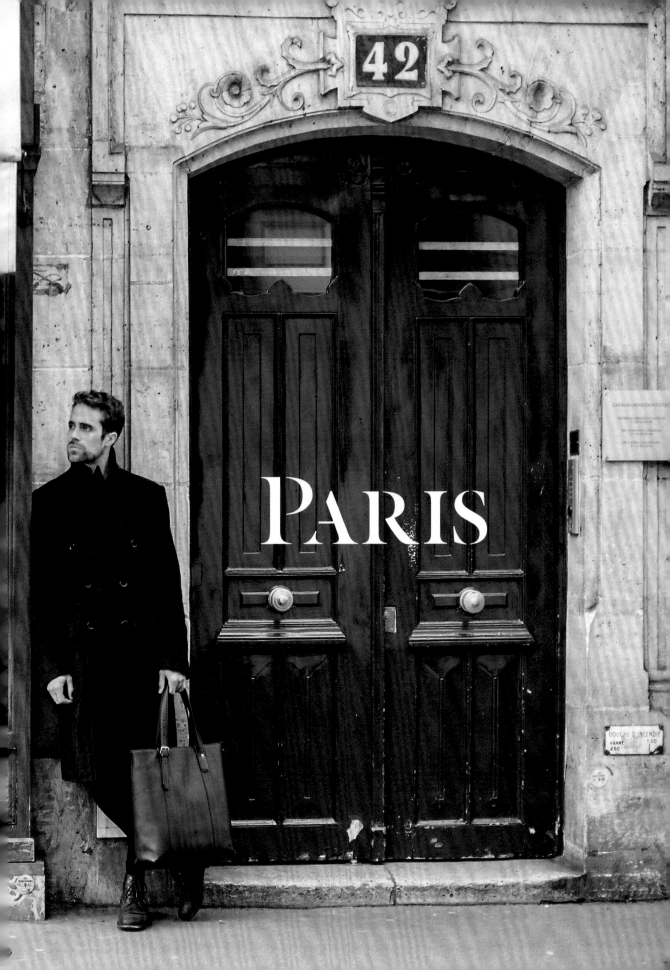

'Paris is grand in all regards. Where some cities are beautiful in appearance only and have a soft interior, Paris gives us picturesque while remaining haughty and hard. Paris provides the perfect daily life.'

Giovanni Dario Laudicina
Fashion editor at *Vogue Hommes*
and Paris resident for three years

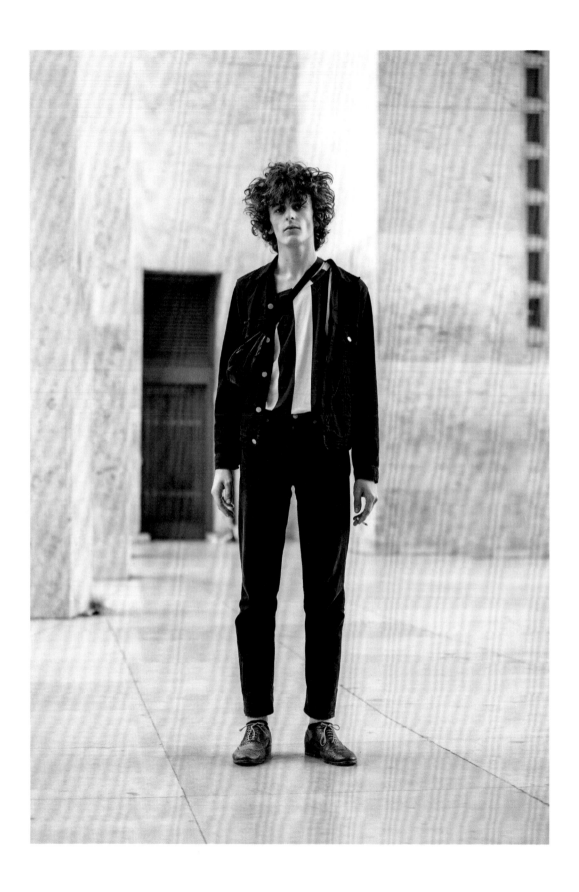

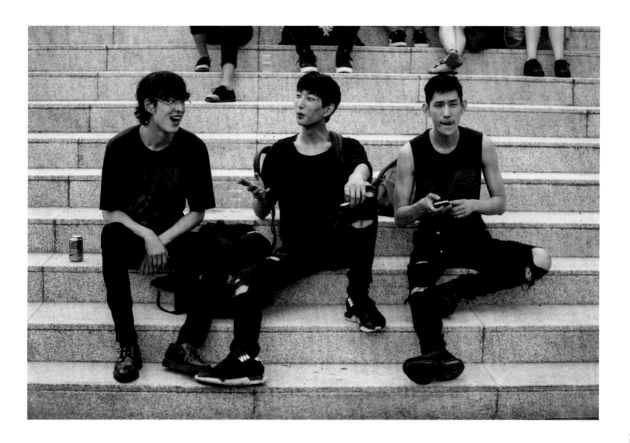

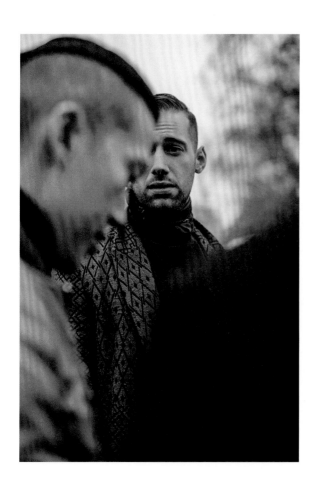

LEFT - Mr Julien Decanali attends a fashion show wearing a coat and sweatshirt by Haider Ackermann.

Quai de Montebello

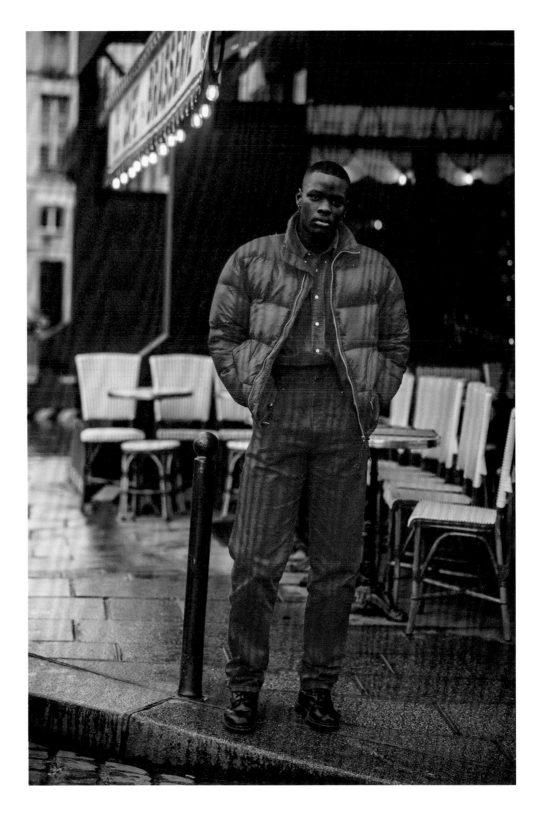

Mr Almamy Sall, a fashion student, wears a vintage Tommy Hilfiger jacket from the 1990s with Wrangler trousers. It took him six months to find both pieces in his favourite shade of red.

Quai Malaquais

Model Mr Dan Stewart leaves the Dior Homme show in a Dior T-shirt.

Avenue Félix d'Hérelle

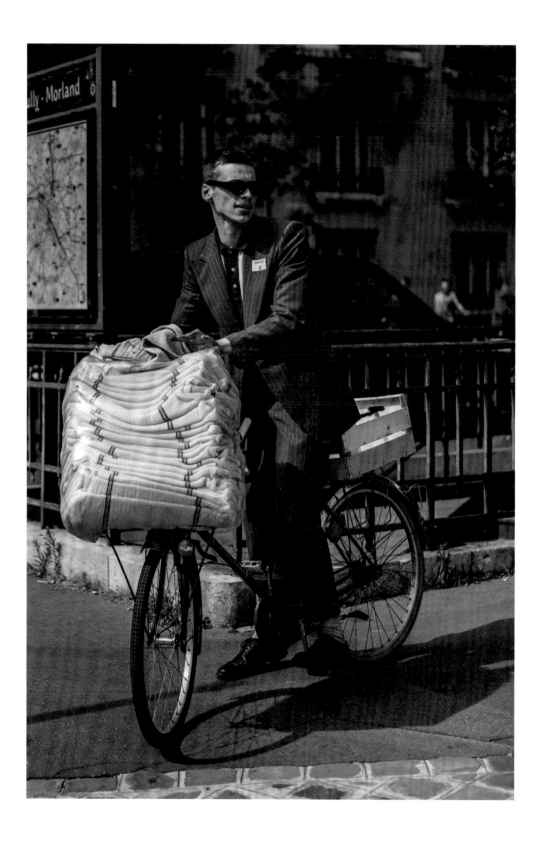

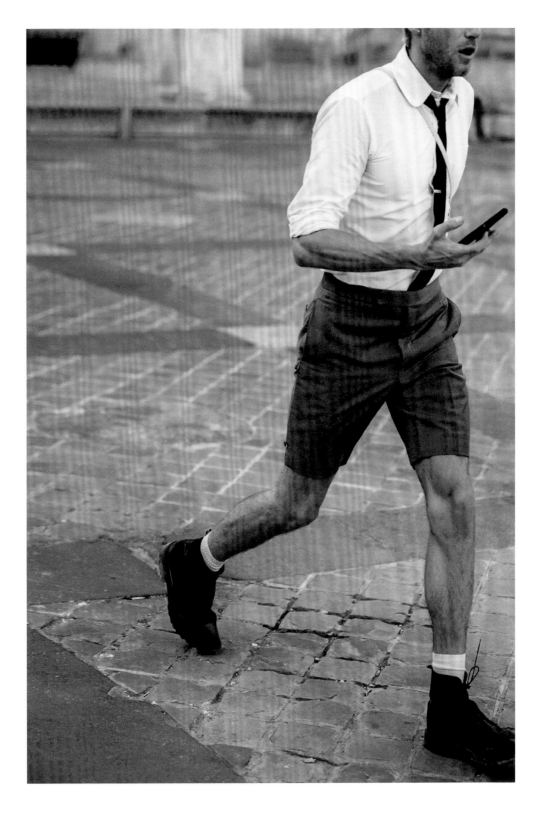

ABOVE - Mr Matthew Foley leaves the Thom Browne show at
École nationale supérieure des beaux-arts.

Rue Bonaparte

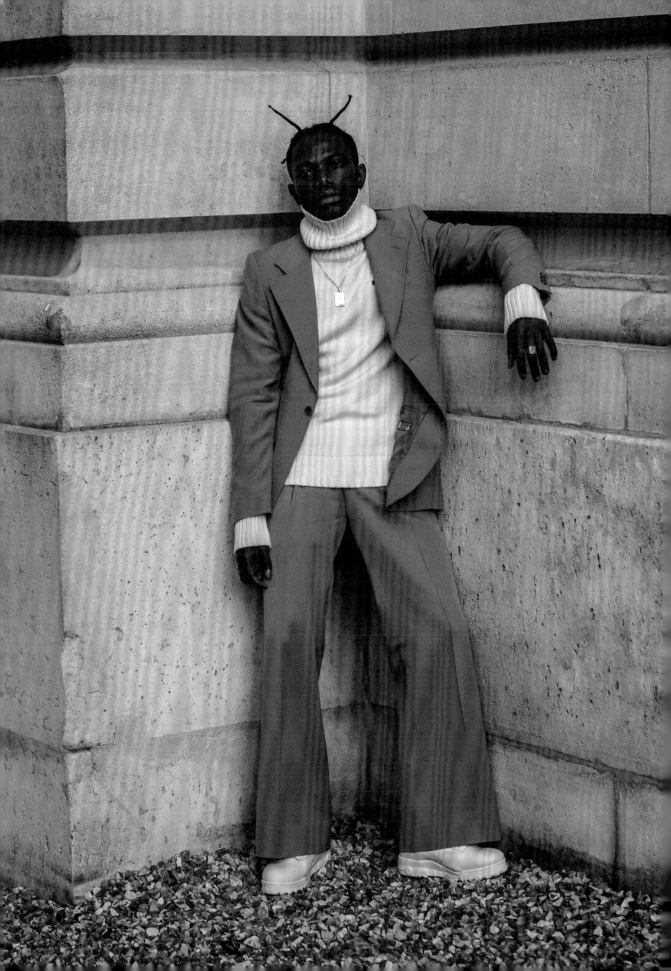

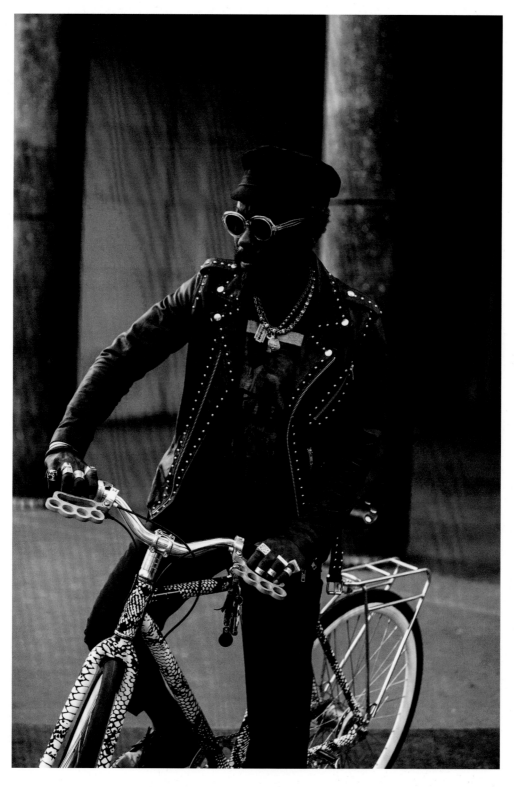

ABOVE - Mr Sam Lambert designed this bike for the project Fuck Cars, Ride Bikes. He wears a leather T-shirt by Avec Ces Frères and sunglasses he designed for Art Comes First in collaboration with Oliver Goldsmith.

Rue Cambon

Mr Edward Siddons

WRITER

Edward Siddons has a sharp wit. It makes sense for a socially and politically motivated writer to have pithy opinions, but Edward presents his with warmth and humour. Whether covering stories on LGBTQ refugees for the *Observer*, reporting from the UN conferences in Stockholm or documenting his struggles as a young male model in the fashion industry, it's obvious that style is secondary to substance for Mr Siddons. Lucky for him, then, that he's the sort of man who looks great in almost anything, with a confident, modest style and also a strong sense of self.

Given his intellectual focus, it's not surprising that Edward considers clothing to be important, a projection of who you are. He explained: 'Clothes are legible objects. Whether you like it or not, your class, gender, politics, aspirations are all read through what you wear, and society treats you accordingly.'

Edward's sartorial message is one of clarity and strength. With a rough-around-the-edges overcoat, he looks powerful but nonchalant, like an academic from the 1950s. I asked how he described his taste.

Minimalist. Dressing is a question of silhouette rather than colour. I nearly always wear only black. A black uniform has meant different things to me at different times. First it acted as a carapace in my early 20s, when I was unsure of myself. Next, it became an expression of my politics – a blank rejection of brand and logo and colour and trend.

Paris to me is an intellectual's playground, a place where ideas are formed, contradicted and re-considered. It seemed fitting, therefore, to shoot Edward on the Left Bank, even more so after he revealed who inspires him.

Virginia Woolf and Judith Butler are probably my most important academic influences, but novelists like James Baldwin and Alan Hollinghurst probably mean more to me. Reading these authors helped me to work out who I was. It gave a context to feelings about my own sexuality. Plus, [Baldwin's] Giovanni's Room was given to me by my first boyfriend. It was a dog-eared second-hand copy that I'll always cherish.

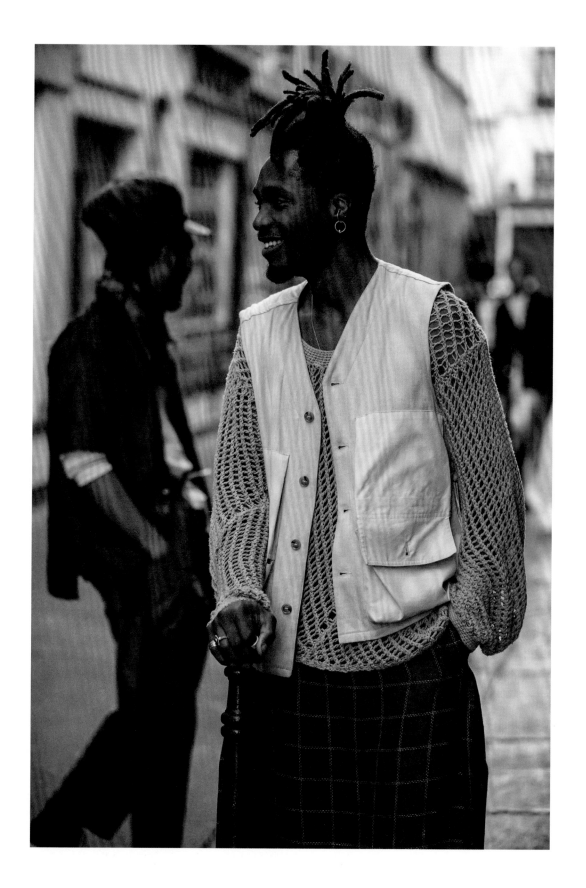

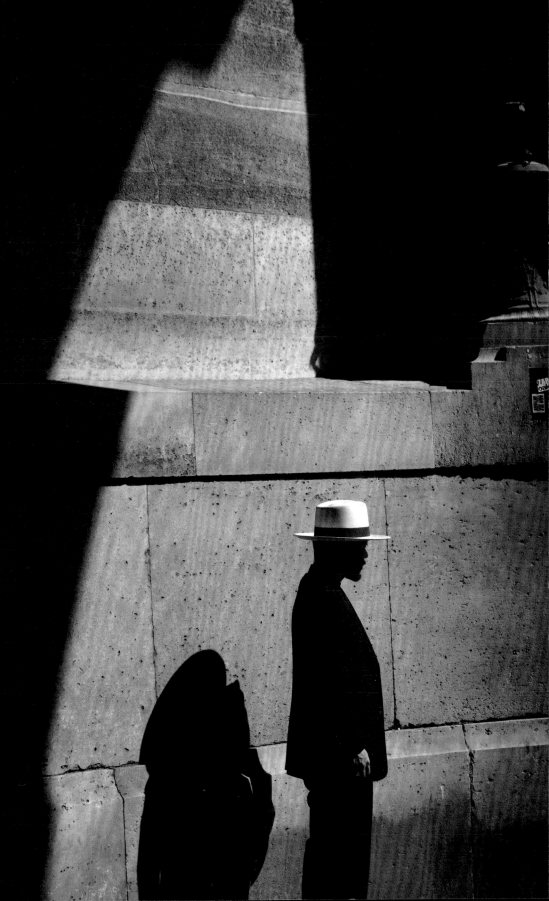

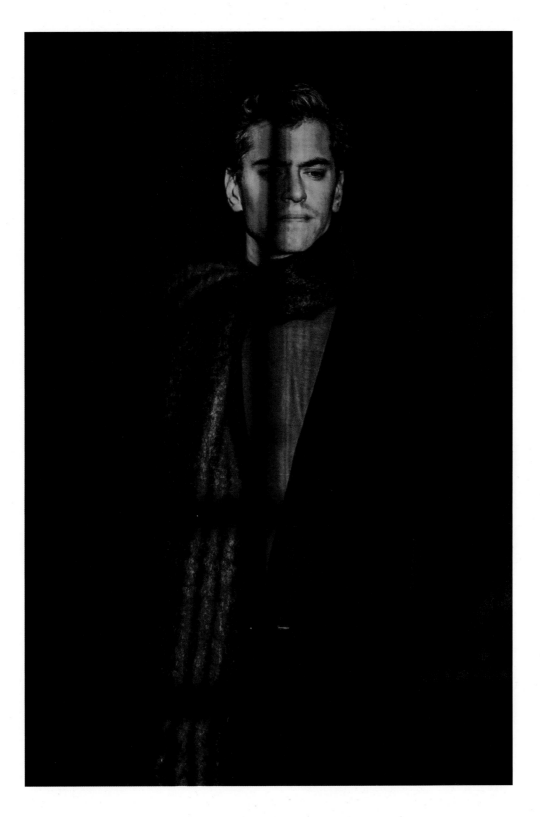

ABOVE - Mr Andrew Barker enswathed in a scarf
designed by Jonathan Anderson for Loewe.

Rue de Rivoli

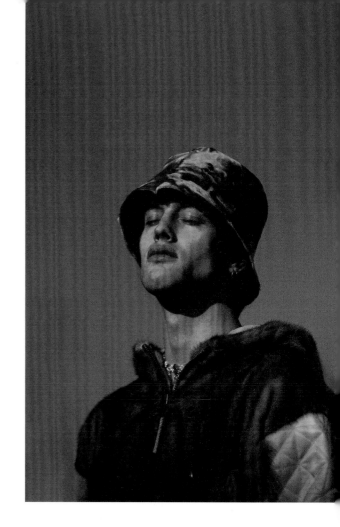

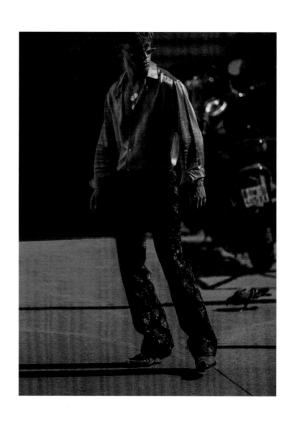

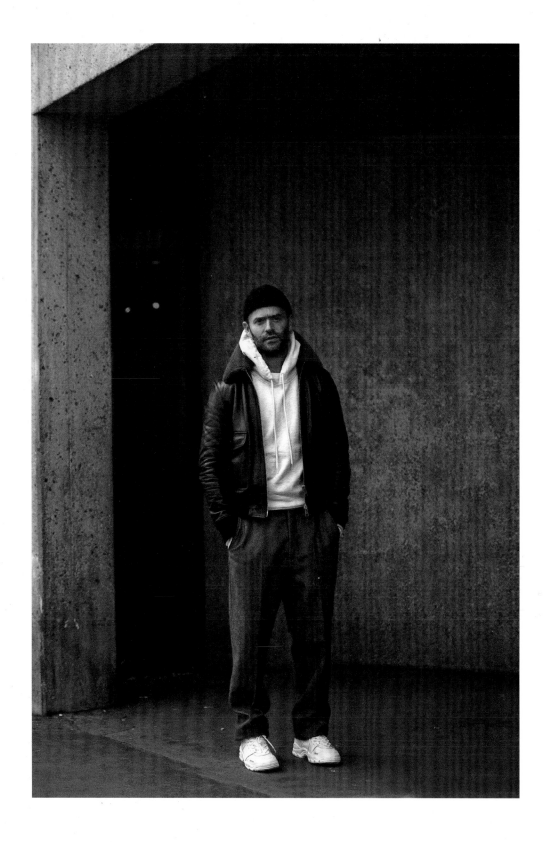

ABOVE - Designer Mr Alexandre Mattiussi wears pieces from his brand, AMI.

Rue de Turenne

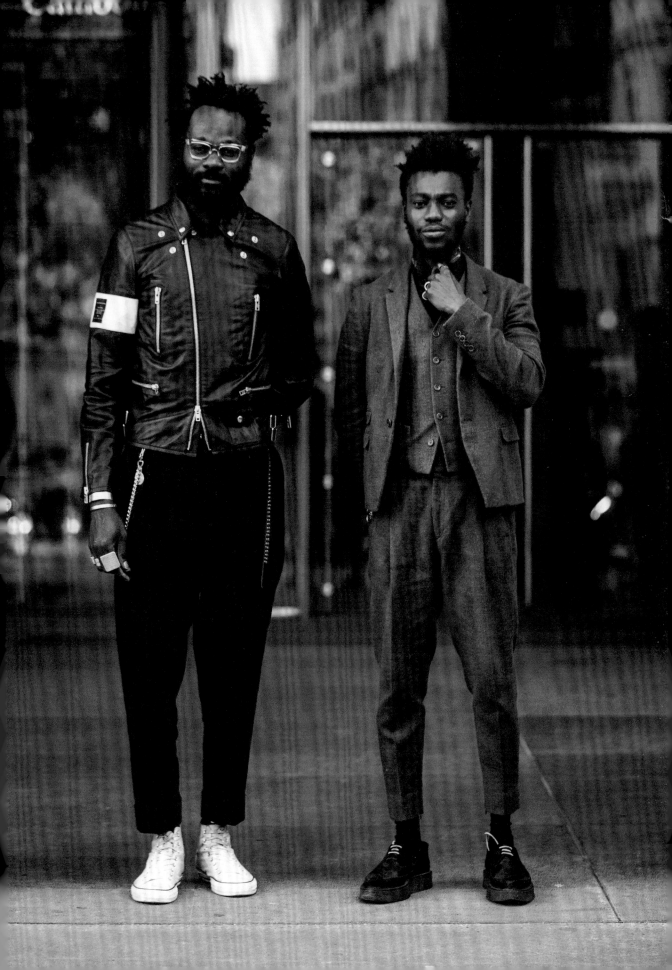

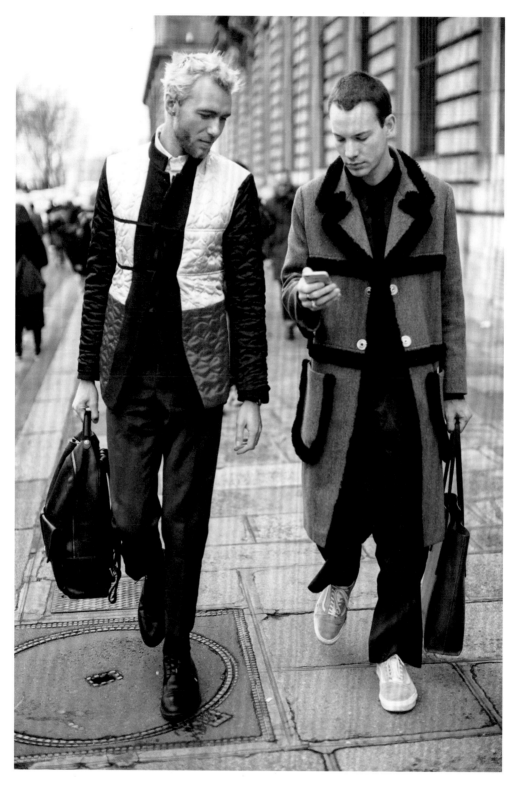

OPPOSITE - Mr Shaquille-Aaron Keith wears an AMI sweater under vintage dungarees he found in FREE'P'STAR, Paris. Shaquille bought his razor necklace on a trip to LA with his best friend, Dexter, who got an identical one to signify their friendship.

Rue La Fayette

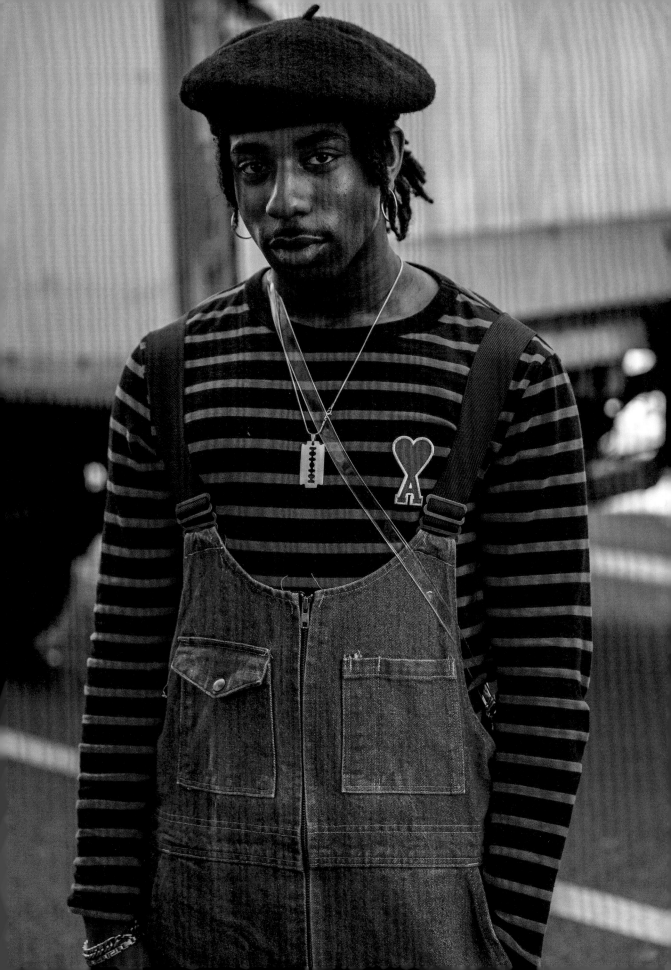

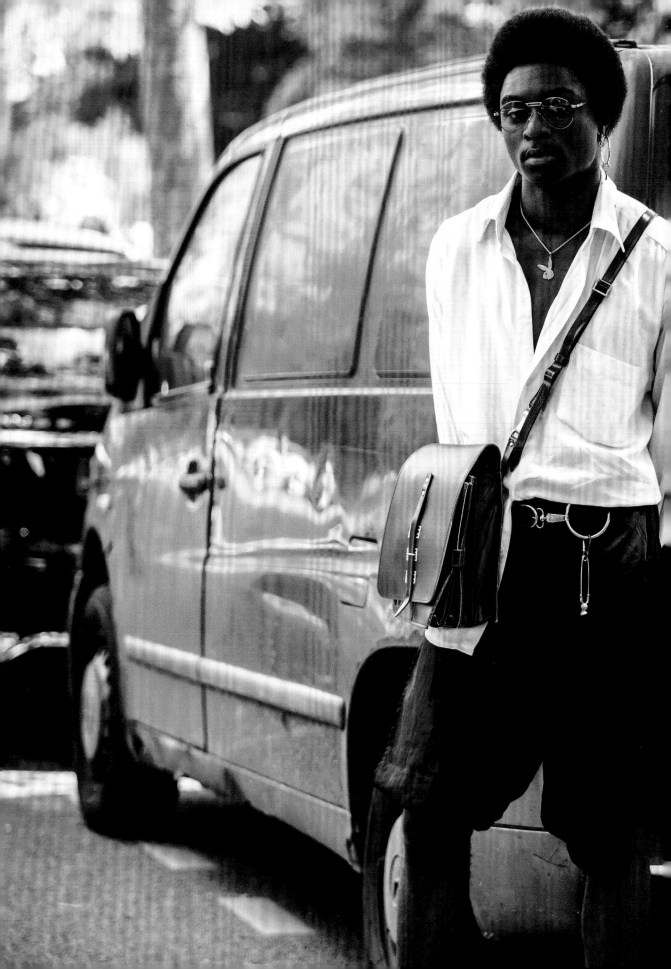

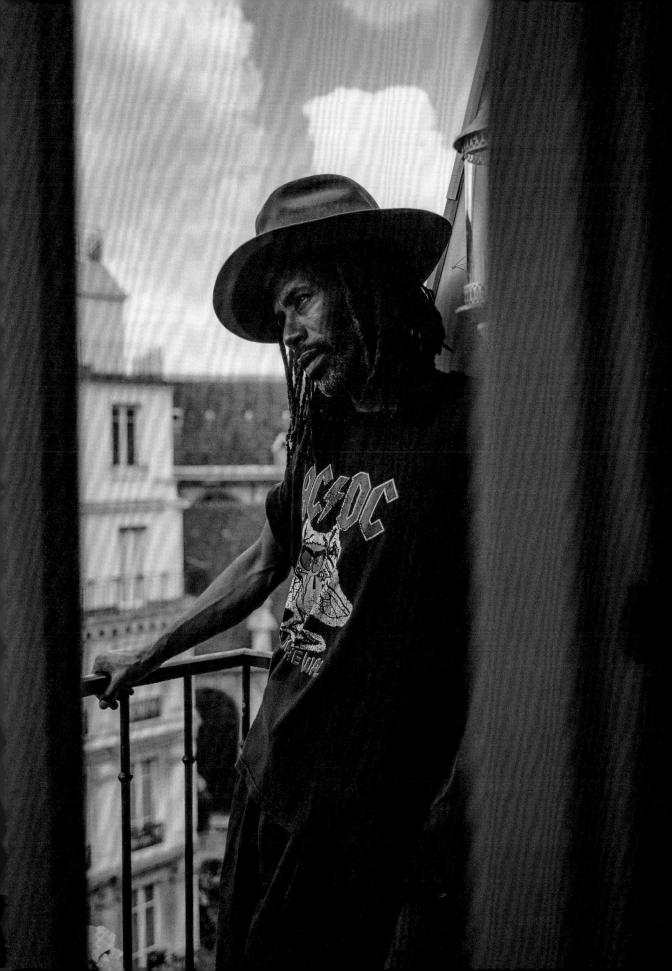

Mr Izé Teixeira

MUSICIAN

The contrast between life on Cape Verde and in France is sharp. Santiago Island may seem far removed from the City of Light, but meeting Izé Teixeira in Paris, I can hardly imagine him in any other setting. Izé himself thanks music for this connection.

I idolize Serge Gainsbourg. He's a man who loves words. The richness of the French language means you can say a lot of things with only a few words. Today, with a cigarette in my mouth, I feel at home, I understand what he used to live.

Izé has a fluidity to his charm that I recognize in French culture. His words are like poetry and his clothing appears to be mostly Parisian vintage. Looking through his wardrobe, I found a nineteenth-century deeply faded blue worker's jacket. Beside this hung a pale-green striped silk shirt from the 1930s. This historic inflection makes sense because, for many years, Izé ran a vintage boutique in the attic of one of Paris's coolest hang-out spots. With an old barber chair in the corner and a single window flooding one end with light, it felt like a mysterious cavern filled with gold.

I have two men who inspire me stylistically: Bob Marley for his message and [Jean-Michel] Basquiat for his imagination. My wardrobe perfectly reflects my musical style, but it's people in the street who influence me the most. I walk everywhere with music in my ears. Eyes and ears fully open.

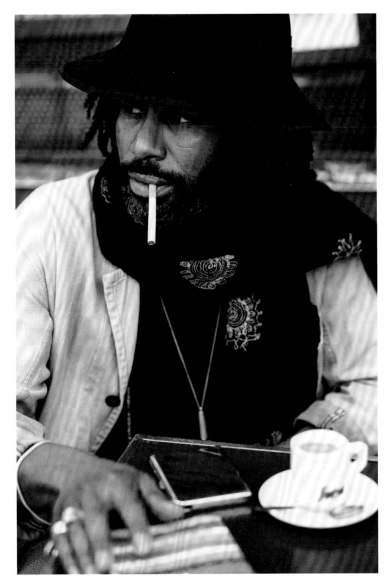

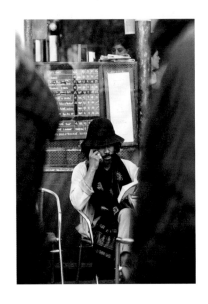

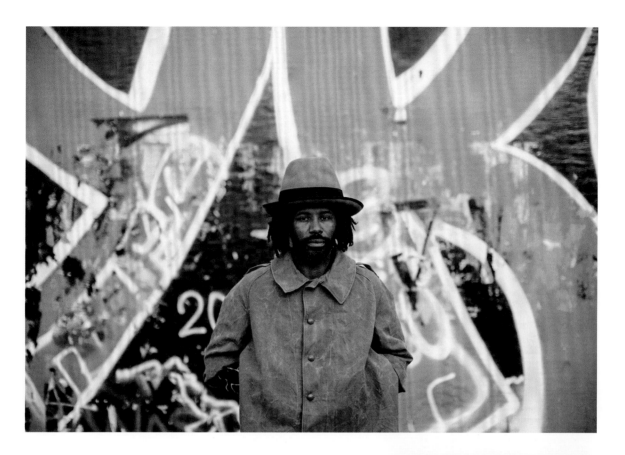

Over the years of knowing Izé, I have watched him juggle the worlds of clothing and music with a perfect balance.

It's important for me to mix the two worlds, as one informs the other. This is a case of two plus two equals five. You can see it in everything I do. They're now inseparable.

I'm grateful to do this work. As a child I always wanted to be a singer. I would wake up every morning in Cape Verde at my grandparents' place and go out to the fields to harvest maize. This time taught me that being simply lucky doesn't exist. You have to put hard work in to see the results you desire.

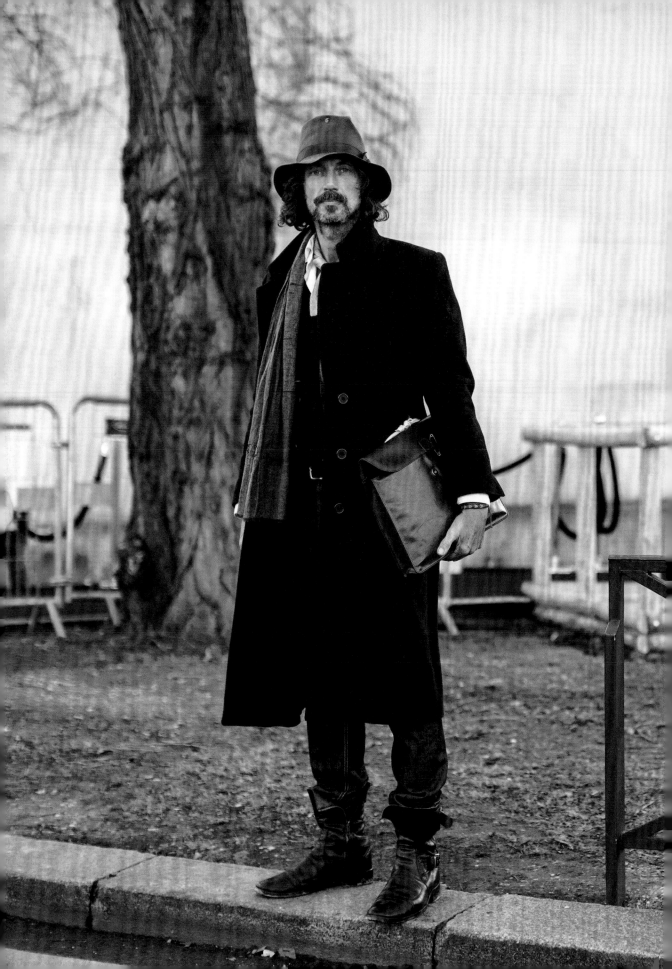

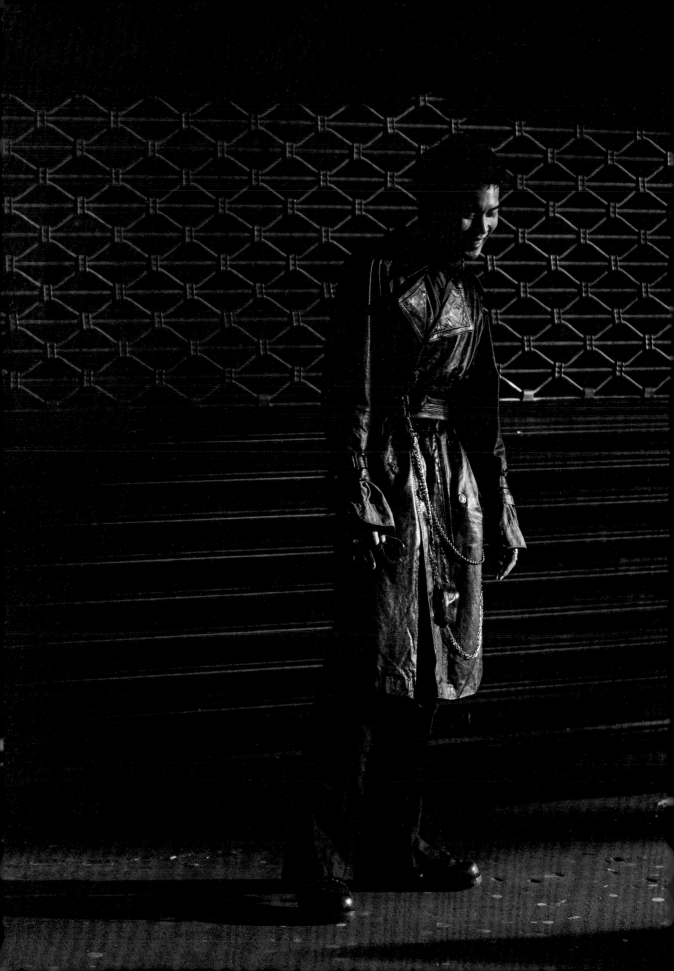

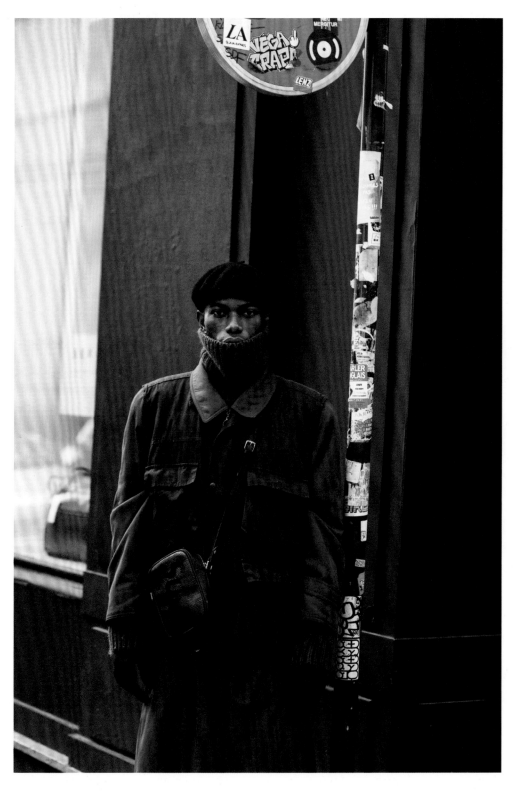

ABOVE - Mr Christ Gomat's coat was a family affair: he designed it,
then his grandmother cut and sewed it together. His bag was created
in a collaboration between Supreme and Louis Vuitton.

Rue Meslay

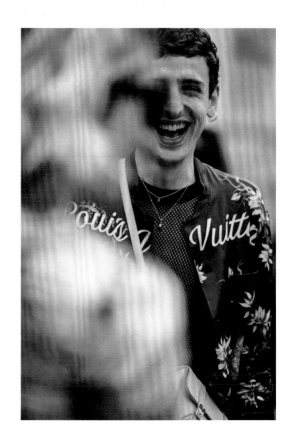

OPPOSITE - Mr Antonio Vattev found this vintage Burberry trench in Rokit Vintage, London.

Avenue Montaigne

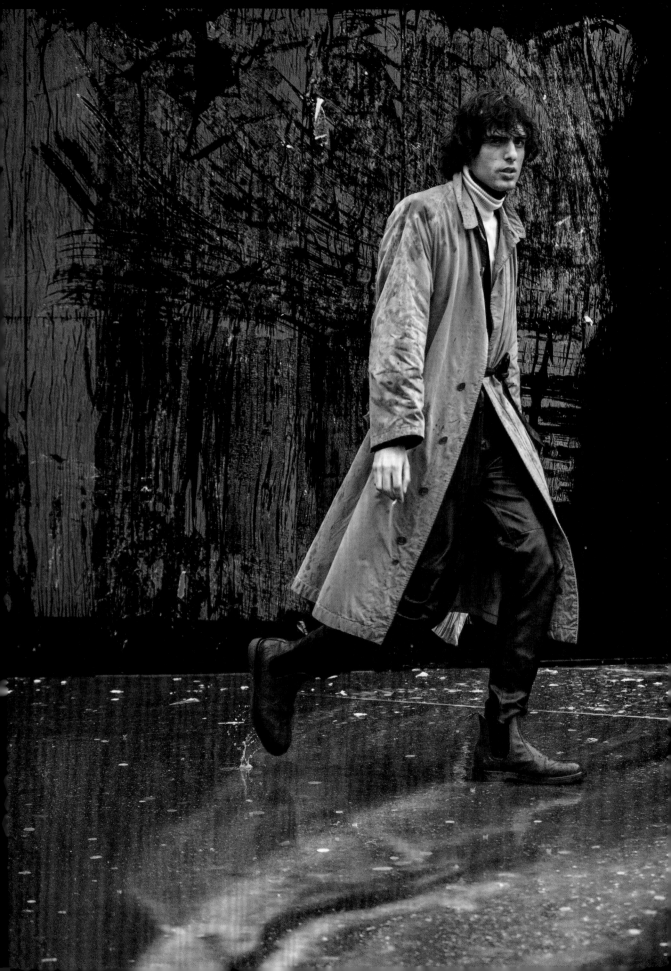

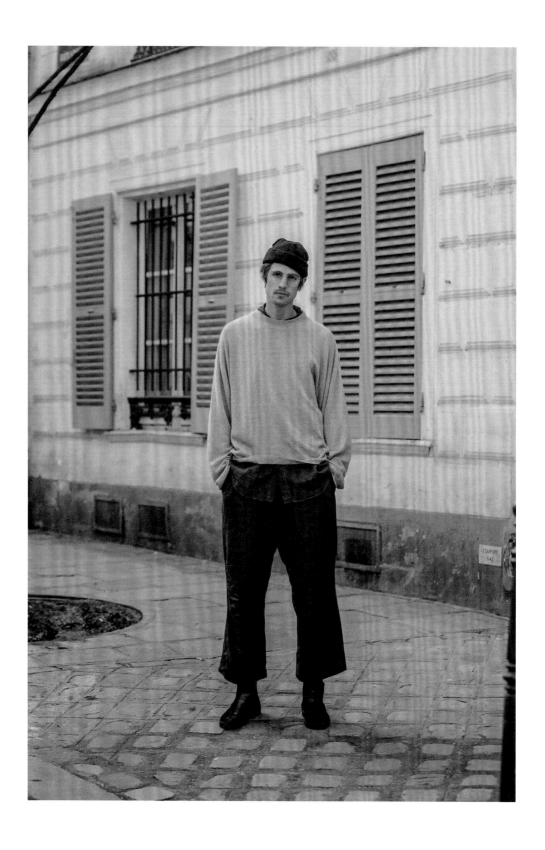

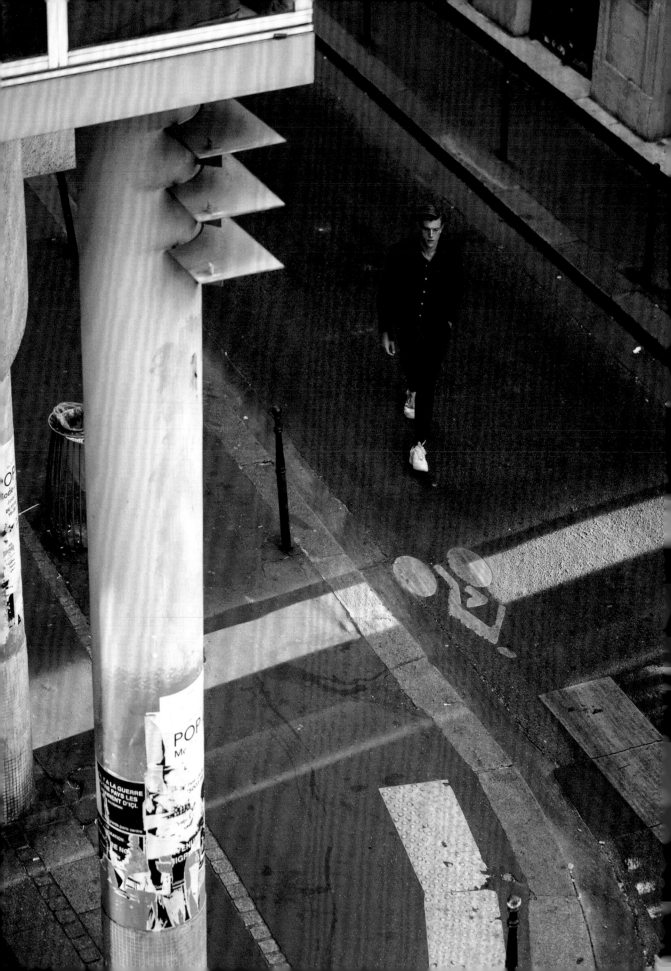

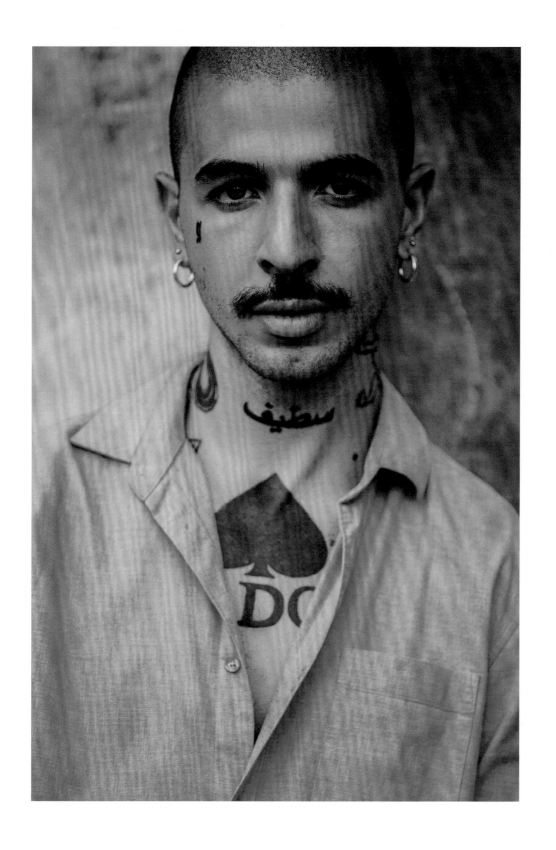

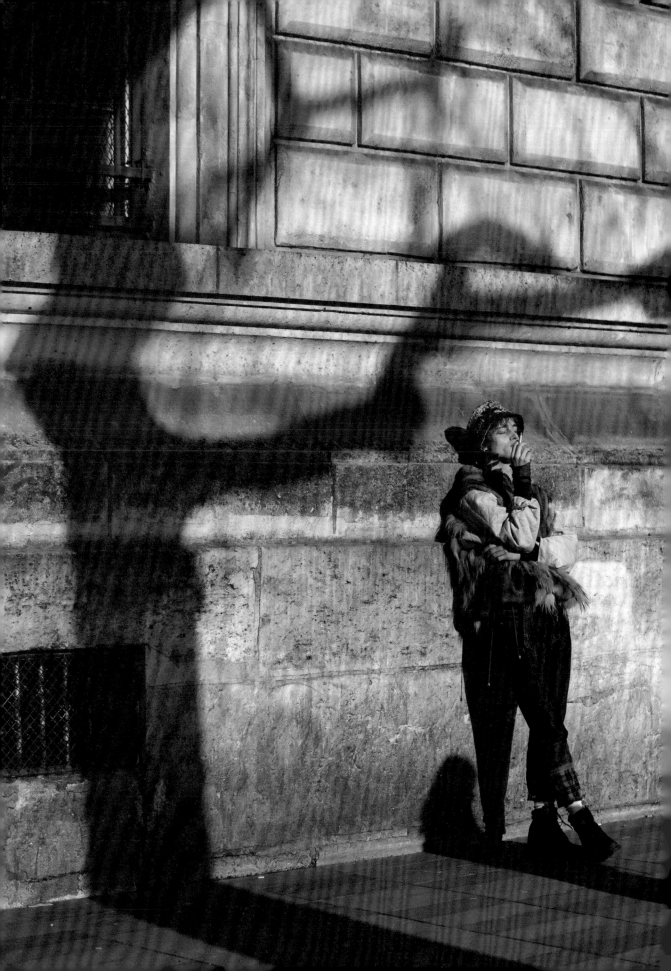

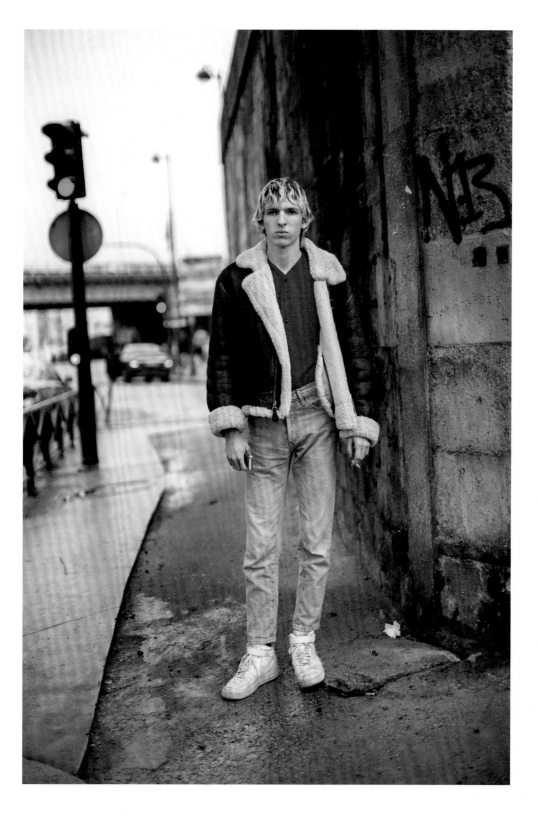

ABOVE - Mr Remi Laforet pairs American Apparel jeans with
his father's leather bomber jacket from the 1970s.

Boulevard Pereire

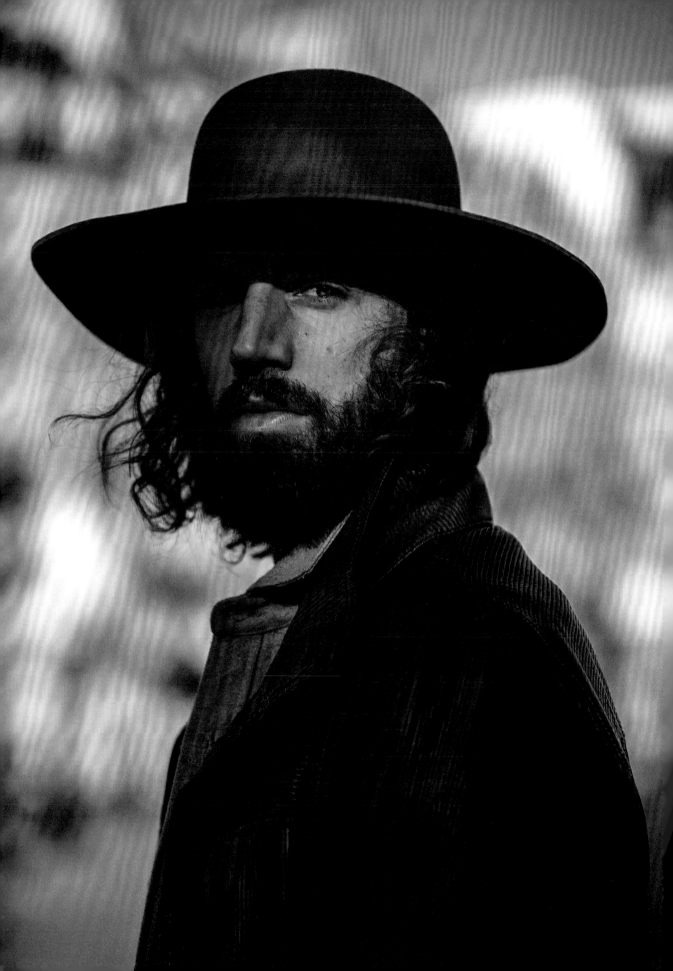

Mr Phil Sullivan

MODEL

The first show in Paris was about to begin. As the fourth city in the Fashion Week calendar, the industry crowd were visibly fatigued as they waited in line outside the Centre Pompidou, an ice-cold wind funnelling down the narrow street.

I stood back for a moment and spotted a tall man sauntering in my direction. He held himself with such authority that I hesitated to approach him, but my curiosity about how he managed to keep the wide-brimmed felt hat on his head in such a brisk wind got the better of me.

Phil Sullivan turned out to be an American from Massachusetts who had acquired this skill from his years working as a model. We got talking about his wardrobe.

I'm lucky that a few designers have given me some incredible clothes, but nothing compares to the vintage items I've picked up on this trip. I love Kiliwatch Paris in the 2nd arrondissement – it's full of hidden treasure. I found a Paul Smith suit in there once. I got a classic Issey Miyake leather jacket yesterday at Chinemachine in Montmartre. My apartment's around the corner, I have to show you.

Phil invited me over to his place to look through his collection, where he unveiled an array of designs created by his friends: an indigo hand-dyed silk shirt by Lucio Castro, colourful wide-leg pants by Thaddeus O'Neil and a hat by Orlando Palacios for

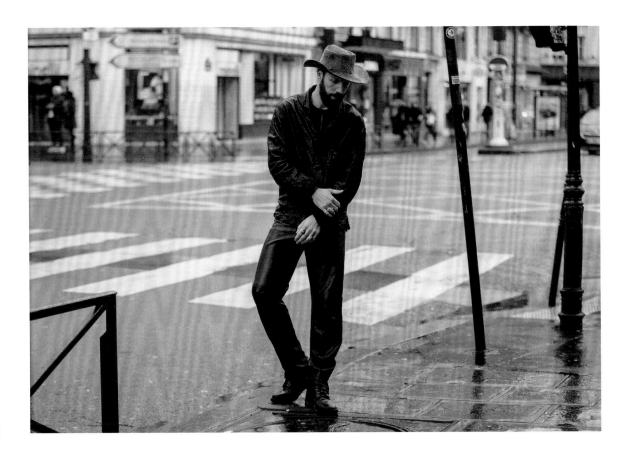

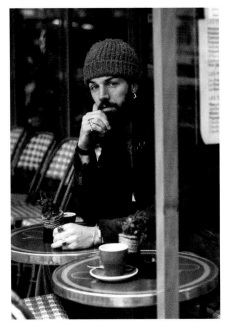

Worth & Worth. As we rummaged through, he described the journey to his current look.

Over the last decade, I collected and hoarded clothing of all styles. It wasn't until I was in the position of having to move apartments last year that I discovered an honest sense of self. Over time my style has changed quite a lot. I'm often described as a bohemian explorer type. I mix fabrics like leather and linen with denim and canvas. I think over the years of experimenting I started to see which styles I felt most comfortable in, discarding items I didn't wear piece by piece. That left the real favourites, the true gems. This also actually reflects my approach to life: I'm adventurous and free-spirited. Living a more minimal, conscious life has enabled me to really embrace that.

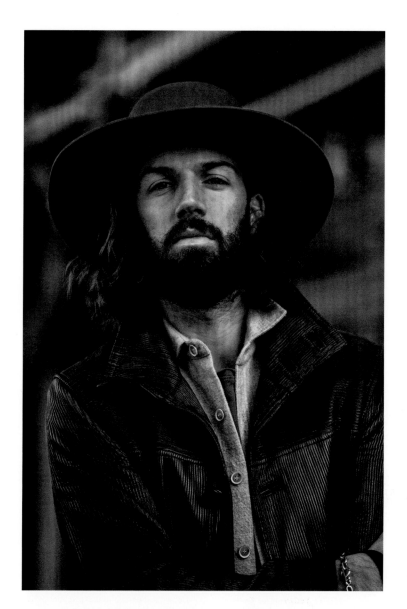

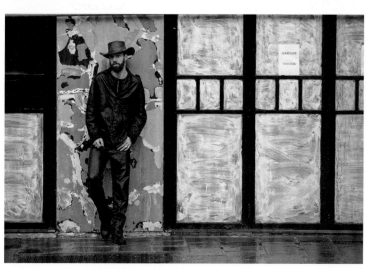

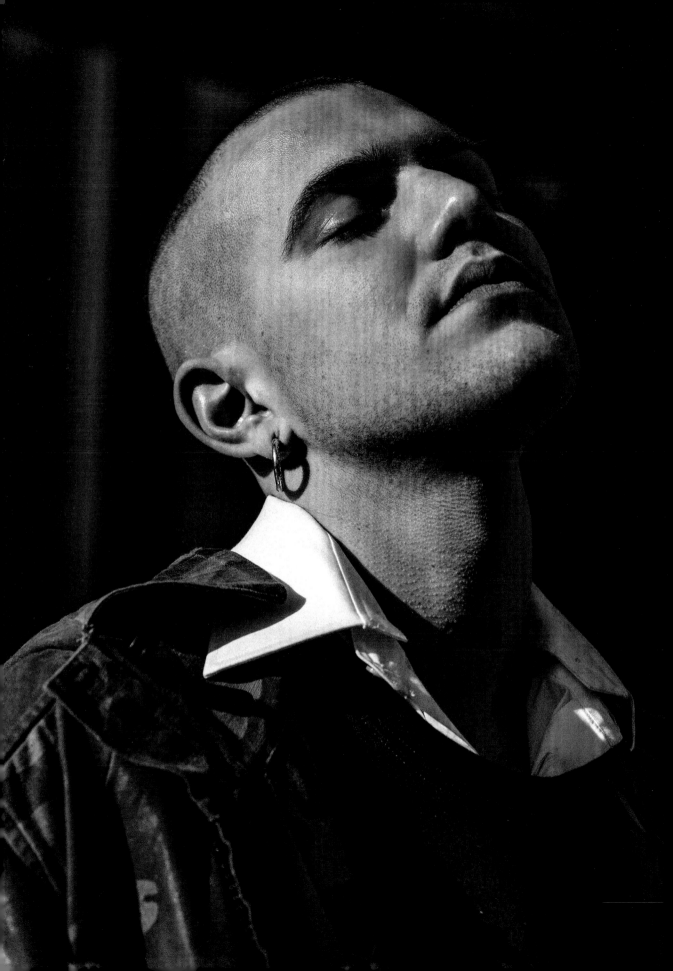

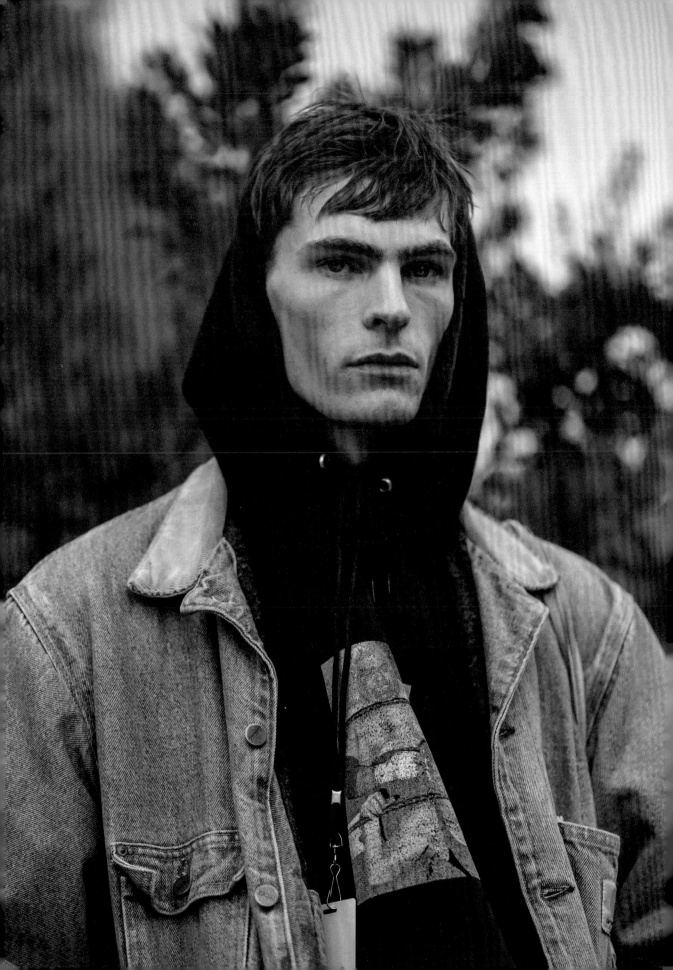

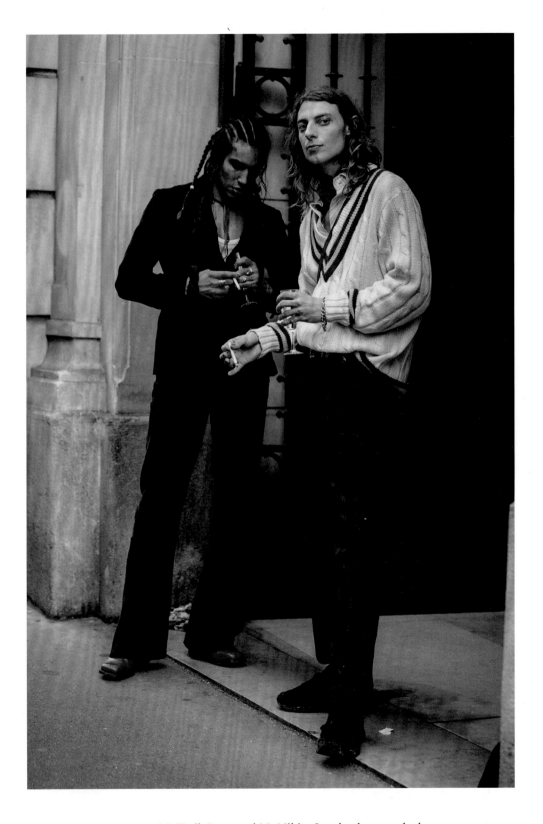

ABOVE - Mr Tarik Berry and Mr Nikita Sereda photographed
after the Vivienne Westwood fashion show.

Rue de Choiseul

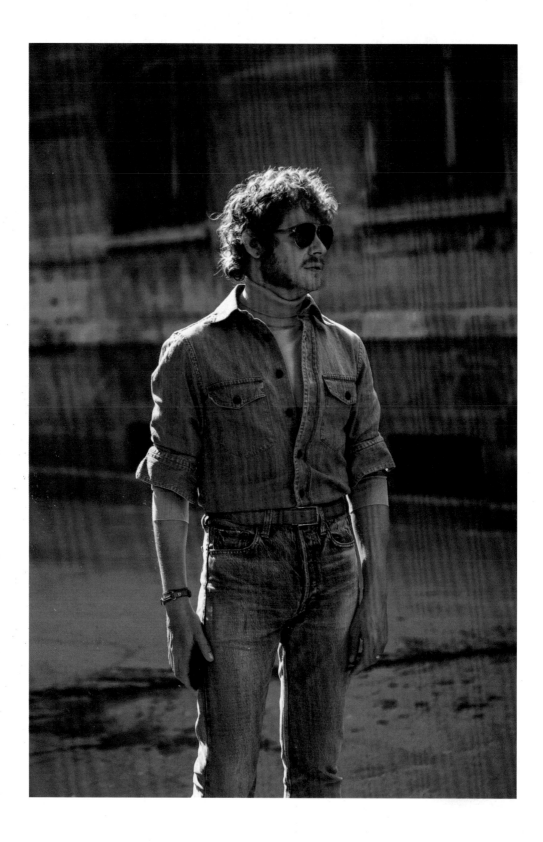

ABOVE - Mr Luke Day in double denim by Dunhill London.

Avenue Trudaine

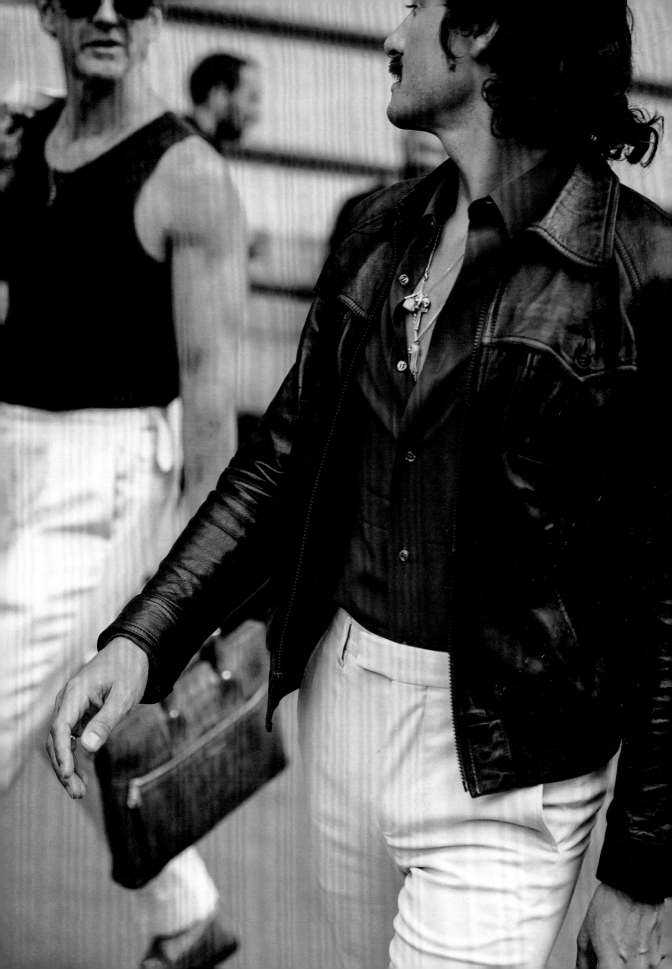

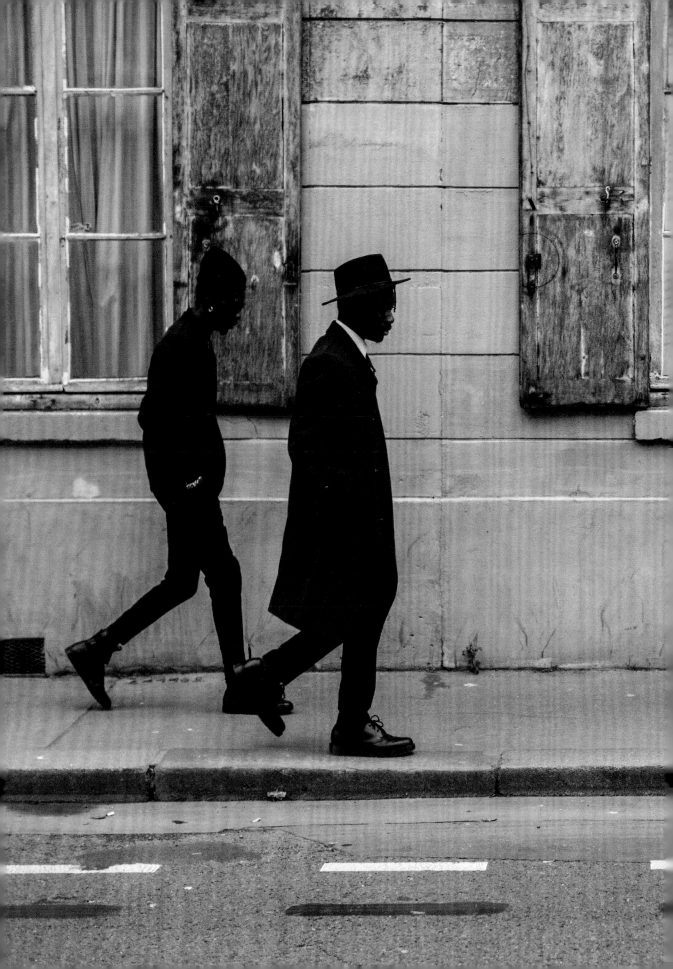

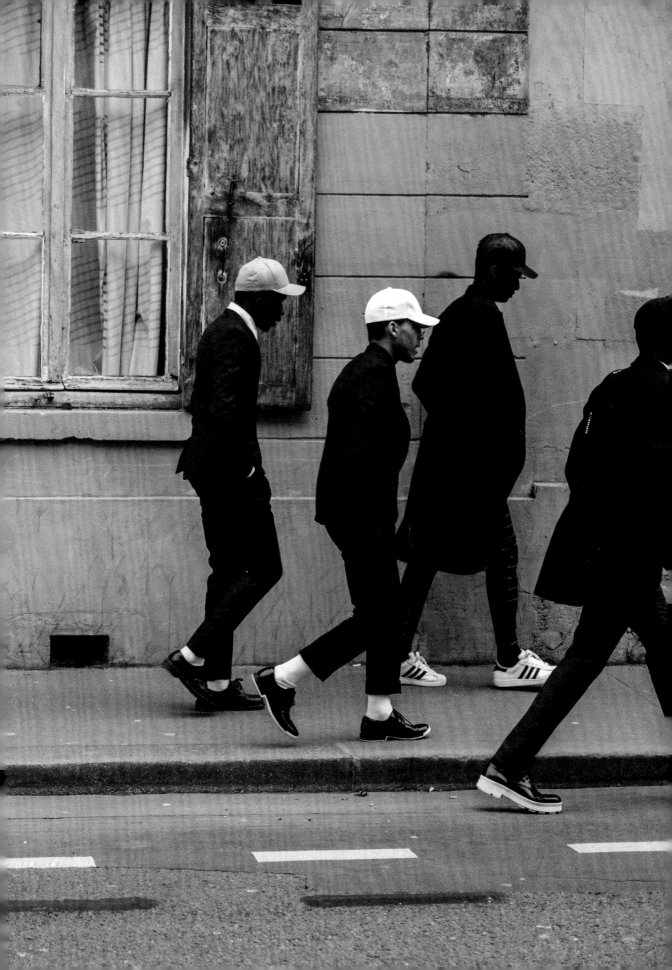

Acknowledgements

Huge thanks to all the men in this book who inform,
inspire and help bring the streets of the world to life.

This project would not be possible without:

Martin Belk
Mary Folliet
Jimin Jeon
Christina Fragou
Andrew Barker, Richard Biedul, Julian Ganio,
Isaac Hinden-Miller, Joe Mowles and Daniel Stern

Sir Paul Smith

Interviews

Paul Weller
Raashid Hooks
Scott Fraser Simpson
Frank Neri
Ko Hooncheol

Sergio Guardì
Andrew Livingston
Juan Manuel Salcito
Blake Abbie
Rainer Andreesen

Edward Siddons
Izé Teixeira
Phil Sullivan

Alastair Nicol and Gaby Cove, *Vogue International*
Hugo Compain and Olivier Lalanne, *Vogue Hommes*
Dylan Jones, Paul Solomons and Luke Day, *British GQ*
Laura Kidd, Jennifer Pryce and Robert Pryce; Katherine,
Sophie, Nicolas, Jo and the team at Laurence King.

And to anyone missed but not forgotten, sincere thanks and gratitude.

Find more at www.JonathanDanielPryce.com